The Other Side of Silence

The Other Side of Silence

Women Tell About Their Experiences with Date Rape

Edited by
Christine Carter

1995
AVOCUS PUBLISHING, INC.
GILSUM, N.H.

THE OTHER SIDE OF SILENCE:
WOMEN TELL ABOUT THEIR EXPERIENCES
WITH DATE RAPE

Published by:
Avocus Publishing, Inc.
Lower Village
Gilsum, NH 03448
Telephone: 603-357-0236
Fax: 603-357-2073
Orders: 800-345-6665

Disclaimer:

Nothing contained in this book is intended in any way to be libelous in nature. Neither is it the intent of Avocus Publishing, Inc. to publish an accusatory statement, direct or implied, of improper motives or illegal action by any individual or institution. Any other interpretation of our printing is erroneous and therefore misunderstood. We believe the public interest will be served by the publication of the authors' experiences. The names of most individuals and institutions have been changed or omitted.

If we had a keen vision and feeling of all ordinary human life, it would be like hearing the grass grow and the squirrel's heart beat, and we should die of that roar which lies on the other side of silence.

—George Eliot
Middlemarch

Acknowledgments

There is no one I need to thank more than Liza Veto. She has helped me with everything: the editorial, the technical, the professional, secretarial, creative, emotional, and spiritual. Every word in this book has been approved by her, and without Liza Veto, the book would not exist.

Heather Earle also deserves credit for helping get this book off the ground. Her intellectual guidance and technical support was fundamental to the formulation of this collection as was her dedication to the daily retrieval and forwarding of my mail while I was abroad.

* * *

I am eternally thankful for Duncan Hodge and Nicky Schmidt. Thinking about real-life rapes day-in and day-out would have destroyed me emotionally if it weren't for these two. Thank you, Duncan, for your unconditional love, understanding, and support. Thank you, Nicky, for struggling with me.

The love and support from my family has also been unending, and they, too, deserve credit for my current sanity. They take pride in everything I do; that knowledge has given me the courage to do anything.

Heather Earle, Missy Bennis, Laura Beth Nielsen, Rachel Perri, Lauren Lieberman, and Dan Garodnick also stuck by me as rare and special friends. They reminded me to be proud of myself when I forgot, and dried my tears when others looked away.

My advisors, Deborah King and Ivy Schweitzer deserve a world of thanks for all of their advice and instruction, as do my assistants, Reini Jensen and Kirsten Doolittle, who worked tirelessly for peanuts.

And finally, I would like to thank the author of each chapter, whose hard work and perseverance, despite sometimes overwhelming trauma, created this book.

Contents

ix

The Other Side of Silence

Foreword

Alan D. Berkowitz, Ph.D.
Director, Counseling Center Hobart and William Smith Colleges

In this book sixteen women bravely and honestly share the details of their experiences as victims and their courageous struggles as survivors of date rape. I found these stories to be powerful, moving, and informative, opening my eyes to the pain and suffering behind the frequently cited statistics about rape and sexual assault. From these stories and the additional chapters by experts on the subject of date rape we can directly experience the impact of rape on women's lives and learn some steps that can be taken to help prevent future assaults from occurring.

We must all insist that men take responsibility for preventing rape while at the same time encouraging women to act to reduce their risk of being raped. While the latter part of this approach may seem controversial and appear to promote victim-blaming, this is only true if we focus on women's risk reduction without at the same time unambiguously and aggressively assigning responsibility and blame to the men who perpetrate and their peers who enable them. Programs that combine strong and vigorous efforts to engage men in rape prevention and educate women about risk reduction strategies are prudent, developmentally sound, and effective. Historically, rape prevention programs have focused on women's concerns and experiences, but in recent years there has been increasing attention devoted to men's responsibility for preventing rape.[1]

Men should take responsibility for preventing rape because most rapes are perpetrated by men. It is morally unacceptable to blame women for the coercive acts of men who force themselves upon unwilling victims or who intentionally overlook expressions of nonconsent. Men who act coercively or without consent must modify their behavior and learn to act in sexually noncoercive ways. All men must take responsibility for reducing sexual assaults by confronting the behaviors of other men who act inappropriately. And men must become more empathic and knowledgeable about the effects of their actions when sexual intimacy is not mutual. The personal

stories in this book can help us develop this empathy and increase our awareness of the painful and damaging results of sexual assault. In addition, the excellent chapters by noted experts covering topics such as rape laws and definitions, consent, victim assistance, rape exams, men's behavior, and a feminist perspective on rape culture provide much needed information and understanding of the subject.

If all men took the necessary steps to ensure that their female partners were consenting and uncoerced then women would not have to experience the trauma, life disruption, self-doubt, and emotional anguish described so vividly in this book. Since this is not likely to happen, however, we must also encourage women to act in ways which will reduce their risk of being victimized without at the same time compromising their freedom of action and sense of agency. In the words of Brenda Niel (Chapter 7): "There must be a compromise that does not blame the rape victim but allows for women to strategize about being less vulnerable."

We can learn much from this book about how to promote this dual agenda of rape prevention for men and risk reduction for women. From the sixteen stories of rape victims, the single perpetrator account, and the insights of noted experts, we can identify patterns and circumstances that are associated with men's victimizing women and women's increased vulnerability.

* * *

Are there common characteristics of rape perpetrators or situations in which rapes are more likely to occur? How can potential perpetrators be identified? Research conducted on these questions suggests that men who are likely to rape often behave inappropriately or disrespectfully toward women, adhere to rape myths, overidentify with traditional masculine roles, and dominate by controlling situations or taking control away from others.[2] Christine Carter provides an excellent overview of the factors associated with men's proclivity to rape in her introduction to this book, and these are further amplified in Paul Kivel's chapter addressing "Why 'Real' Men Rape Women," and Albiston and Nielson's analysis of rape culture titled, "Rape Dictated by Society."

Many of these common characteristics and risk factors can be found in the rape situations described in this book. They include men who disempower women by taking control, acting deceitfully or inconsistently (saying one thing and doing another); men who take advantage of a woman's disorientation resulting from alcohol or strange or unfamiliar circum-

stances; men who escalate sexual contact inappropriately; and men who abuse alcohol themselves. Frequently these men overlook their victim's protests, "no's" and other expressions of nonconsent.

Paul's behavior prior to raping Catherine (Chapter 1) demonstrates this profile. Catherine describes how she was nervous in a foreign country among strangers, but Paul calmed her with his gentle words ("trust me" and "don't worry, I'll take care of you"). After promising to drive her home, he took her to his house, explaining that he "just had to stop for a second to pick something up." Paul then raped her, ignoring her tears, expressions of protests, and attempts to push him away.

The perpetrators described in other chapters behaved in a similar fashion. Eric (Chapter 17) offered to drive Leslie home and engaged in a series of deceptions to lure her up to his room, raping her after ignoring a series of verbal and then physical protests. In Chapter 4, Scott provides a first-hand account of how he got Lisa so drunk that she would not be able to leave his room, "feigned needing to make a few phone calls," and "used pressure to get what [he] wanted." Scott's transformation over the years and his ability to develop a critical understanding of his actions and show remorse for them provides hope that other men may be brought to this realization before they rape or sexually assault someone.

Like Catherine, Leslie, and Lisa, all women can be raped because rape is forced and no woman chooses to be lied to or coerced. Studies of victims suggest that there are few differences between women who have been victimized and those who haven't.[3] At the same time, women can learn to watch for warning signs in the actions of men, as well as in their own reactions and feelings. Many of the 16 women in this book saw themselves as invulnerable ("I never thought it could happen to me" (Chapter 12), "I was dangerously naive" (Chapter 2), thus missing important cues and warning signs. Others overlooked their discomfort when the situation became problematic, like Montana O'Riley who "accepted [her] discomfort as intimidation" (Chapter 2) and Leslie who "[wrote] off the uneasiness [she] felt about his change in plans . . ." (Chapter 17) Almost all of the rape victims had too much to drink ("I knew I was going to drink that night. I wasn't very experienced with hard alcohol" (Chapter 3), "I got unbelievably drunk, by my standards or any other's" (Chapter 6), and many were in isolated, strange, and/or unfamiliar places.

Carol Gilligan (1991) and other writers on women's psychological development describe a time in adolescence when young girls turn to boys for validation and self-esteem, a process which is encouraged and reinforced in our culture. This transfer of authority, status, and decision mak-

ing to men renders women dependent and vulnerable to exploitation: "I was flattered that he liked me" (Chapter 17), "I didn't want to blow my big chance with this guy, so I didn't say anything" (Chapter 19), "I think what I assumed was love was in fact a complicated reliance on him for my sexual identity"(Chapter 20).

Thus by looking up to men, seeking their approval, and accepting sexual scripts which assign initiative-taking to men, women run the risk of being victimized and of overlooking warning signals which may alert them to potential perpetrators. Men who perpetrate often share a common set of beliefs and use similar tactics to coerce their partners into unwanted sex. These common characteristics and behaviors of acquaintance rapists, factors which place women at greater risk, and situational characteristics which increase the risk of rape are summarized below.

Risk Factors for Acquaintance Rape

Male Characteristics and Behaviors
- Disrespectful speech or actions
- Socially inappropriate behavior
- Domineering or controlling behavior
- Acting dishonestly or inconsistently
- Alcohol abuse
- Belief in rape myths
- Irresponsibility
- Hostility toward women

Female Risk Factors
- Sense of invulnerability
- Overlooking discomfort
- Overlooking warning signs
- Idealizing men
- Alcohol abuse

Situational Characteristics
- Isolated or unfamiliar environment

- Women dependent on men for transportation
- Man initiates and/or pays
- Alcohol and/or other drug use

Christine Carter has created a powerful tool for promoting both rape prevention among men and effective risk-reduction strategies for women. This book can be highly recommended for use in a number of settings. Therapists may find that the stories are helpful to survivors in the process of recovery as a means of working out issues of blame, or in working with perpetrators to illustrate men's behavior and create empathy for victims' experiences. The book contains excellent case and analytic material which can be used for readings in academic courses concerned with issues of sexual violence, or for training peer educators who need to become aware of and sensitive to the experience of victims and the problematic behavior of perpetrators.

Those who take the time to read this book will be affected in significant ways. Men will learn of the powerful and often unintentional effects of their actions and be challenged to reexamine and change the sexual scripts we have been taught, scripts which lead us to misperceive our partners' intent and violate them. We also learn that if we are sensitive and caring, we can be an important part of a woman's healing process. Women will gain important exposure to the reality of rape and shed some of the ignorance, trust, and naivete which increases their vulnerability. Both men and women can be alerted to the characteristics and strategies of potential perpetrators and learn to avoid or confront them. Finally, readers will be introduced to the insights of noted experts in the field. In these and many other ways, this book is an important and much needed resource. I hope that all who read it will work to end violence against women and make into reality the goal of mutually empowering, uncoerced, and consenting sexual intimacy in all relationships.

Notes

1. Berkowitz, 1994; Funk, 1993; Kivel, 1992.
2. Berkowitz, Burkhart & Bourg, 1994; Rapaport and Posey, 1991.
3. Harney and Muehlenhard, 1991; Mandoki and Burkhart, 1991.

Bibliography

Berkowitz, A.D. (ed). *Men and Rape: Theory, Research and Prevention Programs in Higher Education.* New Directions for Student Services Monograph #65, Spring 1994. San Francisco: Jossey Bass.

Berkowitz, A.D., Burkhart, B.R., and Bourg, S.E. "Research on College Men and Rape." In: Berkowitz, A.D. (ed). *Men and Rape: Theory, Research and Prevention Programs in Higher Education.* New Directions for Student Services Monograph #65, Spring 1994. San Francisco: Jossey Bass.

Funk, R.E. *Stopping Rape: A Challenge for Men.* Philadelphia: New Society Publishers, 1993.

Gilligan, C. "Women's Psychological Development: Implications for Psychotherapy." In: Gilligan, C., Rogers A.G. and Tolman, D. L. (eds) *Women, Girls and Psychotherapy: Reframing Resistance.* Binghamton: Hawthorne Press, 1991

Harney, P.A., and Muehlenhard, C.L. "Factors That Increase the Likelihood of Victimization." In: Parrot, A. and Bechhofer, L. *Acquaintance Rape: The Hidden Crime.* New York: Wiley Interscience, 1991.

Kivel, P. *Men's Work: How to Stop the Violence that Tears Our Lives Apart.* New York: Ballantine Books, 1992.

Mandoki, C.A. and Burkhart, B.R. "Women as Victims: Antecedents and Consequences of Acquaintance Rape." In: Parrot, A. and Bechhofer, L. *Acquaintance Rape: The Hidden Crime.* New York: Wiley Interscience, 1991.

Rapaport, K.R. and Posey, C.D. "Sexually Coercive College Males." In: Parrot, A. and Bechhofer, L. *Acquaintance Rape: The Hidden Crime.* New York: Wiley Interscience, 1991.

Introduction

Christine Carter

"If there is a single issue that signals the changed relationship between men and women," write the authors of *Sex in America,* "it is forced sex."[1] We usually call the forced sex described by these highly regarded social scientists "date rape," although in most cases, the people involved aren't on dates. They weren't at the drive-in or a romantic restaurant, but were instead at a party, unaccompanied. In fact, only one of the sixteen accounts of rape in this book occurred on what we would consider to be a traditional date.

Nonetheless, this is a book on "date rape." "Date rape" because that is the way the experience of a woman forced into sex by someone she knows is usually labeled in American culture, regardless of whether "boyfriend rape" or "acquaintance rape" would be a more precise term. And because this is a book on "date rape," this is also a book about our expectations and assumptions about sex. The following essays, while they tell stories of rape, tell us just as much about the dysfunctions of the American sexual script: our culture's not-so-subtle way of dictating how men and women interact sexually.

"Date Rape"

"Date rape" is by now a buzz word with two, opposing, uses. On the one hand the term "date rape" is used to identify or heighten awareness of a problem rooted in normal social interactions between men and women. On the other, the phrase "date rape" is often used to legitimize or qualify a rape, making it seem less harmful or violent. In this second sense, the term "date rape" reflects the man's experience: to him, raping a "date" is not nearly so awful as raping a complete stranger, plucked off the street. Scott Stewart, who admits to "date raping" a woman while he was in college (Chapter 4), explains: "To me, date rape requires some gray areas in terms of consent while rape is pure and simple. . . . It troubles me that one would

try to equate what I mistakenly or ignorantly did to Lisa [whom he 'date raped'] with what happened to Ashley [who was raped by a stranger who broke into her home]."

The gray areas are most often within the man's perspective. Provided she is conscious, a woman knows when someone is having sex with her against her will. A man, however, may not be so sure when a woman has and has not consented to sex. A woman experiences forced or coerced sex; but since the man experiences sex as he expected it, rape is qualified, neutralized.

If the term "date rape" reflects the man's experience, then why use it? Why qualify rape at all? Part of the problem is that if "date" is not used, "strange-man-wielding-a-knife" is implied, which distorts our perception of the event. The term date rape allows us to confront social stereotypes about rape: namely that rape is not always, or even usually, perpetrated by a stranger jumping out of the darkness. Putting the term "date" before rape confronts our assumptions that the "rape" always equals "rape by a stranger." Keeping the term "date rape" will allow us to examine the complex of beliefs, indeed the culture, it represents. To deny the term as it is used in our culture would be to deny the cause of the problem.

The cause of this problem, few would argue, lies within the rapists. But rape in America begins with deep roots in false beliefs about rape and rapists—for example, our beliefs about who rapists are. Most of us don't picture the boy next door as one, unless, of course, we were raped by the boy next door—and even then we might not label him a rapist. Instead, we picture a crazed psychopath, an image from the traditional psychiatric view of rape. In American culture, rapists are perceived as sexual deviants, with traditional research focusing on "diagnosing the rapist so that he may be treated and made more like 'normal' men," say sociologists James Check and Neil Malamuth.[2]

Convicted rapists have been subjected to a battery of psychological tests,[3] intelligence scales, physical measurements, investigations of their childhoods, their dreams, and even their genetic makeups, all in an attempt to uncover psychological maladjustments. The results? Few indications that individual differences in personality, intelligence, or genetics can explain rape behavior. Contrary to popular belief, this testing shows that rapists do not differ much mentally from the rest of the population.

Modern social scientists argue that the underlying causes for most rapes are rooted in *social norms* which "cause many men to be inclined to aggress sexually against women."[4] Rape is supported by countless beliefs and myths which allow it to continue undetected and unconfronted. Stud-

ies on date rape, such as those by Mary Koss and her colleagues, indicate that a boy's or man's likelihood of raping is "strongly related to his acceptance of rape myths, violence against women, and his tendency towards sex-role stereotyping."[5] These studies support the hypothesis that rape and sexual aggression is more closely linked to "socially-acquired beliefs, roles, and attitudes"—our cultural norms—than to "gross psychological abnormality," writes Koss.[6] These cultural norms are enacted on an individual basis, and are a part of our social and sexual scripts—our expectations about the way social interactions will occur. Logically then, if we have a culture with norms that support rape, we will have a culture with men who rape.

Rape Myths

Rape supportive beliefs, often called "rape myths," are prejudicial, stereotyped, or false beliefs about rape, rape victims, or rapists. Rape myths dictate that only certain types of men can be rapists; that only certain types of women can be raped; that forced sex under certain circumstances is justified and therefore not really rape. The belief that women "cry rape," or label a consensual sexual experience rape because they feel guilty or regretful about having sex, is an example of a rape myth. Often the largest obstacle women face in trying to press charges against their perpetrators is in first convincing the would-be arresting police officers and district attorneys that something criminal happened to her.

Many people also incorrectly believe that rape is an innocuous act. The belief that "No harm was done" is reflected in actor James Caan's comment after witnessing the depressing conditions in an Ohio prison: "I'm not going to do anything wrong anymore, except maybe for an occasional rape."[7] An assistant mathematics professor at the University of New Brunswick, writing in the student newspaper, also perpetuated this myth when he wrote, "Rape is traumatic only for virtuous women who consider sex outside marriage a sin."[8] Likewise, a jurist in London "freed a teenage rapist after suggesting that his 15-year-old victim could 'get over the trauma' by going on a holiday."[9]

"She wanted it" is another common false belief about rape victims. Implicit in the myth that women always "want it" is the belief that healthy women can always resist rapes if they want to or that no woman can be raped against her will. Dr. Ralph Good, a gynecologist and psychiatrist, illustrated this myth during the William Kennedy Smith trial. Called to the witness stand by defense layer Mark Seiden,

> Good launched into a strange lecture on sex, comparing the labia to a "set of swinging door shutters" and saying of intercourse, "It's like trying to put a thread through a needle. As you know from common experience, you wet the end and twist it a little." Extending the analogy to a woman's resistance during rape, he said, "if the needle is jiggling around a little bit, if you will, it is very, very difficult."[10]

Dr. Good's testimony in the Smith trial suggests this: Bowman could not have been raped, because even a "little bit" of resistance would have made sex "very, very difficult." The fact that 176 women were murdered before, during, or after they were sexually assaulted or raped in 1991 alone,[11] should be testament enough to the fact that women, no matter how strong, cannot always escape a rape. Furthermore, this myth denies the legitimate effectiveness of coersion or threat of violence in causing a woman to submit to rape. Very few rapists actually use a weapon or even extreme physical force; nevertheless, many women are verbally and physically coerced or threatened into unwanted sexual intercourse.

Historically, a woman's reputation was considered evidence of consent ("wanting it"), assuming a sexually experienced woman who supposedly casually selects partners would be more likely to have consented to the act in question. Even today a former Ohio judge, John Angelotta, asserted on national television that:

> A nice girl who gets raped is different than a bad girl who gets raped, a bad girl being one who carries on this course of conduct with men. To me, she's a lot different than a good girl when you come to the question of rape—while agreeing that you may not rape either kind of girl.[12]

An implication of this belief is that once a woman has "said yes" and had sex with one man, she is never again in a position where she can legitimately say "no."

Saying a woman "wanted it" is a statement about her sexual desire. The myth that women always want sex (and thus cannot be raped) does not allow for a difference between women having sexual desire and actually desiring a specific sex act at a specific moment with a specific partner. Sexual desire is translated into universal consent, effectively erasing a woman's right to give or to not give consent.

Likewise, myths that women ask or deserve to be raped are everywhere. "The scene has become all too familiar: a woman who claims she was sexually assaulted; a man who says she asked for it and she got it," writes Tom Mathews for Newsweek about the Mike Tyson trial.

The above examples are merely the beginning, We live in a culture which supports multiple rape myths, all mutually reenforcing. Rape-supportive beliefs do not exist in a vacuum but are created and reenforced by the images and messages conveyed in the media and are supported and enforced by our peer groups, social institutions, and living communities. Everyone who functions in American culture has learned many rape myths, even if we have never raped someone or been raped ourselves.

Rape myths and all rape-supportive beliefs serve to neutralize the perceived damage and violation of nonconsensual sex. The word "rape" begins to seem too strong a label for an incident where an intoxicated woman is intimidated into sex, although she has made it clear she did not want it. Studies have shown that a person's definition of rape[13]—narrowed by the rape myths he or she believes—will also affect the verdicts in a rape trial (allowing a perpetrator to be acquitted), the way a perpetrator is sentenced (giving him a lesser punishment), and perceived injury to the victim[14] (that the violation of her rights was lesser, as was her pain and psychological damage). Rape myth acceptance in both men and women is significantly correlated with a tendency to blame the victim for the assault and excuse the rapist.[15]

Men's endorsement of rape-supportive beliefs has even more telling consequences. Men who adhere to rape-supportive beliefs are likely to show higher levels of sex role stereotyping, adversarial sexual beliefs, sexual conservatism, and acceptance of interpersonal violence.[16] Mary Koss, along with many other social scientists, report that "men who have threatened or actually used force to gain nonconsensual sexual intercourse with female acquaintances [differ] from sexually nonaggressive men in their degree of adherence to several rape-supportive attitudes."[17] The more men believe rape myths, the more likely they are to have coerced sex or raped. Men who adhere to rape-supportive beliefs have also been predicted to be more likely to rape in the future (regardless of their past sexual history), and more likely to say that they and other men would rape if they thought they could get away with it.[18]

Rape-supportive beliefs create a vast gap between the perceived seriousness of a rape that is called "date rape" and a rape that fits the popular conception of a stranger attacking a woman in an alley. The narrow definition of "rape" which exists in the popular mind today does not accurately reflect women's experiences. Women are more often raped by men they know, usually without a weapon.[19] The experiences of victims of date and acquaintance rape are painfully real to them, if to no one else.[20] Clearly, this book is testament to that: not only were the rapes real to the women

who wrote the following chapters, they are *still* real. Many of the authors of this book were raped almost a decade ago, and yet are still dealing with the aftermath of their rapes.

Rape needs to be seen on a continuum of violence that includes all forms of sexism, from dumb blonde jokes to violent rape-murders. To think of rape as a part of a continuum of violence against women is not to classify some rapes as "worse" than others, but rather to acknowledge that rape exists within and is inseparable from a sexist culture. To continue to understand rapes by the character of the rapist, is to continue to propagate myths about rape, namely that strangers rape violently and know that they are raping, while high school and college men rape without violence, without realizing they are raping. Men—men we think of as "nice guys" and trust—often do not realize that forced sex is traumatic for women. "At worst I might hurt her feelings, but she'll get over it. She might just enjoy it, and that would be better," Scott —one of those "nice" guys—recalls thinking before having sex with a barely conscious woman who vomited during intercourse (Chapter 4). Indeed, a number of boys told rape crisis counselors conducting rape education seminars in Washington, D.C. high schools that they "never consider themselves rapists if they force a girl to have sex at the end of a date." Says one boy: "the whole time I'm thinking that she expects to have sex. I'd be a real wimp if I let her get away."[21] David Caballero, who was convicted of felonious sexual assault but sentenced under a law that allows for lenient treatment of youthful offenders, felt the same way: he explained to a judge that leaving his date "bruised and bleeding" was "just your average one-night stand or whatever."[22]

What controls are in place that tell men their misperceptions are morally and factually wrong? Few, if any. Often the law does not; while the law acknowledges that the "injury of rape lies in the meaning of the act to its victim, but the standard for its criminality lies in the meaning of the act to the assailant"[23]—the law requires that the accused possess a "mens rea" (criminal mind) before what he has done is considered criminal. So if the accused "reasonably believed that the victim consented to sex even if she did not," explains Sakthi Murthi in the *California Law Review*,[24] the attacker can be exonerated due to his "mistake of fact"; in other words, what happened may not be considered rape.

To say that many normal men rape is not to say that these men are necessarily intentionally harming the women they rape. They learn from the beginning of their social lives that as "normal," noncriminal people they cannot be rapists. They are taught that male sexuality is powerful and more rewarding to release than to control. They are taught that as men, they de-

serve and should have lots of sex with many women. Men are taught that a certain amount of coercion and force is not harmful, that some women even appreciate it. Men are taught to dominate, to control, to be different (and therefore better) than women. They are taught to take risks and make assumptions to get what they want. Most date rapists rape simply by ignoring women's protests.[25]

Sexual Scripts

This problem could be significantly alleviated if it were socially desirable for women to say "yes" to sex when they want to. Sociologists use the notion of sexual scripts to elucidate how our social constructions of sexuality—like the stigma of women who "say yes"—are internalized. "Sexual scripts serve as blueprints for both choosing a course of action and evaluating behaviors already performed," explain social scientists Suzanna Rose and Irene Frieze.[26] As it stands, a woman's sexual script is not independent of a man's, but instead, a response to his. Women act as gatekeepers to men's actions, and many are expected to say "no" to sex—whether they mean it or not—to preserve their reputations. Complications occur when a woman says "no" and means it; because her script is dependent on his, he is the interpreter of her actions. This poses a problem should she have sexual impulses of her own; since our culture doesn't provide her with a script to independently initiate or participate in sex, she has no script to act out her own desires. And women who *do* have active "yes" scripts are considered whores or sexually predatory. Consider, for example, Sharon Stone's character, Catherine, in *Basic Instinct*, for which Stone became an acclaimed sex symbol. Stone portrays a highly independent, even dominant, sexual being. But Catherine is also a psychotic, sexually predatory murderess: the message sent about sexually independent women is clearly not a positive one.

Most women, however, say "yes" when they mean "yes" and "no" when they mean "no."[27] But explicit "yeses" are not recognized as the norm and are not expected—and often they are not given, just assumed. Men assume women will react to their attempts to initiate sex with passivity or resistance, especially if they are "good girls" protecting their reputations. And some women sometimes still say "no" as they carry out "yes," usually when they think their partner expects them to.[28]

The scripts need to be entirely rewritten. Women—"good girls"—need to be encouraged to initiate sex, and a female "yes" script needs to be written and endorsed. This will require a huge inward glance at our society's

sexual behaviors and beliefs—not just those of women, but of men as well. Before women will author and perform their own "yes" scripts, there will need to be an audience to stand up and cheer them on. How can a culture so unaccustomed to this way of thinking become a supportive audience? Realistic sex education at both cultural and individual levels would be a start.

Although we live in an age of increased sexual activity, it is also an age of lack of progressive information about sex. "The public image of sex in America bears virtually no relationship to the truth," write the authors of *Sex in America*. "The public image consists of myths, and they are not harmless."[29] While many complain that television and movies are overrun with sex, what they are really overrun with is titillation—the bikini-clad women on *Baywatch,* hot sex scenes in *Basic Instinct,* and fetishists on *Donahue* are not giving us any information about real life sex. People base their knowledge about sex on the stereotypes they learn and their own trial and error personal experiences; the realities of sex need to be taught before they are stumbled upon. People need to learn to talk about sex, to bridge the gap between what people say they do, and what people actually do. Box office hits will always feature unrealistically easy big screen sex, but the people who watch them need to understand that reality does not always imitate art.

The most obvious way to begin reeducation is to start with social institutions such as schools. Like California, which has passed legislation requiring colleges and universities to provide rape awareness workshops as well as crisis and counseling centers on campus,[30] the federal government needs to make a commitment to rape education a part of schooling at a younger age in all states—high school students are more likely to be raped than college students. Antioch College has perhaps the most revolutionary date rape policy on any college campus, one which has received much attention and severe criticism. Antioch's solution is explicit communication. The Antioch Student Handbook incudes the following sexuality policy statement:

> All sexual contact and conduct on the Antioch College campus between any two people must be consensual; consent must be obtained verbally before there is any sexual contact or conduct; if the level of sexual intimacy increases during an interaction (i.e., if two people move from kissing while fully clothed—which is one level—to undressing for direct physical contact, which is another level), the people involved need to express their clear verbal consent before moving to

that new level. . . . Asking "Do you want to have sex with me?" is not enough. The request for consent must be specific to each act.

Antioch's solution should not seem unreasonable. But this policy has been ridiculed fiercely by the media, dubbed by George Will as "the strictest, most hilarious sexual correctness code in American academia."[31] All of the ridicule about sexual contracts and women suing men for breach of contract mocks a balancing of the scales; before the Antioch policy, men had the upper hand—they decided what the sexual contract was, what constituted a breach of contract, and what a breach of contract might justify. The parody of the Antioch policy reveals a profound uneasiness with the idea of communicating about sex in explicit detail, and the idea of women who are in control of their sexuality. Katie Roiphe, an English graduate student who has published her opinions on date rape, complains that a policy that mandates consent proposes that women are like children who cannot communicate what they want.[32] If she did some research, she'd see that most men force women to have sex by just not listening to what they know their dates are saying—so it is men who need a policy to mandate that they listen to their partners.

Antioch's policy establishes rape as a real crime, supposedly with a serious punishment. Men at Antioch are pretty concerned about raping someone, which cannot be said for men at many other colleges or universities.[33] They recognize that the policy protects them as well; they know that the women they are with are always consenting participants in whatever sexual activity they are engaging in and that, if they follow it, they are not at risk for being brought up on charges of date rape.

The policy does not make sex easier for the students at Antioch. The media ridicule focuses on the awkwardness of asking for permission to move to each new level ("may I unbutton the fourth button? the fifth?") and the seeming silliness of it all. But when asked, both male and female students will say that sex is better. Yes, the policy does take away a lot of the mystery of sex. But such a policy takes sex to a whole other level, replacing mystery and confusion with mutual satisfaction.

And there still is a certain mystery to being sexually satisfied in new ways. Talking is a large part of hot sex; if it were really as silly as the media makes it out to be, there would not be such a booming phone sex industry. The policy does not seem to stop people from having sex, but it does change *how* they have sex.

Male and female students report liking how the policy has transformed

their sex lives, even if they only use it strictly at the beginning of a relationship or never use it very strictly at all. Antioch's policy has made male students aware of their partners' and their own desires. Other men feel it improves their performance: "Talking about sex really helps take the pressure off, especially for guys who have problems with premature ejaculation, which has become less of a problem for me."[34] Another male student says that the policy has expanded his sexual repertoire into a realm he never dreamed possible: "Since you learn to ask, you're not afraid to ask for new things. You can experiment more and since she says yes, I know she wants to do it. We've done things that I'd have been terrified to even bring up before."[35]

Perhaps one of the most valuable aspects of the policy is that it allows people to talk about sex more: both with their partners and with their friends. Students at Antioch are educating each other, giving each other more real information about sex.

Is Antioch's sexual policy the answer? Not the way it is portrayed in the media now. While the policy as written is gender mutual—women should be asking men for consent as well—the focus of the policy has been on the men, assuming it is the men who really need to do the asking, because it is the men who rape. While logical, this interpretation of the policy is still just a revised version of the male aggressor, female gatekeeper script. Women's roles, while empowered, are still empowered by the men they are with and are still dependent on men for recognition and action. The way the policy is being used now (or the way reporters portray the way the policy is being used now) women still have to wait for men to ask for their "no"s to be heard. The scripts have not been rewritten; instead of either partner having independent or interdependent scripts, one sex is still clearly positioned as dependent on another.

But what if women (and men) were encouraged to ask for what they want as another route to explicit verbal consent? While "May I touch you here?" works, it is a much easier question to visualize men asking than women, because it is men who have a history of performing unwanted behaviors on unwilling partners. But what if the question was encouraged to be, in addition, "Will you touch me here?" Once answered, consent to the request is clear and the question follows what we know to be erotic sex talk. Moreover, whoever asks the question is an active agent in relation to her or his own sexuality. Women in a community that encourages women to ask for what they want will have "yes" scripts, thus changing the perception that a woman's "no" can also mean "yes, but I'm preserving my reputation by saying no."

Clearly the creation of such communities will take time and real effort. Until then, women need to be more informed about the society they live in and the ways that it operates on a sexual level. Women need to know that they can be raped by a "nice guy," someone whom they trust. They need to be warned that alcohol can make it very difficult for a man to hear a no, and for a woman to convey her nonconsent. Women should be taught that men who believe a lot of rape myths or buy into the traditional rules for manhood have a higher history of and proclivity to rape. They also need to know that certain settings (such as a fraternity or men's club) are more conducive to rape and gang rape, so that they can make informed choices about where they socialize. Women need to be taught that rape can occur on a date, in their homes, in a car, in fraternities—even when there are lots of people around. Women need to know how to defend themselves against dates as they would if they were being raped by strangers. Women need to know that they can be raped by someone they know *before* they are being raped by that person (or a year after they were raped by that person); they need be taught not to be embarrassed by screaming or running out of the room. Perhaps most importantly, women need to know that even if they do not scream or run out of the room, even if they were drunk or wearing a sexy dress or went up to his room, it is not their fault if they are raped.

But even if women are entirely aware of risks and prepared to defend themselves, women will still be raped until men decide to stop raping. And all men, not just rapists, need to actively stop rape. Men like the father of the boy in the Spur Posse who claimed that his son, who was arrested for alleged rape, did "nothing . . . that any red-blooded American boy wouldn't do" are going to have to decide that red-blooded American sons shouldn't force sex on red-blooded American daughters.

Men have stakes in this issue as well. Expectations of masculinity are real pressures that have real impacts on the way men live and enjoy their lives. Research done by Alan Berkowitz shows that expectations of masculinity and macho, sexist attitudes make many men uncomfortable. But most of these men never challenge the sexist norm. If such norms are going to change, men who are uncomfortable with current norms will have to be empowered, their feelings legitimized. Alan Berkowitz has created such an environment at Hobart and William Smith Colleges by instituting a mandatory rape education program run by men for men. Popular fraternity members and well-known athletes facilitate the workshops, so what they say is respected and legitimizes the often unspoken antirape attitudes among other men. Says one Hobart student, "I remember thinking that if fraternity guys, who I thought were too macho to be concerned about

women's experiences, could talk about rape then so could I."[36] A student facilitator describes how men influence each other and how the program changes attitudes among men:

> A man may know the difference between saying, "I'd like to get on her," and knowing it is not acceptable to force himself on another person. However, when he verbally puts women down, he may encourage other men to believe that is the way men are supposed to think. They may come to believe this is the way women want to be treated and think, "Other men put women down, why shouldn't I?" . . . Acquaintance rape occurs because one group uses power in a negative way over another. A good facilitator often uses his influence and standing as a student leader in a positive way to promote a change in the way men use power. . . . It is extremely convincing for first-year men to hear their social heroes, men who are not usually outspoken about curbing violence say that acquaintance rape is something men should be discussing. . . ."[37]

These workshops allow men to talk about rape and confront traditional definitions of masculinity. At the same time, these discussions work to destroy the rape myths and change the sexual scripts which facilitate rape by encouraging individual men to evaluate their own behavior. In the end, men not only recognize that rape is a problem, they see that they have the power to stop rape, and find that this use of power is rewarding and constructive. Men learn that they should want explicit consent to sexual intercourse in the first place, and if they or their friends do not want consent, or are not making sure they have it, they either are rapists or are putting themselves at risk to be rapists. Furthermore, they learn that men must be responsible for educating (and stopping) each other. Rape-supportive beliefs taught or perpetuated by "insider" groups such as fraternities will only be expelled if retaught by the fraternity itself; "outsiders" may be able to clear up definitions, but will not be able to change attitudes.

* * *

"We found that there is a strong, robust link between attitudes and sexual behavior," the authors of *Sex in America* conclude from their research.[38] While most men, rapists or not, will not self-identify as rapists, many men will relate to the attitudes that perpetuate rape; many men will, upon recognition of the damage their beliefs do, change their attitudes. Behavior directly reflects attitudes—with a change in attitude will come a change in behavior.

The following stories give detailed examples of the behaviors and attitudes which need to be addressed. They are attitudes and behaviors that are our responsibility to change, and so I hope you will read this book and be more than angry, or struck, or saddened. I hope you will read this and want to take action to stop forced sex from becoming a signal of gender relations in the nineties, as the authors of *Sex in America* suggest it might.

I know, though, that it will be easier for you to read this book without pausing to think about its implications for your own attitudes and behaviors. It will be easier to discount each story as someone else's mistake or misfortune than to realize the horror of it. And it will be easier for you to say she shouldn't have been so drunk, to say you never would have gone there, to say "that's not rape."

And so I leave you with a challenge: Don't turn your back on what the following authors have to say to you. Even if you think you would never find yourself in the same situations that these authors or their perpetrators were in, realize that what these authors have in common with each other is not their situations (where they went or what they did), but the more pervasive cultural influences that made their situations dangerous. Those cultural influences are what you, the reader, also have in common with these authors. And that is what you, the reader, can change.

Notes

1. Robert Michael, John Gagnon, Edward Laumann, and Gina Kolata, *Sex in America* (New York: Little, Brown & Company, 1994), p. 219. The National Opinion Research Center (University of Chicago) survey documented in this book is unprecedented in respect to its size and scientific credibility. Unlike all other major sex surveys, the respondents were scientifically selected and represent a random sample. The resulting data has led to important insights to America's sexual behaviors.

2. James Check and Neil Malamuth, "An empirical assessment of some feminist hypotheses about rape," *International Journal of Women's Studies*, vol. 8, no. 4 (1985), p. 414.

3. Tests have included the Rorschach Inkblot Test, the Minnesota Multiphasic Personality Inventory, the Edwards Personal Preference Schedule, and the Buss-Durkee Hostility Inventory; see, for example, Perdue and Lester, 1972; Karacin, Williams, Guerrero, Salis, Thornby, and Hursch, 1974; Fisher and Rivlin, 1971; Rada, Laws, and Kellner, 1976; Rada 1978; and Money, 1975. There is a significant bias in these studies because the samples consist only of convicted rapists (who are usually not date rapists), when most rapists are never convicted for their

crimes. (Some scholars have suggested that the men in these samples have more in common with other convicts they do than with average rapists.) However, samples which consist solely of convicted rapists have advantages as well. Each case contains compelling evidence of rape; the ambiguity that typifies most identification procedures, legal adjudication, etc. is not usually in question, so each man in the sample is a "confirmed" rapist.

4. Neil Malamuth, "Rape Proclivity Among Males," *Journal of Social Issues*, vol. 37, no. 4 (1981), p. 139.

5. Mary Koss, Kenneth Leonard. Dana Beezley, and Cheryl Oros, "Nonstranger Sexual Aggression: A discriminant analysis of the psychological characteristics of undetected offenders," *Sex Roles*, vol. 12, no. 9 (1985), pp. 981–992.

6. Koss, Leonard, Beezley, and Oros, "Nonstranger Sexual Aggression: A discriminant analysis of the psychological characteristics of undetected offenders," pp. 981–992.

7. *Newsweek*, September 15, 1975, p. 48.

8. "Retro Thinking," *Playboy*, April 1994, p. 47.

9. "Retro Thinking," *Playboy*, April 1994, p. 47.

10. John Taylor, "A theory of the case," *New York*, January 6, 1992, p. 38.

11. Uniform Crime Reports, Crime in the United States, U.S. Department of Justice, Federal Bureau of Investigation, August 30, 1992, p. 19. As far as the police could determine, only 37 of these rape murders took place between strangers.

12. *Angelotta* v. *American Broadcasting Corp.*, 820 F. 2d 806, 806-07 (6th Cir. 1987) (Suit by judge alleging that television program falsely portrayed him as biased against rape victims); Sakthi Murthi, "Rejecting Unreasonable Sexual Expectations: Limits on using a rape victim's sexual history to show the defendant's mistaken belief in consent," *California Law Review*, vol. 79 (1991), p. 550.

13. Martha Burt, "Rape Myths and Acquaintance Rape," *Acquaintance Rape: The Hidden Crime*, eds. Parrot and Bechhofer, New York: Wiley & Sons, (1991), p. 30.

14. Judith Bridges, "Perceptions of Date and Stranger Rape: A difference in sex role expectations and rape-supportive beliefs," *Sex Roles*, vol. 24, no. 5/6 (1991), p. 302.

15. Leslie Margolin, Melody Miller, and Patricia Moran, "When a Kiss Is Not Just a Kiss: Relating violations of consent in kissing to rape myth acceptance," *Sex Roles,* vol. 20, no. 38 (1980), p. 234.

16. Burt, "Rape Myths and Acquaintance Rape," *Acquaintance Rape: The Hidden Crime*, p. 33. See also Burt, 1980; Burt and Albin, 1981.

17. Koss, Leonard, Beezley, Oros, "Nonstranger Sexual Aggression: A discriminant analysis of the psychological characteristics of undetected offenders," p. 989.

18. Malamuth, "Rape Proclivity Among Males," pp. 138, 140. Various studies have found that on the average, about 35% of males indicate some likelihood of raping, and an average of about 20% indicate high likelihoods.

19. Mary Koss, Christine Gidycz, and Nadie Wisniewski, "The Scope of Rape: Incidence and prevalence of sexual aggression and victimization in a national sample of high education students," *Journal of Consulting and Clinical Psychology*, vol. 55 (1987,) pp. 162–170.

20. Robin Warshaw, *I Never Called It Rape*, (New York: Harper & Row, 1988), p. 66. Eighty-two percent of the women in Koss's study who had had experiences which met the legal definitions of rape (whether they acknowledged their experiences as rape or not) said the experiences had permanently changed them, and thirty percent had contemplated or attempted suicide.

21. Jean Seligmann, "The date who rapes," Newsweek, April 9, 1984, pp. 91–92.

22. Patricia Freeman, "Silent no more," *People*, Dec. 17, 1990, pp. 100–102.

23. Catharine MacKinnon, *Toward a Feminist Theory of the State* (Cambridge: Harvard University Press, 1989), p. 180.

24. Sakthi Murthi, "Rejecting Unreasonable Sexual Expectations: Limits on using a rape victim's sexual history to show the defendant's mistaken belief in consent," *California Law Review*, vol. 79 (1991), p. 541. "The lack of a clear definition of the mens rea requirement for rape is demonstrated by the differing approaches to the issue of whether a mistake must be reasonable to exonerate the defendant. The majority of American jurisdictions require that a mistake be both honest and reasonable. This definition adopts a negligence standard for criminal liability. A defendant is negligent, and may be convicted of rape, if a reasonable person in his situation would have realized that the victim did not consent to sex."

25. Charlene Muehlenhard and Melany Linton, "Date rape and sexual aggression in dating situations: Incidence and risk factors," *Journal of Counseling Psychology*, vol. 34, no. 2 (1987).

26. Suzanna Rose and Irene Frieze, "Young Singles' Scripts for a First Date," *Gender & Society*, vol. 3, no. 2 (1989), p. 98.

27. Charlene Muehlenhard and Lisa Holabaugh, "Do women sometimes say no when they mean yes?" *Journal of Personality and Social Psychology*, vol. 54 (1988).

28. Charlen Muehlenhard and Marcia McCoy, "Double Standard/Double Bind," *Psychology of Women Quarterly*, vol. 15 (1991), p. 461.

29. Michael, Gagnon, Laumann, and Kolata, *Sex in America*, p. 1.

30. Patrica Rozée, Py Bateman, and Theresa Gilmore, "The Personal Perspective of Acquaintance Rape Prevention: A Three-Tier Approach," *Acquaintance Rape: The Hidden Crime*, p. 341.

31. George Will, "Sex amidst semicolons," *Newsweek*, October 4 (1993), p. 92.

32. Katie Roiphe, *The Morning After*, (New York: Little, Brown & Company, 1993).

33. Jennifer Wolff, "Sex by the rules," *Glamour*, May 1994, p. 257.

34. Jennifer Wolff, "Sex by the rules," *Glamour*, May 1994, p. 257.

35. Jennifer Wolff, "Sex by the rules," *Glamour*, May 1994, p. 257.

36. Adam Simon, Jack Paris, and Charles A. Ramsay, "Student perspectives on facilitating rape prevention programs," *Men and Rape: Theory, Research, and Prevention Programs in Higher Education*, ed. Alan Berkowitz (San Francisco: Jossey-Bass Publishers, 1994), p. 43.

37. Simon, Paris, and Ramsay, "Student perspectives on facilitating rape prevention programs," *Men and Rape: Theory, Research, and Prevention Programs in Higher Education*, pp. 44-45.

38. Michael, Gagnon, Laumann, and Kolata, *Sex in America*, p. 231.

1

Please God, Help Me: Reconciling Religion and Rape

Catherine Lyons

"Trust me" were the words he so carefully uttered into my ear in his thick French accent. "Trust me." A scared sixteen-year-old girl in the middle of a French rural town, I did not think I had much of a choice. I was in France on a tennis tour. There were about ten teenagers from the U.S. who were selected to go abroad for a month to train. I was prepared to have the time of my life.

When I first arrived in France, I thought I was in paradise. My French "family" was quite wealthy. They had a tennis court and swimming pool in their backyard, which they told me I could use any time. The house was enormous and they put me in a beautiful room with a large canopy bed and pink floral wallpaper. My "brother" in the family was twenty-one, and incredibly handsome and charming. I remember thinking how lucky I was and how I never wanted to leave this perfect dream world. The second night I was in France, my brother took me to the town disco. I was excited since it was the first time I had been to a nightclub. Little did I realize that my French brother would drink a lot that night and leave me alone with one of his friends so he could make a move on another girl. But he told me not to worry. "Paul is a good friend of mine, he'll take you home," my brother whispered to me. I was too frightened and shy to complain, so I just smiled.

Paul seemed friendly enough. "Don't worry, I'll take care of you," he promised. He took my hand and led me to his car. I felt relieved that someone was watching over me. I held the gold cross that hung around my neck in my hand and quickly prayed for God's blessing, remembering my mother telling me never to ride in a car with strangers. Still, I felt secure

that God was protecting me. I was raised in a strict Catholic family and was taught that as long as I was a good girl and behaved myself, everything in life would turn out perfectly. Catholicism meant a lot to me growing up; whenever I was upset or discouraged I had always turned to God and had never been disappointed. My life was a fairy tale and I felt God protected me with a special blessing. I was a very naive child who had always gone to a girls' school and therefore had very little experience with boys. I kissed my first and only boyfriend, and felt shameful for having done so. I trusted everyone and could never imagine anyone wanting to hurt me.

In the car, Paul acted like a perfect gentleman. He spoke in broken sentences because his English was not very good. He asked me about the United States and told me someday he hoped to move out west. "After I make the Olympics, I'll move," he said. At the time, he was in training for the Olympic cross-country skiing team. He smiled at me and put his hand on mine. My heart was pounding, I was so nervous. I tried to think about how comforting it was to have someone take care of me while I was in this foreign town.

Paul drove up the driveway of a small house. I asked him where we were and he told me not to worry, that he just had to stop for a second to pick something up. He flashed me another smile and squeezed my hand. I felt like a child for being so worried, so I smiled back at him while trying to hide my uneasiness. He took my hand and walked me inside. We went into his kitchen and he asked if I wanted anything to eat or drink. I politely declined while he opened a beer for himself. We sat down at the table and talked, mostly about him. He told me how he wanted to move to California, make a lot of money, fall madly in love and raise a big family: the perfect American dream.

Paul finished his beer and took my hand again. I felt lost but was comforted by Paul's firm hand around mine. We walked into the bedroom where his clothes were thrown everywhere and the bed was unmade. I noticed his trophies proudly displayed in a glass case. He looked into my eyes and leaned over and kissed my lips. I automatically pulled back in fear. I felt so awkward and scared. I just wanted to go home, pull the covers over my head, and feel safe once again. I was angry at my French brother for having left me with Paul and I was upset at myself for being foolish enough to go into this stranger's house.

"Don't worry," Paul whispered in my ear tenderly. "Everything will be all right." He kissed me again and I stood still, a thousand thoughts flooding my mind. I started to say, "Look, I don't know you very well, this isn't right," but he silenced my words with kisses. A tear fell from my eye in

confusion and despair. He did not seem to notice. "Please, God, I'm sorry this is happening. Please forgive me," I silently prayed. Paul kissed me harder and pressed me up against his body. I had never been with anyone so mature and experienced before. I tried to pull back but he would not let me. I told him to stop but he did not listen, he just flashed me another smile. I pushed him away but he grabbed me harder by the wrists. "What are you doing?" he asked. "You wanted this." I cried, begging him to leave me alone and to take me home. At that moment I had no idea where I was or how to get back to my house. I did not even know my address. He just laughed at me and held on tighter to my wrists. By this time I was sobbing and trembling in fear. He threw me down on the bed and muttered something in French. I screamed as his six-foot-two-inch muscular body pressed on top of me. He slapped me hard and pinned my arms above my head. The only thing my continued crying accomplished was him hitting me again. I was suffocating between the weight of his body and my hysterical tears. The more I resisted, the more force and violence he used. My head ached, my arms throbbed from his tight grip, and my face burned from his slaps. He ripped off my clothes and quickly unzipped his pants, not even bothering to take them off. I lay under his heavy body, shaking, still praying to God to help me while Paul raped me, his sweaty body on top of my bruised and bloodied one.

He raped me two or three times. I lost count, I felt like a corpse with my spirit floating above watching the whole event. I thought a sword was going right through my body. I was bleeding between my legs while he continued to force his way inside of me. I could tell I was going to have bruises on my arms from where he held me down and around my neck from where he choked me. The whole time he smiled the same sweet smile that I had earlier trusted.

The rest of the night is a blur. I think I passed out at some point. I remember waking up but being too scared to open my eyes in fear that the whole nightmare was actually reality. When I did open them, there he was lying beside me, sleeping contentedly. I was naked. Every time I tried to move I felt a piercing pain in some part of my body. I felt the blood between my legs and wondered if I had been cut open and ripped apart. I lay silent in the bed, not wanting to wake Paul up in fear of what would happen next.

Three hours later he woke up. By that time I was dressed and huddled in the fetal position at the very edge of the bed. The sheets were stained with blood, my face was red and swollen, and my arms and neck were bruised. He looked over at me and smiled. "How are you feeling today? Tired out

from your first experience?" He smiled and laughed. He got up and got dressed. I begged him to take me back to the house where I was staying but he simply replied, "What's the big rush?" He leaned over, held my hand, and gave me a kiss on the cheek. I just sat there, hugging my knees to my chest, scared to say anything for fear of provoking him. He asked me if I was hungry and I shook my head. He stared at me for a while and finally said, "Okay, I'll take you home." I slowly got up, but with every step I felt pain. I tried not to show him how much I hurt. I did not want to give him that satisfaction as well as everything else he had taken from me. I believed that if I pretended the pain was not there, I would soon forget about the whole evening and no one would ever have to know.

In the car, he talked just like he had the night before. However, this time I was silent. He did not seem to notice or care. Looking out the car window I was shocked at what a beautiful day it was. The bright sun seemed to cover up everyone's problems and life went on as normal. I felt like screaming, asking the world how they could pretend everything was wonderful when in one night I had lost all my pride and self-respect. This man had taken the one thing that was sacred to me, and I wanted everyone to know that he was evil, and deserved to be punished. As soon as I thought of retribution however, I shrank back and told myself that was impossible because I would rather die than have my family know what had happened to me. I was afraid my family would see me as the tainted person I thought I was.

Paul and I finally arrived at the house where I was staying. Paul stopped the car and asked, "Don't you want to see me anymore?" I fought back my tears and just got out of the car. Paul waited and watched me go inside. He was confident that I would be too scared and ashamed to ever tell anyone what happened. I was in a foreign country without friends and without family, and Paul knew I had nowhere to turn, and that I would be too ashamed to tell anyone what had happened at his house. Besides, it was not my native country, and I had willingly gotten into his car and entered his house. What could a scared sixteen-year-old girl do in a foreign country in which she had only been two days? Nothing, and Paul knew that.

I walked upstairs and fell on the bed, crying hysterically. My mother's words were in my head about how nice, proper girls waited until they were married to lose their virginity. She also said that everything happens for a reason. What did I do in God's eyes worthy of this punishment? I tried to pray to God but I felt the distance between us had grown too large. I looked down at the gold cross that hung around my neck. It was my great-grandmother's and had been given to me on my confirmation. I took it off and

put it away in my bags. I still have never managed to put it back around my neck. At first I took the cross off because I felt I was no longer worthy of wearing it. I felt the cross mocked my faith, which had not been great enough to protect me, and reminded me of my lost virginity. Now I cannot wear my cross because it reminds me of what a trusting and innocent person I was. I no longer want to put my trust in blind faith.

The next week I made myself very sick and refused to leave my bed. I explained the bruises by saying I fell down the stairs that night when I had gotten up to get a glass of water. I camouflaged the bruises as best as possible, and did everything conceivable to keep the truth hidden. For a girl who had never lied, I found myself becoming quite proficient at it.

I finally went home to the United States, but was embarrassed when I saw my mother. I wondered if she would realize I was no longer the same daughter. I thought anyone would be able to tell I was stained. I felt dirty and considered myself to be permanently ruined. I even vowed to never get married because my husband would be getting "damaged goods" and I would be undeserving of his love. My mother did not seem to notice my inner torment, however, except that I looked very ill. I had lost fifteen pounds from my already lean frame. I was pale and my eyes no longer had the same idealistic sparkle.

My family knew I was in a deep depression but had no idea of the cause. I spoke very little to anyone and stayed at home as much as possible. I never wanted to see my friends because I was afraid they would look right through me and know my soul had been torn apart. I lived in constant fear of someone finding out the truth about my rape.

I assumed that eventually, with time, my life would return to normal. I honestly believed that I could block out what had happened to me. My depression did not go away, however. Each night I woke up to find my bed engulfed with flames, and my body consumed by the fire. I envisioned myself burning in hell, only to awake and realize that reality was more painful than the nightmare. I was afraid to sleep but I was even more afraid to get out of my bed every morning and face the day ahead of me. Nightmares haunted me day and night, and there was no escape from the memories or the guilt. I still believed I was responsible for my rape, that it was God's way of telling me I was unworthy of his love. I would look at my baby sister and almost cry out in pain. I was afraid that I might taint her, and she was such a perfect, innocent little creature, deserving of everyone's love. I would watch my sister play and laugh, and convince myself that her happiness would do for the both of us.

The healing process was a long and arduous road. I was an extremely

self-destructive person before I decided to try and regain control of my life. I would cut parts of my arms so I could feel physical pain. I believed that if the physical pain was great enough, it would block out my mental anguish. I had to keep hurting myself physically, in order to have the strength to face each day emotionally. My cuts gave me something tangible to watch heal. Unfortunately, my emotional scars remained untreated.

After a year of destructive behavior, I finally became tired of feeling worthless and blaming myself for something I had no control over. I had tried drugs, alcohol, anything to numb the pain, but nothing worked—chemical substances only made me feel worse about myself. My life was out of control, and I was hurting all the people who cared about me. I knew I had to change in order to keep the one thing that still mattered to me, my family.

During my self-destructive period, I was completely resentful and cruel to my mother and sister. No one understood the person I was anymore and I felt abandoned. I was positive the mother who had once doted on me had grown to resent me. I did everything I could to make our lives nightmares and I hated myself for it. I wanted to let my family know that I loved them, but all that came out was anger. I wanted to explain to them why I had changed, why I had turned into a spiteful, bitter person but I kept the secret buried inside. To this day I want to explain to my family what made me turn into a different person my junior year in high school, but I am still afraid to share my pain. I fear that knowing about the rape will change their feelings for me. I do not want their pity and I do not want them to view me as tainted. Even though the cost of not telling my family is great, the risk of telling my family is still greater. I have come so far, and feel so close to my family despite my secret, that I would never do anything to jeopardize our relationship.

I faced the healing process alone and it started when I stopped looking for an easy solution to my depression. Running away from the pain did not help—I knew I had to face it. Step-by-step I went over the night of the rape in my head. I told myself the assault was not my fault and there was no way I could have known what was going to happen, nor any way I could have prevented it.

The first step was to release myself from blame so I could begin the process of recovery. I would no longer dwell in the past because I had a whole future in front of me, and I became determined to take advantage of it. Since taking the first step, and realizing that I control my own future, the healing process has gotten easier. After two years, I was finally able to tell my close friends about my rape, which relieved me of an enormous bur-

den. I decided I could not hide for the rest of my life, so I told a couple of friends and decided to let them pass judgment.

It was an enormous relief to finally talk to someone about the rape, even though there was very little my friends could do except show understanding. One friend encouraged me to see a therapist and helped me start the process of ongoing healing. It took me a year to actually tell my therapist about my rape. Then each week the guilt dissipated and a new confidence emerged. Sharing what happened helped me to come to terms with my rape. I learned the rape was not something I would forget, but I did not have to let it destroy my life either.

My rape is something I have come to accept as a part of my past that has shaped the person I am now. Every time I tell someone about the rape, I open up an extremely vulnerable part of myself. It is a risk I am willing to take because I want my friends to respect me for who I am, as I have come to respect myself.

The one barrier that still remains is religion, something my mother and I argue about frequently. My mother goes to church every Sunday and expects her children to do the same. I still cannot enter a Catholic church without strong feelings of pain and inadequacy. My sentiments are a mixture of rejecting the Church because it could not protect me, and hiding from the Church because my faith after the rape is not adequate. I try and explain to my mother that I am religious and I do believe in God, but that I would rather pray by myself and not in a public place of worship. However, my mother cannot understand my personal choices about worship and she sometimes refers to me as her "heathen daughter." I wish I could explain to my mother the whole truth about why it is too painful for me to go to church, but instead I simply accept her remarks even though I feel a stabbing pain inside.

My fairy tale childhood ended abruptly that summer in France when I turned sixteen. Some people would say it was unfairly taken from me, but one thing I have learned through my struggle to overcome the lasting pain of rape is to never lay blame on the past. The life in front of me is my responsibility, and I believe it is my duty not to throw away my future because of Paul's violence in my past. There are still times when I am frightened to be alone with a man. I can be sitting in my room and my boyfriend will make a sudden move and I will cower, thinking he is going to hit me. It is difficult for me to trust men. I still feel that they only want to hurt me or get me into bed. I take my fears one at a time and try and work through them but it is a continuous battle. I force myself to trust people because I refuse to live my life in fear.

A part of me died that night, but now there is a new part which is stronger. I have come to realize that I can depend on myself. I have faced one of the most difficult experiences of my life and I have not let it defeat me. I am confident with the knowledge that no tragedy, no matter how painful, will be able to destroy me. I am a survivor. I am no longer an idealistic, trusting girl. I am a stronger, more confident person and I am ready to face any challenge.

2

An All-American Rape

Montana O'Riley

My mother turned to me, panic-stricken. A friend had just told her about another friend's daughter who was raped but didn't tell anyone. "Montana," my mother said to me seriously, "you would tell us if you were ever raped, wouldn't you?" Puzzled by the question, I couldn't understand what would possess someone to stay silent about being raped.

I don't remember how old this memory is, but at least 10 years later, I *was* raped, and for a long time I didn't tell anyone either. Unlike most of my friends, I knew women could be raped by men they knew, not because I'd heard it on television or read it in *Glamour*, but because I had a friend who'd been raped. But I didn't really know her whole story, and I didn't understand exactly how a date rape occurred. Because I couldn't comprehend logistically how one peer could rape another, or why a woman wouldn't tell anyone she had been raped, I was dangerously naive.

Before my high school friends and I left for our grad trip to Mexico, one girl's mother kept telling us to stick together and be careful. "Why is she so paranoid?" we asked. My friend explained that her cousin had been raped by a Mexican policeman in Cancun, and her mom was terrified to let us go. When we arrived in Mexico, my only fear was of being raped by one of the Mexican men who hissed and shouted at us, or by the leering security guard at our hotel.

The first thing we did when we got to Mexico was put on our bikinis, hit the beach, and order drinks. We ordered drinks at all hours of the day and flirted with everyone who flirted with us. It was the first time I'd been on a trip without adult supervision and I felt that our trip was symbolic of my new freedom. We were on our way to college, finally.

At night, we searched for men to fawn over us. Boys had always been attracted to me, and a lot of my confidence and fun on that trip came from

31

meeting a lot of new guys. We all fooled around with the guys we met; although we each had previously set our own sexual limits. Because I went to such a small high school, I had never even kissed a guy who wasn't a friend. Kissing nameless boys in Mexico was thrilling, and I didn't see anything wrong with it. Although it would have been easy to become reckless in our fun, we were cautious: we agreed not to leave groups of two unless there was no doubt of the other's safety.

When was there no doubt of each other's safety? We assessed our own and each other's safety by numbers, groups. As long as we weren't *alone*, we would be safe from the rapists and muggers, who we wrongly assumed to be Mexican. On June 30, 1990, I was with a big, strong, American male. I would be safe with him.

It was the end of the evening and we were in my favorite bar, right on the water and somewhat outside. There was a huge guy with a gorgeous body hitting on my beautiful friend Kimberly, and a pang of jealousy ran through me. I was unashamedly staring at him when she told him she was "involved." He noticed me and moved over to where I was dancing. At about the same time there was a sleazy sailor who had invited himself to dance with each of my friends. When he got to me I said, "No thank you," and walked away. I was a strong, self-willed person and I didn't feel I had to be nice to a 35-year-old drunk who hit on younger women. The other guy watched this little scene, made his way over to me, and introduced himself as Eric.

"I like a girl who can choose her dance partners," he said. I'm not sure how sober I was, although I know I wasn't too drunk. I had been drinking throughout the day and decided not to drink that night. Eric danced with me for a while, and then went to another part of the bar. All of my friends drooled over him once he was gone, and I wanted him back, fawning over me for their benefit. I remember spotting him and going to the bar near where he was drinking very heavily. I ordered and chugged a beer to get him to notice me again. The next thing I remember, I was dancing with him on a tabletop with hundreds of other hormone-soaked teens.

I labeled him a scammer immediately, but I danced with him anyway because he was fun. We flirted, but I let him know right away that I wouldn't leave with him and that our playfulness wasn't leading anywhere. I said to his face, "I am not going to sleep with you. I am not going to leave with you. This ends when I leave." I repeated myself, and I remember he laughed at me for being so adamant about leaving alone. I have always been pretty confident, and because the bars were full of recent grads looking for scams, I thought it necessary to be so blunt. Eric understood me. I

was surprised that he didn't move on to another woman who wanted to do more than dance.

We were definitely playing mind games. I think he was mildly insulted that I was so uninterested in him sexually, and in retaliation he mocked me, making me sound paranoid and prudish. In turn, I found other playful ways to belittle him. I believed our games were all good-natured, a battle of the wits. I didn't realized he was serious and determined to win.

After a while, I got tired and stopped having fun. My friends were leaving, and I wanted to go with them. I didn't trust Eric, even though he continually reassured me he wasn't after anything sexual, but I felt stuck with him, like he was some sort of social obligation. My uneasiness showed: he kept asking me why I didn't trust him. At one point, I told him about my friend who had been date raped. I actually wasn't afraid that I would be raped by Eric; in fact, I couldn't conceive of it. I just knew that it was a good excuse not to trust him.

"Look," Eric replied firmly in that charming deep voice, "I am not like whoever raped your friend."

I still didn't really trust Eric, but I accepted my discomfort as intimidation. I was not intimidated by Eric's actions, but by our difference in social status: I thought he was rich, much older than me, and drop-dead gorgeous. I didn't think he could hurt me; to the contrary, I thought he would protect me. He bought me a beer and we sat on the patio and talked, although he was so drunk I was really just listening to him babble. I wanted to leave, but I didn't know how to get away without making him think I was a loser. I didn't consider doing anything but enacting the scene I had in my head: we would talk for a little while longer, I would become tired, he would walk me home and on the way we might make out a little, and then I would never see him again. I didn't want to change that script, I just wanted to speed it up. Because my friends had gone back to our hotel, I felt dependent on him for my safety. I was terrified of the security guards and strangers lurking in the dark.

We walked down to the beach, where there were tons of couples and sweaty dancers swimming. As we approached the bungalows in front of my hotel, we began to kiss heavily. I liked making out with him; I remember having fun although it was probably more intense than I'd intended. Unfortunately, I let my guard down. He had convinced me that he understood my limits when he never had any intentions of respecting my limits at all.

I remember little about the next few minutes. I was raped after I thought I had taken every precaution: I had repeatedly made my intentions clear, I

had stayed within earshot and view of others. By the time I clearly understood that I was being raped, no action of mine could reverse what had happened. He moved my underwear aside and penetrated so quickly I had no idea what he had done or was doing. Although I was a virgin, I don't remember feeling any physical pain, only confusion. I stopped him, I don't remember how. My journal says *I struck underneath his jaw with the heel of my palm, causing him to bite his tongue, throwing him off guard*, but to be honest I don't remember this. It's possible I fantasized that ending to make myself seem more powerful. I very vaguely remember paralysis, shock, trembling, tears. But I didn't break away. Ironically, I was afraid to run up to my hotel, irrationally panicked that I would be attacked by the security guard.

He tried, and penetrated me twice, but each time I got his penis out of me before too long. He held me by the wrists and called me a prude. He asked me why I didn't trust him. He said he should have used a condom because he had herpes, but not to worry because the scabs weren't out. He suggested that he might have AIDS.

He took my underwear to give to his father, as some sort of "trophy."

I remember what happened the rest of that night in feelings; I can hardly narrate what happened. I remember wondering what a scab was, standing up, sitting down, a security guard who might have been checking on me. I remember Eric's turquoise pique shirt, the kind with an alligator icon. I remember the confusion and panic and choking tears that return to me as I write. I remember and I live the memory: my pulse racing so fast, my hands shaking so hard, I can no longer look at the computer screen as I look to the person in me who wasn't raped for her protection, for her solace, for her help in finishing my story.

All of a sudden, Eric got this look on his face, like everything wasn't so funny anymore. "How many times have you had sex?" he asked me. I wouldn't answer. "Because you felt pretty tight." I didn't know whether he was taunting me or feeling guilty for what he had done; I couldn't understand why it suddenly mattered to him if I was a virgin or not.

He tried to convince me to come to his hotel room by saying he'd pay for my taxi. I was appalled, confused, angry, but I don't know if I told him that. I ran like I want to run now, back to my hotel room, panicked, pounding like a maniac on the lime green door, "Let me in, oh God, let me in, I'm going to be attacked."

My best friend Stephanie woke up and let me in. I took a shower and when I came out she was sitting up on my bed. "You were in there for 40 minutes," she said. I don't remember if I said anything in response.

Later that night, there was a terrific thunderstorm that woke everyone up. Young, wild, drunken Americans ran around our hotel hooting and banging on doors in the pouring rain. I lay quaking in my bed, terrified I would be raped by one of the drunk guys who my other friends wanted to go outside and join. But Stephanie was also very frightened. "Bolt the door," I said, and she did. I know I told Stephanie that night or the next morning that the cute guy I had been dancing with tried to rape me. She was sympathetic, but she never expressed any relief for me that he *hadn't* in fact raped me. I know she would have if she'd been sure I wasn't hurt. But she knew I was hurt, and for the time being, she responded to that.

I never admitted to anyone on that trip that I was raped that night, although I know they suspected because I suddenly was not interested in going to bars or in meeting boys. I did tell my friends that he *tried* to rape me, and warned everyone to be careful. No one ever asked exactly what happened, and I never explained. But even though we had five more days in Mexico, no one had fun anymore. I maintained a relative calm—ironically it was Stephanie who lost it, becoming fearful and teary at the slightest provocation. While we all realized our vulnerability, I had aged a thousand years. All of my innocence and trust had been destroyed. But I knew that what had happened to me would never happen again, at least not in the same way. I would never again be so naive; if someone tried to rape me again, I would know exactly what was going on. I blamed my unmitigated naiveté for not realizing that I was being raped until it was happening.

Possibly the hardest thing for me to deal with is that I was a virgin. Not by lack of opportunity, but by choice. I had carefully preserved my virginity and he had stolen it.

I can't explain the rage that I still feel about the theft of my virginity. It's a rage that comes from the core of my bone, that seethes at the unfairness of it all: my virginity was *mine*, goddamnit. My virginity was my freedom, my pride, my self-control, my right of passage into womanhood, my concept of God, my sexuality. Eric shattered my virginity and all that it stood for. I left Mexico with no idea how difficult it was going to be to reconstruct my identity as a woman. All I knew was that I was very alone: I no longer believed in God.

Unfortunately, my rape remained a secret that burned inside of me. I was desperately worried that I had herpes or maybe even HIV, but I waited until I arrived at college to be tested (because I could do it anonymously). I didn't want people to know that I wasn't as perfect or as strong as they thought I was, that I couldn't prevent my own rape even though there wasn't a gun in my ear or a knife at my throat. At the same time I knew I

didn't deserve to be raped, that I had a right to set my own limits. I fiercely blamed Eric and the sexist and racist society that led me to believe that I only needed to fear the Mexican police, not the American boy. I was mad that I had been taught to submit when intimidated: *"If you're ever mugged, just give the guy what he wants. Your life is worth more than what is in your wallet, and if he kills you, he'll get it anyway."* Most of all, I was furious that I'd been taught that I could "just say no," and my word would be respected. I was furious that I didn't even recognize that I was in a situation I should have been running from.

I was furious that Eric would never know the damage he had done to me and probably to many others. Dear, handsome Eric, if only you understood that when you take sex you are taking so much more—you steal a whole perception of the world—and you instill a lifelong anger, fear, frustration, hatred.

Eventually, I couldn't keep my anger to myself anymore. I felt an intense need to warn others, to show that what happened to me could have been prevented had I not been so trusting or if I had known that I could be raped by an all-American boy. It got to the point where I would cry out of sheer fury anytime I heard the word rape, and eventually it happened in front of some good friends. I told them what had happened to me in Mexico, and, to my surprise, they understood, they were angry, and they promised to be there when I needed them. It turned out that a few others had also been raped. The knowledge that I was not alone fueled my anger and I began to send my story to newspapers and magazines under generic pen names.

My high school newspaper published my story, and to my horror the paper came out on a day that I was visiting from college. Everyone was talking about my article, but no one knew that I had written it. The people I heard talking thought I deserved to be raped, that I had led him on. They thought this even though I had omitted everything I thought they could blame me for. I learned from them how shameful it was to be raped.

That day, I split into two people. The rape survivor became a fierce dragon of anger and shame who was insulted by the people who believed she deserved it, or that it wasn't rape at all. The other woman in me, who was never raped, was a brilliant intellectual who began to create elaborate and convincing cover-ups for the dragon when she spit her fire of anger. Together, the intellectual and the dragon could coexist in my head without me wearing a badge that said "raped." I could educate people and to my knowledge, people never said, "Oh, she's doing this because she was *raped.*" When I saw suspicion creep into someone's eyes, I would launch

into a passionate spiel: "And why is it that people always assume that people who fight rape have been raped themselves? Isn't rape horrid enough that I can work to stop it without having gone through it? What I want to know is, why isn't *everyone* as appalled as I am? I also do work for the homeless, but nobody ever accuses me of once having been homeless. . . ." Or the excuse that insulted the dragon the most: "If I'd been raped, I wouldn't be as emotionally steady as I am doing this work. I take a lot of sociology classes—my interest in and activism towards stopping rape is as much an intellectual as an emotional pursuit." This type of acting—pretending I haven't been raped—isn't fun, it makes me slightly nauseated, and it chips away at my self-esteem.

Fortunately, the day I visited my high school, something else happened which affected the way I would relate to my rape for years to come. I was having lunch at my favorite teacher's house when he brought up the article I had written for the paper.

"Isn't that just horrible?" he said.

"Yes."

"It really makes you realize what kind of world we live in." He was visibly upset. Without any warning to myself or to him I blurted out, "I wrote it."

"What?"

"I wrote the article."

He began to cry. Although he quickly pulled himself together the tears he shed for me had a lasting and profound effect on my life. His tears confirmed that what I had experienced was just as horrible as I thought, and for years I would rely on this memory for confidence and reassurance. I told him the whole story, although he'd already read it in the newspaper, and we talked about why I had decided not to tell my parents. He understood. He was something of a surrogate parent for me then; I needed someone older and wiser to assure me that I had survived the attack, that I was still a whole and worthwhile person.

The dragon and the intellectual still exist in me, although the intellectual is dominant. Secretly, though, I am proud of the dragon I hide. She is the fiery side of the feminist in me, the edge in my personality. She is the one who no longer cares if I offend people with snide remarks when someone tells a sexist joke. She is the side of me that can be cynical, jaded, and sometimes pessimistic. She is still hidden, and she torments me because I hide her. But she is powerful, and she has a mouth that breathes fire.

Know this: the dragon wouldn't exist if I had been raped alone, in a vacuum. She was created from my knowledge that I was not raped alone in a vacuum, but that my rape occurred in and was permitted by a sexist culture

that raped not just me, but many of my sisters as well. I would not still be angry if I could write off what happened to my virginity as an unfortunate mishap, or a random accident. But I can't, because it wasn't. Date rape is a common thread among women in America, and that knowledge keeps me angry.

Every once in a while—about once a year, maybe less—I have an hour or two where the whole world looks dark and oppressive. I cry hysterically, and a haunting image of a bright turquoise shirt hangs over my head. I feel violated all over again. And then, just as suddenly as the attack came on, I snap out of it, and swear that I will never feel sorry for myself again, embarrassed if someone was around to see me fall apart.

My life is as normal and as successful as it was before I was raped, and really, little has changed about me: I've integrated the two beings within me now. I think because I never entirely lost control of my rape (because he never had an orgasm, I feel like I kept him from getting what he really wanted), I recovered pretty quickly, although I'm not really sure what "recovered" means. I saw a counselor twice, and both times she assured me that I am mentally healthy. For a while, I needed to come to grips with what happened to me, to grieve for my virginity, to test the shaky waters of trust slowly. I'm no longer naive, but I manage to trust people, every once in a while.

I have a wonderful boyfriend who understands that my rape doesn't define or dictate who I am or what I do. He was the first, and one of the only, people to whom I unveiled my secret in whole, detail by detail. He cried and cried; he understood, and it hurt him, too. He has been actively supportive and is always, always there for me. He doesn't laugh at dumb blonde jokes and considers himself a feminist, even though his friends don't think it's cool. He does rape education. He would never want to have sex with me if I didn't want to have sex, too, and he expects me to initiate sex as often as he does.

What really haunts me now is why I've kept it such a secret, why I am still so ashamed.

> *I am afraid people will think I must have strange sexual hang-ups.*
> *I am afraid that they will attribute my feminism to the assault; not everyone knows that I was a feminist in high school too, long before I was raped.*
> *I am afraid that they will discredit the work I do in rape education, thinking my motives are only selfish.*
> *I am afraid that this is something that I will have to deal with publicly for the rest of my life.*

While I've dealt with most of my fear, I'll never be proud of surviving a rape. And I don't necessarily need to be *proud* of it; but I would like to stop feeling ashamed. I'd really like to tell my parents about it, but out of habit and cowardice, I don't. I didn't tell them originally because I didn't want to shatter their image of me as strong and capable. I didn't want them to regret the freedom they had granted me, or to worry about my safety. I was afraid they would insist I see a therapist when I already had my own. I was afraid of losing the independence I had just gained. I was never angry at them for letting me be naive, but I lacked the vocabulary and the previous experience to talk with them about sex, and I was ashamed to tell them that I had been fooling around with the guy. *(No, I wasn't gagged and strapped down. Yes, I was raped. Yes, I was fooling around with him).* I didn't want my parents to blame themselves for what happened to me.

Eventually I could see that my parents weren't going to take away my freedom, that they believe in me and would probably be amazed that I had survived such an experience relatively unscathed. Later, I realized that they would understand that I was sexually active and that I shouldn't have had any problem explaining the details to them. Though they don't know it, their sexual ethics helped me: to them, virginity wasn't everything, but love was. I wasn't going to be either a "good girl" or a "bad girl"; I wasn't ruined by the loss of my virginity. Knowing this always lessened my guilt and heightened my respect for the sanctity of sex.

I see now that I could not have recovered the way I did had I told my parents about my rape. I needed to regain the freedom Eric took from me alone, to prove to myself that I am still strong and independent. But each time I write about my rape, I write for them. I want to tell them—it's such a part of me now—but I don't know how.

My parents would have been proud of how I handled myself throughout the evening, I wrote in my high school newspaper. *But it's funny: I never even thought to scream,* which is exactly what they would have wanted me to do. Eric just wasn't the type of man I knew how to scream at.

I know that I will teach my friends and daughters differently. I will teach them to scream not with rage or frustration, as I have, but with power and prevention. To hell with social graces, I'd like to hear screams of forward momentum—accompanied by a sharp knee to the offending groin. Even if the groin that offends is rich, drop-dead gorgeous, and intimidating.

That bloodcurdling scream is within me, waiting to be sung.

3

"So Fucking Beautiful": Rebuilding Self-Image in the Aftermath of Rape

Susy Struble

I woke up suddenly but the light was too strong for my eyes so I kept them shut. My surroundings came to me through impressions: a spring breeze, sunlight, and singing birds. When I finally opened my eyes, I didn't know where I was at first. The room was overwhelmingly bright with morning light reflecting off hospital-white walls. The floors were wood, but I don't remember if there were any posters, or a stereo, or bookshelves. The room was unfamiliar. By the second minute I turned numb and realized I was lying naked on my back on a mattress. There were no covers and no one was with me. I couldn't move. I remember thinking back to my third-grade yoga instruction, wondering if this was the state of consciousness we had been trying to reach; I could feel and understand every square inch of my body. My back hurt, my thighs were sticky and sore when I rubbed them together, and my hands felt as if I'd been clutching a pole all night. I think that the moment I realized what had happened my mind skipped and blanked. Eventually a young man walked into the room. I don't really remember what he looked like, except that he was tall and had sandy brown hair. He was very quiet. I can't remember what he said either but he must have offered to take me back to my friend's dorm. He left and I dressed in a daze; my mind was so far away that I forgot my underwear. He dropped me off in front of her dorm and we never said a word.

I was sixteen and a junior in high school. That winter I had met a freshman from college while skiing—I'll call him Josh. He was a great guy and he went to my ideal college. It had been my dream college since I had first visited it at fourteen. We became good friends—he lived only an hour away—and he invited me to visit him at school after his spring break. I

41

jumped at the chance, so my parents and I drove out for a weekend that March, stopping at other prospective colleges along the way.

I stayed with my parents at a hotel the first night, but they let me stay with Josh in his dorm the last night since we were going to an off-campus party and wouldn't return until late. My parents were not overly permissive but they knew how level-headed and strong-willed I was and they trusted Josh. I had always been extremely independent and by sixteen truly had the maturity of an average twenty-five year old, although not the depth of experience. I had drank before—never enough to get drunk—but I knew my limits and was very adept at handling just about any situation. I was not naive about the potentially dangerous outcome of mixing young men and alcohol. I just say this to exonerate my parents from any blame, I suppose. We were very close and their confidence in me was neither misplaced nor a result of not caring.

I suppose it was my overconfidence that kept me from paying attention to warning signs that I was in over my head. I was wearing a skirt when I met Josh at his dorm before the party and he strongly insisted that I change into pants. He was worried about the extra attention I'd receive if I wore the skirt, even though it reached my knees. I just shrugged it off, as his argument was kind of flattering, and changed to stop his pestering. We hung out in his dorm for a while and then left for the party. It was nearby, in a house called the "Hut" where five or six juniors from his fraternity lived. As we were walking, I told Josh that I knew I was going to drink that night. I wasn't very experienced with hard alcohol and I asked him to watch out for me and to cut me off if I couldn't handle it. He agreed and told me to make sure that I stuck by him, saying something to the effect that there were a lot of strange men at college and my going to this party was like a sheep walking into a den of wolves. Coupled with his insistence that I wear long pants, this comment should have warned me that the college social scene was unlike any I had encountered before. However, I felt that Josh liked me and I naively interpreted his warning as possessiveness and jealousy.

What I remember of that night is foggy. I only remember having two "Inks"—they were awful drinks, really sweet and sticky—and I remember a bunch of drunken men with their arms encircling each other's shoulders gathered around a garbage can of Inks singing fraternity songs. I remember talking to a lot of college students—mostly men—and having a great time. I don't remember seeing Josh around anywhere. I remember being in the basement, pushed up against the wall by a large guy who was kissing me. I didn't want him kissing me, but I couldn't say no or shove him away.

I was helpless; my mind was coherent but I couldn't make my intoxicated body move or respond. I remember looking up and seeing a shorter guy who I'd talked to extensively earlier walk up the stairs, holding a beer and shaking his head at me as if he were disgusted by my behavior. I called out to him—but not aloud, I think—to help get this guy off me, that I really wasn't the type of girl you should shake your head at and leave alone. I remember finally shoving the tall man away and going into the bathroom, which had an orange door and a bright fluorescent light. He pounded on the door while I threw up in the sink. The next thing I remember is being on a bed with him on top of me, trying to shove his penis into me. I remember it hurting terribly and saying no and I pushed his hips away and tried to roll over. He grabbed my shoulders hard and shoved me up further on the bed and my head slammed against the wall. He asked me if I was OK . . . and that's the last thing I remember.

We left the next afternoon for Williams College. My parents were alarmed when they saw that I was hung over and joked nervously about it, but I assured them that everything had been great. I don't know why I didn't tell them what had happened. I don't think it was because I was scared or embarrassed. It probably never occurred to me to tell them; I've always tried to deal with my problems by myself. Besides, it was over and what could be done about it? I laid down on the backseat and pretended to sleep for the whole ride. I felt as if I were in a movie: too pained to move, I lay clutching the cold seat and numbly watched the treetops fly past the car window. My mind hovered somewhere just above full recollection; I was embarrassed that I'd left my underwear in that strange bedroom. I was dancing around my memory of what had happened, too scared to actually jump in. My only thought was the superficial embarrassment and worry over what the students I had met thought of me now. When we arrived at our hotel in Williams my parents went down for dinner and I stayed behind to take a shower. I turned the water on as hot as possible and washed the blood and semen from between my legs. There were bruises on my arms and thighs and a huge lump on my head. I cried.

I don't know when I named what had happened to me as rape. The morning after the party, Josh walked out of his dorm room just as I walked in. We stood apart and looked at each other in silence. I had managed to maintain my numbness during the ride to Josh's but again a sudden flood of emotion and awareness flowed through me. My mind allowed me to realize that something horrible and unwanted had happened to me, but I couldn't have gotten the word rape past my tongue had I tried. It's a terrible cliché, but at that moment I aged a hundred lifetimes over. I'll never

forget the look of bewilderment, shame, and hurt on Josh's face: he turned into a helpless, ignorant little boy in front of me while I felt the pain of thousands of years somehow supporting me. I define my womanhood by that moment—not the taking of my virginity, but the sudden knowledge of centuries of women's outrage like steel infused into my spine. Josh finally broke the silence with some mumbled neutral comment. I wasn't surprised that he didn't question or console me. By his actions I knew he knew what had happened, or at least had a good idea, and I also knew he was incapable of handling the situation. I didn't speak about the previous night either. I didn't want him involved at all. I wasn't worried that he wouldn't believe me; I simply couldn't explain what had happened. He wouldn't understand nor could he help me. I felt alone and I liked that: like a completely different species, wholly separate from everything about him. He went back to bed while I laid down on the couch and ate a whole bag of Oreos, which I later forced myself to throw up.

Until I wrote this story, Josh and I hadn't spoken about that night. I didn't tell anyone what had happened for two years, besides a friend who I knew would pay for an abortion if I needed one. And I didn't even tell him the full story; I was repressing my memories of that night and couldn't frankly discuss it even with my most trusted friend. The possibility of disease never occurred to me. When I woke up in the middle of the night a few weeks later and my period had started, I cried. And until recently, that was the last time I really thought about what had happened and the last time I cried over it as well. I never tried to rationalize or explain it to myself. Nor did I consciously blame myself or the college. I simply blanked it out. The mind is incredibly adept at repression and intellectualization—I didn't think twice about applying to the same college "early decision." After all, it was my ideal college. I was accepted and I enrolled.

During Homecoming of my freshman year, I was sexually assaulted by the same man who I believe had raped me two years earlier. Although it was the Thursday before Homecoming Weekend, alumni had already flooded the town. In fact, I went home early from a party that night because there were too many alums trying to prove their old alcohol capacities in the fraternity basements. I lived in a single dorm room near one of the more popular fraternities. Around two or three o'clock in the morning, I woke to heavy pounding on my door and a man shouting for me to let him in. I wasn't at all alarmed—I was used to drunk friends stopping by at all hours and had even opened my door several times in the morning to find friends passed out in the hallway. I opened the door a crack and saw a tall, sandy-haired man trying to stand up by holding on to the door frame. I

didn't recognize him so I didn't open the door any further (there were no chain latches on the doors or peepholes) and asked him what he wanted. I wasn't afraid or worried; I figured he was another drunk and lost alum. He said he had met me when I was a prospective student and that he hadn't forgotten me. I can't describe the rush of awareness that hit me: I stood in shock, my hands frozen on the door, thinking about the night two years earlier which I had suppressed so well. The center of my constructed world disappeared. He said "you're as fucking beautiful as you were then, god, you're so beautiful," and pushed the door open. He grabbed my shoulders, shoved me against the wall and tried to kiss me. I couldn't move or breathe and I think I might have blacked out for a few seconds. I finally pushed him away, and while he regained his balance I ran into the hallway. He followed and kept saying that he wanted to talk to me, just talk. I said that was fine, that that was why I had gone into the hallway, then I jumped back into my room and slammed the door. I stood in the middle of my room and stared at the locked door while he pounded on the other side, begging me to just give him a chance. He eventually gave up and left. I retched for a while in the wastepaper basket—I was afraid to go out, even though I'd heard him stumble away—then sat at my desk until dawn. I didn't know with any certainty if he was the same man who had raped me at sixteen and I still don't. I remember the rape only in shaky snapshots and I worry that I have repressed or dramatized certain points in order to better deal with it. But the similarities between the two men are too unnerving.

I didn't tell anyone about this event either until much later. Actually, when I was first approached about writing about my rape I forgot to mention the sexual assault. Why? Do I just lump it in with all the other sexual abuses that have happened to me over the years? The discomforting stares, unwanted groping, rude and threatening remarks from strangers, "overzealous" dates, drunken attacks in bars and on the street—so many abuses, small and large, have occurred to me over the years that I can't recall them all. I was never really upset about them when they happened because I always felt in control, never truly endangered. They just added to my general contempt for men. But the assault made me see these incidents for what they were: unwarranted and prolific abuses. I lost confidence in my ability to be in control. My world was suddenly not a safe or good place anymore.

But why didn't I speak out, and why do I still have trouble doing so now? Have I simply become inured to these things? Have I resigned myself to them as my lot in life because I am a woman, especially an attractive woman? Do I actually expect it? Do I feel that hopeless and helpless about myself—and about my rights and power as a woman—to not tell

anyone or do anything? I definitely have a personality that doesn't cry over "spilt milk." Or am I crying so much that my forgetfulness is some sort of defense? Anyone reading this is probably dumfounded that I didn't press charges, but it never occurred to me that I could do something about either the rape or the assault. I didn't trust my undergraduate advisor and I was unaware of any campus sexual assault resources. Looking back, I wonder how these stories would have stood up in court. But I think I didn't take any action not only because I was ignorant of any recourse, but also because I was embarrassed, ashamed, and felt incredibly hopeless. I wasn't worried that no one would believe my story. But why bother? What could be done to erase what had happened? I felt no anger or desire for revenge. I took the rape, assault, and numerous other sexual abuses as "normal" parts of college life. To speak against the college would have been a sacrilege to me. Maybe I was afraid that my potential confidant would have told me that I had been "asking for it" by going to parties, drinking and talking to men. Writing this even now, I am afraid that the reader will agree, even though I've received enough training and education through my own anti-rape activities that I know better than to blame myself.

Maybe I was afraid that I would be told to expect such things because of my looks. The assailant's comments during the assault certainly point to that: "fucking beautiful," or beautiful enough to fuck. When I finally spoke to Josh a few months ago it seemed that he almost saw the rape that way as well: he was trying to "explain" how a college senior could rape a sixteen-year-old girl by saying that the rapist didn't really know how old I was because he was blinded by my "earth-shattering beauty." I don't think I'll ever untangle the psychological mess this left me in. I've always felt awkward about my appearance, but the rape threw me into deep confusion. Before, my looks made me envied by girls and deemed unapproachable by guys. Now I felt cursed and branded as an easy target. I felt that I would never be seen as the person I was but rather as an object to be used and hurt. I could no longer see myself clearly through my own sight but rather saw myself as I imagined others saw me, as my assailant saw me. I wrote a story a while ago about a prisoner in a tower with one window overlooking a beautiful and peaceful valley. However, a mirror was placed outside his window so he could never admire the view—he could only stare at the reflection of the tower's gray stone. His punishment was to forever desire to see the wonderful view he knew was in front of him but to never actually see anything but a sterile reflection. It wasn't until I wrote this that I realized the connection: I've lost the ability to see my true self. Most people wish to see a different, improved reflection when they look in a mirror;

I don't even see a recognizable reflection. After the rape I lost myself and distrusted everyone.

However, these feelings didn't really appear in my behavior until after the assault my freshman year. It was my first year away from home. I was emotionally vulnerable and could no longer box up the jumble of horrid memories the assault had triggered. If I had had a roommate the first two years of college I would have been committed to some sort of treatment center; no one could have lived with me. Looking back, I can't believe how psychologically disturbed I was at that time. Yet I put on a good enough show that I don't think anyone ever realized how crazy I was. I had been a very outgoing, gregarious person, but after the assault I holed up in my dorm room and had to force myself to leave even for classes. I cried constantly—in my dorm room, in the bathroom between classes, in the library, in the computer center. Because I couldn't deal with my big problems of the rape and assault, I instead became stressed over trivial matters. I ground and chipped my teeth in my sleep so badly that I had to have extensive dental work. My abuse of food escalated and I gained an inordinate amount of weight. I was so incredibly self-conscious that anything related to my appearance, from catching my reflection in a window to seeing my clothes hanging in the closet, could cause a complete emotional breakdown. Getting ready to go out meant an hour of hellish mental gymnastics as I debated the hypocrisy of trying to be attractive to the sex I feared, despised, yet somehow needed. Walking across campus was torture. I couldn't look people in the eye, especially men. I constantly wondered how men perceived me. Every time a man talked to me I panicked. My mind would flip-flop between worrying how to deal with him if he were attracted to me and berating myself for ever thinking that he could be attracted to someone as pathetic and gross as I was. I especially wondered what the men in my rapist's fraternity thought of me. Did they know what had happened? What was the story they heard? Was it a joke that was passed down from year to year and told repeatedly at meetings? I wanted to start a relationship with a man my senior year at college but I couldn't do it; he was a member of that fraternity and I was certain that he had heard a skewed version of that night and thought poorly of me. My relationships with women deteriorated as well. I was so envious of how happy, clean, and simple their lives seemed and I felt so loathsome in comparison (how ironic that so many women at the college had similar experiences to mine). I joined a sorority my sophomore year, hoping to find comfort in the company of women, but it only reinforced my feelings of alienation and loneliness. It saddens me to think of all the men and women I didn't get to

know at college because of my insecurity and distrust. It is the one thing I regret most in my life.

My relationship with my boyfriend at home fell apart as soon as I returned from my college visits. I haven't had a healthy relationship since. I wasn't really afraid of him, I simply couldn't believe that he really "saw" me; he was just like all the others. I did not tell him about the rape. I have plenty of male friends but I can't move into intimacy without all my trust in the man crumbling and blowing away. Although intellectually I know this distrust is ridiculous—not all men are abusive—something deep down still tells me it's the only safe way. I did have one long-term relationship in college that started soon after the assault. Unfortunately, he used my sexuality as a psychological weapon against me and a year later I was left more emotionally unstable and bewildered than ever. I also feel that I was too "loose" with my sexuality in college. Part of this stemmed from the more sexually liberal atmosphere of college life, but it mostly resulted from my complete confusion over my sexuality and its place in my life. Sex meant nothing to me. I had no self-confidence and little self-respect, but mostly I didn't understand sex. To me, sex was purely physical. I couldn't deal with the conflicting emotions sex brought up so I pretended they weren't there.

My abuse of food progressed in a similar fashion. Although my eating problems started in an adolescent power struggle between me and my parents, it exploded into uncontrollable abuse after the rape. I was disgusted and scared by my body; it seemed alien and dirty. I didn't blame myself for what had happened, yet I still felt that my body had somehow betrayed me. Before, I had generally taken joy in the pure strength and beauty of my body, but it now seemed to have directly caused me to be hurt. My body hadn't handled the alcohol well, hadn't fended off the attack in the basement, and had even passed out during the rape. I remember picking at my salad during dinner with my parents the night after the rape and longing to stab and rake my Judas flesh with the fork. My binging worsened. No matter how hard I tried I could rarely force myself to vomit, so I instead abused laxatives. I wanted to be attractive but I was scared to allow myself to be so. My subconscious told me that overeating and gaining weight was what I HAD to do in order to be safe. I didn't need to draw any more attention to myself, did I? From my parents I learned that I could never be good-looking enough to satisfy them, and from the rape I learned that being attractive gave men free license to hurt you. Moreover, I could never be attractive enough to hide the bitter and twisted person I had become inside. In high school I would eat enormous amounts of foods I hated—biscuits from Kentucky Fried Chicken, candy bars, raw sugar, anything—in

order to hurt my body as much as possible. At college and away from my parents' security/domination, my eating disorder took on epic proportions. I would eat two pizzas, drink a six-pack of Diet Coke and be so ill afterwards that I could only lie on the floor in my dark room and cry for hours. I finally spoke with a counselor at my college health center my freshman spring, mainly because my boyfriend told me that I disgusted him. In our initial discussion I casually told the counselor about the rape—but not the assault—and admitted that it might have played a small part in my eating problems. She suggested that it was probably the main cause. I never returned for another appointment. I don't know exactly what I thought was causing my eating disorder, but I felt that blaming the rape for all my problems was using it as a scapegoat. I didn't want to talk about the rape and I didn't want anyone to think I felt sorry for myself because of it

I can't pinpoint the exact moment when I consciously used the word rape to describe what happened to me; I believe that it was the counselor who first defined it as such. But I do remember the moment I began to pull my shattered psyche together. I studied abroad my junior fall and winter and returned to campus that spring with a strength and clarity that I hadn't had in years. My first day back I went over to my good friend Amy's house, which I hadn't seen before. She wasn't home, so I walked in and flopped down on the bed to write her a note. It was a beautiful spring day, sunny with a slight breeze. I laid on the bed and watched the shadows' shifting pattern on the white wall. Birds sang outside. Suddenly I couldn't breathe or hear. I stared and stared at the shadows trying to fight off the nauseating falling feeling I had: I was in the same room in which I'd woken up that terrible morning four years earlier. The bed was in the same place. The view and sounds were exactly the same. I don't know how long I laid there paralyzed, clutching a pencil and some paper. When I finally sat up the paper was damp with perspiration. Yet I felt strangely relieved, as if some perverted circle had been completed and I was ready to move on. My mind had gone numb just as it had four years earlier, but this time it surfaced with the certainty that the rape and assault were things I could deal with. I was ready.

I called Josh before I wrote this to make sure I had the facts as straight as possible. He did say that he had been worried when he couldn't find me at the party. He questioned his fraternity brothers, but they told him that I was "fine" and that he should relax and not bother me—and I'm sure they pressured him to drink more. I don't fault Josh for what happened; he was a naive freshman trying to make a good impression with his brothers. But why didn't the older, more "knowledgeable" brothers help me? Did no one

realize what was going on? Was that considered normal behavior? Or was there a scheme to get me in bed somehow? Josh also told me my rapist's name. Some lingering repression mechanism makes me unable to remember it; I have to refer to the notes I took on our conversation. I know what he looks like from his fraternity picture, and the face matches what I vaguely remember. The temptation to write his name now in bold letters is overwhelming, yet I can't bring myself to and I don't know why. I worry that my silence might endanger other women—I hope it hasn't already. I loathe and pity him, and I'm completely bewildered by it all. I would love to meet him. I would love to tell him how I can't look into a mirror without feeling deep disgust for myself. How I smashed all my mirrors in high school. I want to tell him that I'm torn between wanting to be attractive and my fear of doing so. How after he assaulted me I started to slash my face but ended up just slashing my arms with scissors because I still hoped that I could someday be proud of my looks—maybe someday someone might love me despite my being so disgusting. I want to describe to him the pain of my twisted relationship with food that exploded after the rape. How my weight problem has torn apart my family and changed my life. How my self-hatred has driven away and hurt the people I love but how I can't seem to stop it. How I mistrust men and see all men as predators. How I'm afraid I will never have a meaningful relationship with a man. I would love for him to go through the confusion I went through—and am still going through—over my sexuality and its power. I would love for him to live a day full of the self-doubt, self-loathing, and hopelessness that I have. I want to give him all the cynicism and bitterness that I've carried around for so long and of which I'm so tired.

I would love to drown him in all the tears I've cried while writing this.

4

Absolut Seduction

Scott Stewart

It took me seven years to understand and reluctantly admit to myself that I had date raped someone. I had always suspected that I hurt someone, and my conscience and pride often reminded me that I had done something wrong, but I never would have understood that what I did is date rape. Rape is such a loathsome, powerful word. To me it conjures up the image of a gruesome maniac who breaks into a woman's apartment with a knife. He's insane with hatred and violence. He takes what he wants, takes pleasure in another's pain, and thinks nothing of condemning a woman to a tortured existence.

I would have admitted that the circumstances of the incident I am about to relate were a little ugly. I would have agreed that I was manipulative, maybe even a little ruthless. However, while I felt that my behavior was morally despicable, I also thought that I had played on the safe side of the line that separates "seduction" from rape. In my mind I had not forced her to do anything, and I certainly never intended to hurt her. I was sincerely sorry for my insensitivity and coarseness, but I would have considered the accusation of date rape a melodramatic exercise in paranoia. "I just got her drunk and we had sex," I would have said.

I considered rape a far greater offense that required violence I was not capable of, and malicious intentions I could never feel. Throughout my life I had consciously chosen less forceful paths. In college, when this incident took place, I had not joined the rugby team or a fraternity largely because I had seen destructive qualities develop or emerge among a few well-intentioned friends who had decided to join the pack. Not that I was a wimp, but I just never felt the need to prove my masculinity through aggression.

I think that most women who knew me considered me a sincere, "nice guy" who was in touch with himself and his feelings. My parents had always been happy and fulfilled in their marriage, and I accepted their idealistic perceptions of love and sex. I was a hopeless romantic and frequently

indulged in intense infatuations—a couple of which actually ended in real love. Most of my best friends were also female, and I thought I had a fairly enlightened respect for women. I believed that men and women are more similar than different, and that they are always equal. In any case, I felt that we are all just individuals, and that every individual deserves respect.

Despite my respect for women, however, I had always been obsessed with sex. Once I shed the commitment of my high school love and tasted the freedom and sexual opportunity of college life, my idealism melted away to reveal a sexual ethic that, while innocent in its intentions, had predatory results. Love and sex were two different things to me, and I thought that women could be pursued for either. I was a prince when love was on my mind, but when sex was the objective, I thought that I could rightfully do anything that was not overtly forceful, violent, or deceitful to "seduce" young women from beyond the conservative influence of over-protective, naysaying parents—the primary source, I thought, of any reluctance on their part. I thought that deep down, most women wanted sex as much as I did, but that guilt forced them to offer at least token resistance. Sex was playful, and not until a women said no a couple of times—when she really meant it—did I know it was time to stop. I thought that my high-pressure strategy was playing by the rules since I knew that ultimately I would accept her outright refusal. I stayed out of trouble probably because to those who succumbed to my tactics, I was still the "nice guy" the morning after in an effort to reassure them that what we did was right—a tactic that always worked for me. Now, however, I realize that I am very lucky that there is only one woman out there who considers me a date rapist.

I had never really examined my sexual behavior prior to the incident I am about to describe, but the morning after it, I knew that I had gone too far. I knew that I had been extraordinarily insensitive and callous in my pursuit. I would not have called it date rape then, but I knew that I had crossed a line between right and wrong. My world was not shaken at first, but in retribution, I made a casual vow to extend greater respect to *all* women and grant more sanctity to the act of sex. Then I more or less forgave myself for my carelessness and moved on.

I would not tell my story if I thought it was an isolated incident, but I heard too many stories like mine shared and dismissed when I was in college. While most guys I hung out with were fairly discreet, if one was suspected of "scamming" successfully, other guys would taunt him until he revealed at least vague details for public amusement. It was bonding in humiliation, not so much of the woman who was often left anonymous and

objectified, but of the guy who had reduced himself to "sloppy sex." I guess in a way, many of us did want "the point" as a badge of our desirability and reassurance that we were as good as anybody else. I think many guys I knew were genuinely uncomfortable with these admissions, however, and generally tried to protect individuals and details. If our stories were told in a "wow, what a party!" way, I think it was out of embarrassment and in hopes they would just blend in with the craziness of campus life. Being accused of grungy, drunken sex is not as embarrassing against a background of "some guy woke up half-naked in front of the dean's office!" or "some girl got caught peeing in the fireplace of Baxter!" The stories tended to just round out another wacky night on campus. There were few secrets in my small college, and among guys who were trying to "scam" (most guys), it seemed that an alarming number of them eventually had a questionable sexual encounter.

This is the first time I have shared my story. One person on campus knew what happened, and I think a few more suspected, but I was never hazed, questioned, or made to feel guilty for what I did. I was certainly never accused of date rape. I doubt that the victim referred to the incident as date rape either. She may have blamed herself, not knowing that I had meticulously manipulated the situation and planned everything.

* * *

I was about eighteen years old, and halfway through my freshman year at a small New England college. My social life centered on a group of about a dozen friends who lived in my dorm. It was a good group of people that I had gotten to know quickly freshman year. We all studied hard, but since most of us were away from home for the first time, we partied harder. When winter turned the campus into a bleak wasteland, we spent a lot of our free time just hanging out in someone's room, joking, laughing, and debating. We liked to be together, and beer or a bong often animated our friendships and fun. In most respects we were like groups of friends on any campus.

It was a Saturday night, and my friends packed into my room before heading out into a blizzard to cruise frat parties. I was excited to be entertaining since we usually hung out in Rob's room, and because I had just purchased a new stereo which was a big status symbol. My happiness was complete when Susan, my best friend and soul mate, finally arrived from dinner. Our friendship had grown deep and fast, but by this point in the year I was eager for more. That is another story, but suffice it to say that I

had fallen in love with her. Unfortunately, Susan was not available, so I hid my feelings for her, began to feel isolated in our friendship, and was feeling an obsessive infatuation set in.

Everyone made space when Susan entered the small room, followed tentatively by her younger sister, Lisa. Still in high school, Lisa was up to check out our campus for the weekend. She smiled awkwardly, appearing a little nervous and intimidated. As she stood there I could tell that she lacked Susan's boldness and dry sense of humor—the things I liked best about Susan—but I liked Lisa's quiet, pensive demeanor. She looked a little like Susan, but she was brunette and had more refined features. Although she was younger, Lisa had an aura of sophistication that I found particularly attractive next to Susan's blonde earthiness. Lisa also had a phenomenal body.

Through my eighteen-year-old eyes Lisa was irresistible. I wanted her. It was an innocent but familiar lusting that, at that age, I experienced at least a half a dozen times a day. My discreet gaze from afar would fuel a fantasy, and within seconds I would create the personality and soul of someone I had never met—instant "love." Unfortunately, such instant crushes would usually leave me too overwhelmed, indeed too vulnerable, to do anything about them.

Susan and Lisa sat down and joined in. We were running out of beer so I pulled out a bottle of Absolut vodka. We toasted something and passed shot glasses around. Lisa laughed and downed hers with confidence, and then had a second "to catch up." "She can drink. That's good," I remember thinking. Unlike the handful of women I'd lusted over that day, I saw potential. I still do not understand why her familial link to Susan did not seem a prohibition; on the contrary, it seemed to justify my desire.

A very basic plan began to form in my alcohol and hormone-soaked brain. "All is fair in love and war. If she gets drunk, maybe I can sleep with her." It was not a malicious thought, but a naive beginning to the game of seduction and sex as I understood it. Projecting into the future, I thought "at worst I might hurt her feelings, but she'll get over it by the time she leaves campus. She might just enjoy it, and that would be better. Sex is a good thing." I figured an entire evening on frat row would afford plenty of opportunities for me to make a move.

I remember craving sex long before I ever experienced it, even before I really understood what it was, how to do it, or its emotional and physical intensity. Once I was initiated, however, I felt inadequate, unsatisfied, and incomplete if I was not sexually active. For the record, I had slept with five or six women in my life prior to this night, and I had already learned that

sex was far better if it was within a loving relationship. However, I was only halfway across the dry sexual landscape of my freshman year, and I was ready for sex with just about anyone, in any way. I felt lucky that I just had a chance with Lisa who, if she were not leaving the next day, was someone I would be pleased to befriend and date.

After a couple of beers and a few shots in rapid succession my memory begins to fade, so I cannot tell you exactly what happened, what I said, or what she said. I remember paying a lot of attention to Lisa, but being cautious so she would not catch on to me. I made Lisa feel welcome, but I reinforced that her way into the group was through the neck of the vodka bottle. I dominated a drinking game and—surprise—Lisa drank most often. Not knowing the territory, Lisa frequently committed "party fouls" which required "penalty shots." An hour after the first shot, the bottle was dead, two thirds of it shared between Lisa and me. Lisa seemed more relaxed and looked happier, but I knew that in a matter of minutes, she would be in no condition to go anywhere.

Last to arrive and first to leave, Susan left our happy hour early to see her boyfriend. She suggested that Lisa walk down to the frats with the rest of us. I remember thinking at that point that the rest would be easy; Lisa seemed to like me well enough and she had definitely loosened up, even told a few jokes. Susan and Lisa agreed to meet up later at one of the frats. Our party started to break up soon after Susan left. As I searched my room for my jacket, I feigned needing to make a couple of phone calls. Everyone milled around for a minute, and then walked out. I was Susan's best friend, so Lisa would wait and come with me.

I discreetly locked the door behind the last person. Not to lock Lisa in, but to make sure that a visitor would not interrupt us, upset Lisa, and cause her to leave. I moved close and kissed her, seizing the opportunity and hoping for the best. We had hardly exchanged a word aside from my impersonal hosting gibberish, but Lisa returned my kiss, more out of shock, I even knew then, than genuine affection. She did not exactly melt in my arms, but she did not resist or protest as I moved her onto my bed and undressed her. She drunkenly nodded "yes," she was on the pill. I remember thinking that sexual arousal would help keep her awake, and intensifying my efforts when I realized that it did.

I never really considered the consequences of what I was doing, how it might impact Lisa's life, or jeopardize my relationship with Susan. Although I had tried to bring about this course of events and vaguely recall feeling proud of my success, I never really expected it to happen. I expected Lisa to laugh and push me away. Once Lisa was naked in front of

me, consequences were the last thing on my mind, and I assumed that it would be our secret to keep from Susan.

I'm not sure how I would have reacted if Lisa had protested or resisted at any point leading up to or during sex. I am sure that I would have tried to convert a verbal protest, convincing her that what we were doing was perfectly normal. If she had pushed me away, I think I would have tried to calm her down and then tried to seduce her again. I *do* know that if she had struggled or hit me, I would have backed off fast. I maintain that I am not a violent person, and there is no way I could have restrained her or hit her.

A refusal would have surprised me anyway, since I had purposely picked out the easiest target. I suspected that Lisa's self-esteem was vulnerable, she seemed in awe of me and all her sister's friends, and now she was thoroughly intoxicated. As soon as Lisa returned my kiss I was sure that, one way or another, I could get her to go all the way. Once on the bed, I rolled on top of her and slowly penetrated. Lisa's arms rested by her side most of the time, and I remember being disappointed that she was not a more passionate lover. I interpreted her lethargic participation as a lack of experience and passion, not as a sign of reluctance, resistance, or drunkenness. I distinctly heard her murmur someone else's name, the alcohol transporting her farther into her slumber. I paused only briefly when she vomited.

The phone woke me up several hours afterwards, and I answered it. It was Susan calling to see if Lisa was there. As I looked at Lisa's naked and unconscious body lying on my bed, I lied to my best friend and said no. I could not fess up to Susan in my condition, and I figured that Lisa would want to make up her own story, too. I expected that she would be embarrassed to admit to Susan that she had had sex with someone she just met, and that she would want to protect our secret in her own way.

Susan spent much of the night looking for Lisa around campus, but she never called campus security or the police. Knowing that Lisa was drunk, I think Susan realized that Lisa could be anywhere and with anyone, but was probably just curled up safely in some odd place where her consciousness was overcome by the blanket of alcohol. Campus was not considered a dangerous place, and to Susan, sounding an alarm probably seemed melodramatic.

Lisa woke up in my bed early Sunday morning. Both of us were in a haze and at a loss for words. I cannot remember the few words we did share, nor their tone. I only remember that Lisa left quickly, and then disappeared quietly off campus that afternoon. I felt bad about what had happened, and Susan yelled at me on the phone for a few minutes, but

somehow my shame lasted only a day. By Monday I could tell that Susan and I were still speaking, and by the following weekend there was some other drama to occupy our minds.

I did not feel that what I had done was fundamentally wrong, just pitifully uncool. I was guilty of sex that lacked civility and smoothness, "bad sex" I thought, which I could dismiss as an indiscretion that Lisa would surely forget about quickly. Nonetheless, I was embarrassed by my behavior, and I was thankful that only Lisa and Susan knew what happened. I filed the experience away as a significant mistake, decided I needed to exert better discipline over my immature and insensitive sexual behavior, and moved on.

In the months that followed, Susan and I never really talked about Lisa, but our relationship gradually cooled off. I called Susan at home over spring break and, still feeling guilty about "what happened between Lisa and me," I asked her if Lisa was all right. "She's fine," and "no, you can't talk to her," Susan said. I had no idea how Lisa felt, and I did not accept that I date raped Lisa until nine years later, but I wanted to apologize to Lisa because I do not like leaving messes behind. I would have told her that I was sorry, and perhaps that I felt responsible for what happened. I wanted her to know that, in a way, I commiserated in any pain she felt. I might have told Lisa that I wished it had happened in a more romantic and proper way. Thinking that Lisa might feel ashamed rather than violated, and that my opinion of her might be the source of that shame, I probably would have told her that I did not think any less of her.

For a year or so I felt close to Lisa because I felt a physical bond. Lisa's thoughts and emotions, however, seemed closely guarded. I never got to speak to her, and though I inquired several times, Susan never gave me any idea how Lisa reacted to what I did to her that night. It was too easy to disassociate myself from the entire affair, so I did. My conscience, however, was left to sort out the clashing image of Lisa's beautiful body draped over my bed, and the dreadful sounds of her throwing up into a trash can, half-unconscious in the midst of sex.

* * *

In the aftermath, my modest feelings of guilt were balanced by a more desperate sense of entitlement. I knew how badly I had always craved sex, and I knew how difficult it had been to control powerful feelings that seemed to well up from deep down inside. Sexual frustration made me resent the fact that many women would withhold something that seemed such a sim-

ple pleasure, even a basic need for me. Occasionally, I still catch myself thinking, "What's the big deal? If you use a condom there are no risks or repercussions. Sex is always a good thing."

It took nine years for my understanding to evolve from my "bad sex" interpretation to date rape. I knew at the time that I had gone too far, but it was not until my relationship with Susan began to deteriorate that I began to question what I did to Lisa. Though Susan never said it, I realized she was pulling away from me because I had violated her trust, not to mention Lisa's. I do not think that at the time Susan considered what happened date rape, either, but a violation of our friendship.

I had always been curious about sex from women's points of view, and as my female friends and I matured, we were able to discuss sex in more honest and open ways. Progressively they disproved my theory that all women could, or wanted to, take sex as lightly as I did. Several explained to me that the profound *physical* intrusion of intercourse was, they felt, nearly always paralleled by an *emotional* intrusion of equal intensity. Understanding sex in these terms, I started to understand that sometimes there is a fine line that separates sex as an act of affection, and sex as an act of aggression. I realized also that this line is not necessarily defined by my intentions, but by the degree of consent of the woman and the emotional impact of my "seduction." Finally, I realized that consent could be questioned when alcohol is involved, and that to manipulate a woman into sex by any means was a wicked game, and in the case of Lisa, may have been rape.

I do not think I ever would have fully understood my offense or its consequences had I not learned from the feelings and painful experiences of two subsequent girlfriends.

The first woman, Julia, was a victim of incest by her father, and his rationalizations for having sex with her were chillingly familiar to me, echoing against the absolutism of my own sexual ethic. He lusted after Julia because she reminded him of her mother when she was younger, before she had a nervous breakdown and he left her. Although he had remarried, he missed her terribly and this, he felt, justified a chronic carnal desire for Julia. Fifteen years later Julia was still very bitter, but she had channeled her anger into productive endeavors to prove, I think, that her father could not control or destroy her. We talked about it often, and though I longed to help, I soon realized that she only wanted me to share her hatred for her father. I loved Julia, so I self-righteously joined in her contempt for a man who taught me a lot about myself.

More recently a woman named Ashley provided my second exposure to

the impacts of sexual violence. Ashley was very quiet, gentle, and pensive. She seemed extraordinarily vulnerable and, had she not been the most endearing woman I had ever met, I would have left for fear that I could not cope with her mysterious emotions. I soon learned that Ashley had fallen victim to a serial rapist who broke into her apartment, raped her at knife point, and then beat her so badly she spent two weeks in the hospital. I know very little since Ashley did not like to talk about what happened. Even at the most joyous and social of times, however, Ashley would often fade off into her own world and quietly relive her nightmare. During our short relationship I did what I could to help her cope with the debilitating emotional pain that still haunted her four years after the attack, but for the most part, her silence left me feeling painfully helpless.

Perhaps as proof of a certain rehabilitation on my part, I should mention that Ashley drove the sexual part of our relationship. Apparently I was only the second man she felt she could be intimate with, and the first she really desired to be intimate with, in the four years since her attack. She attributed this to an absence of pressure and acts of sensitivity on my part. The first time we were ever naked together I remember Ashley giggling in joy and astonishment at how quickly she felt comfortable with me. Unfortunately, a couple of times during our lovemaking I realized that Ashley was not with me—she was having a flashback, she answered—and all I could do was transform our sex into a soothing cuddle and dry her tears with the pillowcase. Unlike Julia's father, I saw no common ground with Ashley's attacker, but I cursed him as well.

Unfortunately, that did not exorcise Ashley's trauma either. In the end I had to accept that I was in love with a person Ashley would probably never be again, and that ultimately, there was little I could do to help her. Ashley had not really helped herself yet, and realizing this, Ashley ended our relationship.

If there was a pattern to my sexual abuse, it was using pressure to get what I wanted. After my experience with Lisa, however, I largely corrected my sexual behavior just by reducing the amount of pressure I would let myself exert on a woman. I did this less out of respect for women or fear of accusations than to protect my own pride; in the past I had sometimes felt like a used car salesman on television, and I thought it was time to turn down the volume. I realized through my relationships with Julia and Ashley, however, that I still needed to change the channel. It may seem simplistic, but by sharing in the emotional fallout of their experiences, even if they seemed removed from my own offenses, I finally understood that sex

was not always a good thing, and that if it involved manipulation or violence, it was an evil thing. Today I can say that not only is pressure not one of my tactics, but that I do not have tactics.

No, I did not have the courage, nor think it best, to recount my offense to either Julia or Ashley, but my love for both of them forced me to examine my own behavior within a more objective framework, and with a less adversarial view of the way things between men and women ought to be. I came to accept the inherent force and violence of what I did to Lisa. I came to see that I had restrained Lisa with a bottle of vodka, and that, had she protested, I was prepared to beat her with words. I realized that, especially under the influence of alcohol, I would have resorted to emotional warfare to get what I wanted that night. For a long time my guilt took shelter in the innocence of my intentions, but I realize now that the fact that I never would have exerted physical force would provide as much consolation to Lisa as reassuring Ashley that her attack could have been much worse.

I do not know Lisa, but it bothers me that I have contributed to the vast pool of pain that is part of female sexuality—the same pool of pain that Julia and Ashley swim in regularly. I still have to do some juggling to understand all of the facets of my guilt, and I must contemplate them simultaneously to *feel* guilty. Nine years after date raping Lisa, what insulates me from feeling the full force of my guilt is the difficulty I have in interpreting the events in a way that allows Lisa to give up all responsibility. I feel that at the very least she needed to say no. It seems ironic that to accept the blame I am compelled to bear, I must believe that Lisa was helpless from the moment I met her. Harder still, I must convince myself that she did not even need to say no.

I realize, however, that Lisa's irresponsibility does not make me innocent. I know that I crafted my hospitality that night to ease her inhibitions, and possibly even take away her ability to say no. I realize that even if she had said no, I might not have accepted it. I realize that as much as I wanted sex, I had no right to take it.

5

When Is "Yes" Not Consent?

Daniel M. Nelson[1]

Dr. Nelson holds a Ph.D. in ethics from Princeton. He is on several task forces on sexual assault and is senior associate dean at Dartmouth College.

People concerned about the prevalence of date rape on college campuses often try to convey the message that when it comes to sex, "no means no." Women have been encouraged to articulate their desires when they don't want sexual intercourse as part of a date, relationship, or other occasion for sexual intimacy. Men have been exhorted to listen for and respect "no" or other forms of resistance to their sexual advances, rather than to presume that resistance is a disguise for a woman's actual desires, a part of some ritualistic dance inevitably consummated by a "yes."[2] Anyone who has forced a sexual encounter on someone who has said "no" is guilty of sexual assault or rape.

That message, unfortunately, is still far from being widely heard or believed. There's still another message, however, that is equally important but seemingly more difficult to convey: A person's "yes" to sex doesn't always count as yes. "Yes" shouldn't be understood as consent if the yes is not freely given.

Stating that a person's "yes" doesn't count as consent if it isn't free means that the yes—verbal or expressed in other ways—cannot be coerced, uninformed, or impaired. A woman threatened with some kind of harm if she doesn't agree to some form of sexual activity hasn't agreed to anything at all, no matter what words she is compelled to utter or regardless of her subsequent silence or seeming compliance. And even if it isn't a matter of threats or force but rather of a man's badgering and ultimately wearing down a woman's resistance, her compliance is better understood as "exhausted temporary acquiescence" than consent, or at least the quality of consent that should inform decisions about sexual intimacy. There is a difference, in other words, between seduction and harassment or coercion.

Consent in sexual relationships also has to be informed. Most of us are familiar with the notion of informed consent in medical contexts: You've been wronged if the medical procedure to which you have agreed is secretly for medical research purposes and not for your own medical benefit, if the dangerous or unpleasant side effects of an experimental medication are not explained to you, or if you are too young or otherwise incompetent to make a reasonable judgement about medical treatment for which your permission is requested. The law considers sexual intercourse with minors—with those below the "age of consent"—as "statutory rape" in part because we presume that the very young are not yet capable of making responsible and well-informed decisions about having sex and because we want to protect them from exploitation and harm.

But the notion of "informed consent" also has implications for sexual relations between adults. It is important for adults in a relationship to be clear and honest about what they want from one another and to be honest about the implications of any sexual relationship they might have. Sexual partners who misrepresent their sexual history, lie about not having sexually transmitted diseases (like AIDS) when they do, or contend that they are using appropriate forms of birth and disease control when they are not, put one another at risk of serious harm. Consent to sexual intercourse when such information is withheld or falsified can't be sufficiently informed. Our society is only beginning to struggle with whether or how to regulate that through law, but obtaining a person's consent to sexual relations under false pretenses is clearly a moral offense.

There are other informed-consent issues that concern common preludes to sex. Asking someone to come up to your room after a party "to talk" may well signal an invitation, clearly understood by both people, for some sort of sexual intimacy. On the other hand, one of the people may sincerely want only a limited degree of sexual intimacy (or none at all), and it would be a mistake for the other person to act on the presumption of a shared unspoken intention to become physically intimate. It would be a profound mistake, with potentially tragic consequences, for a person to persist in presuming that consenting to come to a private room to talk, to have a drink, to sit on a bed, to kiss, or to lie naked in one another's arms, is anything other than just that. Men and women just can't *assume* their partner's consent to sex. A man who assumes that a woman understands and shares his intentions to have sex with her, for example, is in danger if he doesn't communicate his intentions and confirm her agreement to them. Unfortunately, a woman's willingness to share in sexual intimacy just short of in-

tercourse may well be interpreted as signaling a desire to have intercourse unless she makes it clear where and when she wants to stop. A woman who assumes that a man will understand any reservations or objections she has to his advances is also in danger if she doesn't make her objections clear and enforce them.

One of the most difficult consent issues seems to concern impaired consent, especially consent that is impaired by alcohol or other drug use. If consent is a necessary condition for sexual activity not being forced, it should seem clear that someone who doesn't have the mental capacity to give consent, because of significant impairment by alcohol, shouldn't be a sexual partner. That's not to say that someone who has been drinking is incapable of consenting to sex, or that someone very intoxicated might not feel just fine the next morning about the previous evening's encounter. However, if someone is sufficiently impaired, consent is not valid. Someone who "consents" while very drunk isn't in any position to consent to anything.

I very deliberately put "consents" in quotation marks here because a range of behaviors that might well seem like consent to an intoxicated man or woman may appear very different in the sober light of day—even if we wouldn't categorize the encounter as a clear-cut case of sexual assault. The exhausted acquiescence of a stoned woman who is almost passed out but cannot get her insistent date off of her is not meaningful consent. The slurred speech of a woman trying to explain what she doesn't want without hurting her companion's feelings may not be attended to by a date whose conscience and consciousness are slumbering. Our true intentions are notoriously inaccessible to outside observers and sometimes even to ourselves. The behavior of the man who intends to have sex under any circumstance in which he thinks he will not get himself into trouble appears very similar to the behavior of the man who makes a tragic mistake because intoxication makes it easy for him to ignore the resistance of a woman who is too intoxicated to summon the words to yell at him or the energy to push him away vigorously. Under the influence of too much alcohol, even otherwise good people can be responsible for behaviors that indeed warrant the labels "sexual abuse," "assault," or "rape." Many people get egotistical, belligerent, and headstrong when drunk—and thus can wake up to find themselves accurately called rapists because of something they did that they might not even clearly remember.

Consider this description of someone whose blood alcohol level is in the range of .14–.17% (for the average 120-pound woman, that's seven drinks

over three to four hours; for the average 175-pound man, that's about six drinks over an hour or eight drinks over two hours):

> Major impairment of all mental and physical functions; euphoric (pleasant) feelings are beginning to give way to dysphoric (unpleasant) feelings; difficulties in walking, talking, and standing; severe deficits in judgment and perception; "play" becomes increasingly violent; risk of accidental injury to self and others increases; impotence is likely; blackouts (periods of amnesia for all or part of drinking episode) occur for some at this level; significant loss of control over behavior.[3]

Consider the description of someone whose blood alcohol level is .25% (for the same average 120-pound woman, that's nine or ten drinks over the same three- to four-hour period; for a 175-pound man, that's nine drinks during an hour or ten or eleven drinks over a two-hour period):

> Dysphoric and/or numb; all mental, physical, and sensory functions are severely impaired; nausea and vomiting; risk of severe injury from falls and accidents; increased risk of asphyxiation from choking on vomit.[4]

It isn't uncommon for students to reach those blood alcohol levels during an evening of partying. And it's not uncommon for those students to "hook up" or have sex; and because of alcohol-induced impairment, it's not uncommon for sexual intercourse to be without one person's free consent. If a complaint to the police or college authorities results and if someone is accused of sexual assault, abuse, or rape, there obviously is not strict evidence of the person's blood alcohol level at the time, but it might well be possible for the complainant or witnesses to provide persuasive accounts of how much someone had to drink over a specific period of time. No matter what the complainant is alleged to have said or done during the sexual encounter itself, a court or disciplinary panel might well conclude that consent was sufficiently impaired to be invalid, and the accused might be found guilty. How impaired is too impaired to consent is a matter of case by case judgement, considering all the evidence available.

Men are sometimes socialized to believe that the way to "score" with a woman is to get her drunk, assuming she'll feel freer or might be willing to do things drunk that she wouldn't do sober. "Working out a yes" in this way—using alcohol to push for acquiescence—used to be called taking advantage of a woman, and it's wrong. Sex under such circumstances is frequently assaultive or abusive, an act of violence. But what if the woman

wants to get drunk? What if nobody is spiking her drinks but she chooses to get herself drunk? If she doesn't object to sex while she's intoxicated, or especially if she says yes with her words or seems to be implying yes with her body language, hasn't the man rather than the woman been wronged if the next morning she complains that she was raped?

Depending on the level of impairment and what desires were or were not communicated, the woman has still been wronged, and the man has still done wrong, even in those circumstances. Her consent is still necessary for the sexual activity not to be an act of violence against her. The fact that she chose to get drunk does not mean that she gave up her right not to have harm done to her. She might be held responsible for her own intoxication, if that violates local laws or college regulations. And one might conclude she exercised extraordinarily poor judgment by drinking so much that she left herself vulnerable to men who might not respect her personhood and choose to use her for their own purposes. But if someone abused or assaulted her, it isn't her fault. The fault lies with the man who intimately touched or penetrated her without her freely given permission, the permission that is hers alone to give. She might have wanted to have sex while intoxicated, yet she might not. There isn't any sure way to know. Men who have sex with intoxicated women run the risk of harming them and leave themselves vulnerable to very legitimate complaints of sexual assault or abuse.

Not surprisingly, this conclusion seems obvious to more women than men. Men seem to have a much easier time seeing the same moral point in financial or other physical contexts than they do when sex is concerned. If while I'm intoxicated I sign a contract consenting to give you my house and my car, I am likely to go running to a judge the next day and complain I was too impaired to know what I was doing; the contract should be invalidated because despite the "yes" indicated by my signature, I didn't sign the contract freely or willingly. If while I'm intoxicated you cause me physical harm and yet I don't resist, I might well complain you assaulted me while I was too impaired to know what I was doing. If my physician solicits my consent to a risky medical procedure or experiment while I am under the influence of mind-altering medication, I am likely to accuse the physician and hospital of malpractice and ethics violations. Why then do we find it so hard to see that the woman and not the man has been violated following a complaint that sexual intercourse took place while the woman was too drunk, too impaired to consent?

We tend to find it even harder to assign men the responsibility for abuse, rape, or assault against a woman when the man and the woman are both in-

toxicated, feeling that we at least ought to hold neither or both of them responsible. If you choose to impair yourself by becoming intoxicated, however, you can certainly be held responsible for the wrongful things you do to others. Being intoxicated does not excuse your harmful behavior. The drunk who breaks windows or beats someone up is not excused because of intoxication. In fact, in some places intoxication is considered an aggravating circumstance when a crime or violation is committed. And again, being intoxicated even by choice does not make you fair game for the harm others might inflict on you.

If you agree with this way of thinking about consent, impairment, and sexual activity—about the capacity and right of women to choose or decline sexual intimacy—there are obvious practical implications for your behavior. But you don't have to agree with what has been said here in order for those implications to be equally pressing. If you think there is a good chance that a judge, jury, or college disciplinary authority might think along these lines, you have good reasons to modify your behavior. Presuming you have accepted the notion that "no means no," it is important to be sure that you have actually been given a yes. The yes doesn't have to be a signature on a dotted line or a verbal statement overheard by three sober witnesses. Clearly, consent in sexual matters doesn't work that way. But you would be wise to be sure that the yes is really a yes, whether it is expressed in words or otherwise. Part of being sure that the yes is really consent is being sure that neither you nor your partner is impaired, being sure neither of you is intoxicated. That can be a bit more complicated than it sounds:

> . . . impairment becomes noticeable at blood alcohol levels of 0.05%, which can occur when as few as two drinks are consumed in an hour by a 160-pound individual.
>
> *The deceptive part about impairment is that, by definition, impaired judgment cannot recognize its own impairment.* The individual thinks he or she is functioning well, when actually he or she is not. Later, there is an impaired memory of the impaired performance.
>
> *Impairment can be a group process.* If a group of individuals are all drinking heavily, they may reassure one another that they are all functioning well, when in fact each of them has significant mental and behavioral impairment that would be obvious to an outside observer.[5]

A good strategy if you choose to drink, then, is to know what you want your limits to be and to decide beforehand how much alcohol it is prudent for you to consume. Nonetheless, it is an unfortunate reality that some stu-

dents are unwilling to exercise that kind of responsibility about alcohol consumption or they drink precisely in order to become intoxicated. Even if they make that choice, they do not choose to be sexually assaulted or, presumably, to rape. They should think in advance about what they want in the way of relationships or intimacy and decide in advance how to protect themselves against unwanted or tragic outcomes. That's difficult, of course, if you are not quite sure what you want in the way of intimacy with someone. Even though it goes against a strong tide of student culture that can encourage alcohol abuse as a means for achieving at least an intimation of emotional or physical intimacy, men and women would be wise to decide in advance not to combine alcohol abuse with sexual activity.

Balancing values, desires, and behavior can be a difficult struggle in a permissive society. It is easy to forget, or never to learn, that there is a difference between casually "hooking up" and having a satisfying sexual relationship. The freedom to have casual sex with relative strangers while intoxicated does not necessarily promote sexual pleasure. Men and women sometimes talk about feeling pushed into sex because of what they mistakenly perceive or presume are the expectations of their partners. People sometimes camouflage their insecurity about sexual intimacy by engaging in locker-room humor, creating further pressure and peer expectations for what it means to be a man or woman. But sexual intimacy that neither person actually wants, or sex under duress or the influence of excessive alcohol consumption, is simply bad sex. It's likely to be bad at the moment, in part because it usually isn't sexually satisfying (a man who is extremely drunk will often have difficulty having sex or even staying awake) and because it doesn't necessarily satisfy a deeper desire for personal intimacy. It's bad in the long run because of the emotional and psychological damage experienced by people who routinely engage in meaningless or abusive sex.

If you want to be sexually intimate with someone, do it because both of you truly want it—not because you think the other person expects it from you—and do it when both of you are sober. If you don't want to be sober, don't be sexually intimate while you are intoxicated. And if you choose to combine sex with alcohol abuse, be aware of the significant risks you are taking. Not only are you more likely to engage in unsafe sexual practices with all the attendant risks of disease, you also run the risk of harming someone or of being harmed yourself. When intoxicated men and women are having sex, especially outside of long-term relationships, men run the risk of being too impaired to exercise good judgment, of being too impaired to interpret accurately the verbal and nonverbal cues that signal the

woman's desires, and of behaving in ways they wouldn't if they were sober. A man who has sex with an impaired woman runs the risk of being accused of abusing or raping her if she was too intoxicated to consent to the sexual activity. A woman who engages in sexual intimacy while intoxicated runs the risk of not being fully able to protect herself against unwanted pregnancy or sexually transmitted disease, or to fully communicate her desires or frustrations, or of being physically or mentally incapacitated if more sexual intimacy than she desires is being forced on her. She runs the risk of being raped. It wouldn't be her fault, but it's a risk she can minimize.

Besides taking care to protect themselves, students can also help protect their friends. Women can make agreements with their friends (male and female) to stick together at parties where large amounts of alcohol are consumed, asked to be warned to slow down if they are drinking too much. Men in particular can intervene with other men if they see that a woman's desires are not being respected, if they see a friend, teammate, or fraternity brother entering a situation where, because of a person's level of intoxication, the risks of harm are high. Men especially can make it clear that their circle of friends, teammates, or fraternity brothers will not condone behavior that is demeaning or potentially harmful to women. We all want to be liked, accepted, and respected by our friends. Peer pressure against sexual assault or abuse can be one of the most effective deterrents to its happening. It is important to be responsible for ourselves, but we also need to do a better job of taking care of one another.

Notes

1. I am very grateful to Mary Childers, director of Equal Opportunity and Affirmative Action at Dartmouth, and to Steve Blum, former undergraduate judicial affairs officer at Dartmouth, for their careful reading of an earlier draft and for their helpful comments and suggestions, including ideas and wording for specific sections in the essay.

2. In response to the realities of sexual relationships among students, we need to avoid presuming that the man's role is always to push for "yes," that the woman's role is to say "no," or that this is exclusively a heterosexual issue.

3. Dartmouth College Access Series brochure *Alcohol Use and Health Risks*.

4. Dartmouth College Access Series brochure *Alcohol Use and Health Risks*.

5. Dartmouth College Access Series brochure *Alcohol Use and Health Risks*.

6

"Frats Rape, Frats Rape": Rape Sanctioned by the Bonds of Brotherhood

Heather Wolfe

The summer of 1994 was not known for its terrific weather. The Belmont College campus was subdued, dampened by overcast skies. Fences and barriers blocked off the center of campus for construction. The sun came out when it had nothing better to do, but mostly left the clouds and humidity to rain on idle students.

One of the worst storms of the summer was the day I sat before the college judiciary board for my rape trial. I was raped in the spring by another student, a close acquaintance, in my dorm room. I passed out in my room one night, outrageously intoxicated. I woke up to pain and the sound of bed springs. I had been undressed, and somebody was on top of me, indulging in my body.

Three months later, I presented my case before a panel of professors, students, and administrators in a sterile administration conference room. The sounds of the storm were so deafening that we could hardly hear the case. Several times we had to pause in the proceedings and wait for the thunder to pass so we could hear the questions and responses. We had to pause to adjust the audio recorder because the sound of wind and rain drowned out our voices.

At the time, I couldn't help thinking that the storm was symbolic of some higher power passing judgment alongside the assistant dean of students. I wanted to believe that the powers of nature had coalesced and successfully lobbied that guilty, three-term suspension. In retrospect, I believe the storm portended the grim aftermath of a rape trial. It was a foreboding warning that my internal struggle with my rape was not enough. I was also to face public disclosure of my trial and rape, fraternity style.

I was raped early Sunday morning, April 26, 1992 in my room. The perpetrator was an acquaintance and friend of several months.

I met "Jim" in the beginning of winter term in a fraternity that we both went to regularly. Most of our socializing was in this fraternity and he has since pledged this house. I would see him frequently on the weekends and he never made any sexual advances toward me. I spoke of him often to my roommates and sang his praises as a rare and special person.

On Friday night, the night before the rape, I saw a side of Jim I previously did not know. We were both in his fraternity, both more or less sober. Three o'clock came and I decided to walk home with a friend. Jim joined us. My friend went off toward her dorm and Jim continued to walk with me. As we walked, he held my hand. I did not mind; I trusted him as a friend. We said goodnight outside my dorm, but he asked to come up to see my room. I was very tired and wanted to sleep, but he was strangely persistent. For the first time since I'd known him, Jim seemed to want to pursue a relationship beyond friendship. I wanted to avoid this, but agreed to let him in my room. If he brought up the subject, I could speak my mind.

He came in my room and almost immediately started kissing me. I thought a goodnight kiss was fine. I pulled away and told him I couldn't go any further and that I did not want a sexual relationship. He didn't seem to hear me. He kissed me again. I said no again. He blew this off, tried to convince me otherwise and pulled me into him. He heard nothing I said. I stopped, physically moved away from him and he followed and kissed me again and tried to pull up my shirt. When we were sitting on my bed he tried to push me to lie down. He started joking and taunting me, saying, "Oh, frats rape, frats rape." He mocked me. "What are you afraid of?" I repeatedly told him "no," and only when I stood up and forcefully said that he *had* to get out of my room did he oblige. My opinion of him changed. He seemed only to want to get me into bed. I felt his desire was natural, but his persistence offensive. I planned to write off the incident and my high opinion of him. "There's nothing special about him," I thought, "he's just your average frat boy."

On Saturday night, I went out with friends and got unbelievably drunk, by my standards or any other's. I'd been drinking quite heavily since the beginning of my freshman year. It seemed like everybody did. Those who say that drinking at Belmont is an unpressured, individual choice are dead wrong. Alcohol is everywhere and central to everything here. For freshmen like me, who wanted so badly to understand the new college environment, drinking came naturally. Alcohol is what I saw around every corner, alcohol is what I saw valued, so alcohol is what I turned to. I drank hard al-

cohol that Saturday night. I drank beer. So many beers that I could no longer count them. I passed over my ability to think rationally. I don't remember this, but friends told me the next day that I grabbed people's beers and finished them. I had anywhere from 13 to 17 drinks in me, perhaps more.

I told a friend that I wanted to go to a fraternity where I knew many of the brothers and usually end up on nights out. This was Jim's house, but I hadn't thought of seeing him. I wanted a change of environment and to see other friends. Because I was clearly too drunk to be left unchaperoned, a friend walked me over. I barely remember the walk. In the fraternity, I saw Jim but did not speak to him. He was on the other side of the room getting beers for brothers. My friend told me that I was only there about twenty minutes. Another friend, a brother in the house, saw me sitting by myself on a bench looking miserable and almost passed out. He came and spoke to me and decided that I needed to go home. I remember speaking with him, or rather at him, and walking home, but I don't remember anything I said. He held me up to help me walk a straight line. My memories flash back like insignificant scenes from a movie, which you remember seeing, but can't remember what happened. We got to my room, I took off my boots and passed out on my bed, fully clothed. My friend told me it was around four A.M. I didn't have the energy or coordination to do anything but sleep. I remember thinking as he left that I should get up and lock my door, *(lock the door, lock the door, lock the door)*, but I was weak, fading, intoxicated, and passed out before I could think of moving.

The next thing I heard was the creaking of bed springs. Somebody was crawling on my bed. I was deeply passed out and could not and did not want to respond. My memories fragment between blackouts and deep sleep. I remember sounds and a few vague images and feelings. A man kneeled above me, pulled off my pants and threw them over his shoulder. I remember somebody kissing me, or dreaming somebody was kissing me. In the deep sleep before waking up, external sounds and movements enter dreams. My body wanted to sleep and fought against waking. I did not speak and do not remember his voice. I heard the sound of glasses being placed on my desk, and the creaking of bedsprings *(bedsprings, bedsprings, bedsprings)*.

I remember sex blending into sleep. It was neither a dream nor a nightmare—I didn't have the strength or capability to discern between the two. Sex blended into my dreams, and I was unable to approve or disapprove.

I felt jabbing pains and only then did I begin to register what was occurring. I screamed or gasped in pain. He kept going and hurt me again. I

gasped again and began to feel sick. My room was black and I couldn't see the face of the person on top of me. I began to push against his chest, to somehow try to push him off me. I was disoriented, intoxicated, and unco-ordinated. Everything was dark, blurry, drunk. I began sobbing. I wanted to scream, but my mouth was not listening to my brain. I felt my world slip beyond my control, it was moving too fast and I was sucked in, way over my head. I continued pushing against him helplessly, both my hands against his chest, and sobbed, "no, no, no." When he got off me, I rolled over and pretended to be passed out. I did not have the energy or orienta-tion to confront him. I was afraid and wanted him to leave. He didn't say anything. I just heard the rustle of him getting dressed. He came over and asked "Are you okay? Are you okay?" Then the door shut and I was alone. I lay in my bed for a while, crying. Crying didn't sober me up at all, but I became conscious of my actions. I was still unbelievably drunk. I got up and put on clothes. I turned on my light and locked my door. The clock said six A.M. I sat on my bed and drank water, realizing, "This is rape." This is rape. *This is rape. This is rape.*

I didn't know if he'd used a condom or not and I was afraid of preg-nancy. I went to the hospital for a full rape exam the next day. They checked me out physically and allowed me to talk to the police. I filed a re-port against Jim that day. They asked me if I had any signs of physical in-jury or abuse. Any blood, scratches, *bruises*? "No," I thought. "Are you crazy? He didn't beat me. There was no resistance. He came in, played with my body as he pleased, and left. It was all very neat and clean." The bruises are not on my body. I'm bruised in a place only I can see, I thought. Rape is a physical, sexual assault, but nobody can see what I feel on the in-side. I understand that now.

Jim called that evening, business as usual. He asked me out to dinner. He seemed to have no idea that he had committed a crime. I told him I did not want to speak to him or see him. Bewildered, he did not understand my temper. He said he wanted to talk about what happened between us. I said I would obtain a restraining order against him if he came near me.

I couldn't sleep in my own room for several days. I stayed with friends. The sound of my bedsprings haunted me. I woke up afraid when I rolled over and heard the creak. I dreamed about people outside on my fire es-cape. I woke up feeling watched and powerless, like somebody else was controlling me. When I stayed with a friend, I had vivid nightmares about swarms of people I knew invading the room where we slept—I didn't want them there but couldn't speak to make them leave. I slept for a week with

the lights on. Not until I switched around my furniture could I sleep in my room. I threw up for two days as a reaction to the medications given by the hospital. My grades, my schoolwork, and my life fell crashing to the floor like beads of a necklace with a broken cord.

When the sentence of a three-term suspension was handed down to Jim, I felt the bell jar of burden, tension, and pain lifting. I breathed freely again knowing that the confusion, the contemplation, and preparation could be released now that some "justice" had been served. For four months, I tried to reorganize and reconstruct my life. My body and person had been stripped to nothing. When control over the body is violated, any sense of self dissolves. My faith in people disappeared like smoke. For four months, I tried to come to terms with my dislocation. I could not connect with people. I could not cross the screen between my life and everything around me. My pain was internal and no matter who wanted to help, they could not understand. Every time I tried to tell somebody—my parents, my sister, my friends—every time I looked for help, I realized I was isolated. They could sympathize, but could not *know*.

I tried to maintain a grasp on what my life had been like before the rape. I stopped drinking, but continued to go to fraternities and clung to my friends as best I could. I had formally pressed college charges against Jim. My decision was difficult but correct. I never thought anyone would doubt me. I did not, however, think like many brothers in this fraternity.

We sat in the conference room during the trial, listening to the storm, listening to testimony and interrogation.

A professor on the committee asked Jim, "Was there consent?"

"I thought so," he said.

"Was there verbal consent?" the professor continued.

"Well, not really entirely. It just seemed like everything was okay," Jim responded.

"So there was no verbal consent. Didn't you think to ask if 'everything was okay'? You asked her twice after you had sex. Why not before?"

"I just thought everything was okay. I guess I just didn't think about it at the time. I just wasn't thinking," said Jim.

He just wasn't thinking.

The night the sentence was handed down, I stopped by his fraternity. I didn't hold anything against the house. Taking Jim before the Judiciary Board was my action against an individual. I felt no hostility toward the

collective fraternity. Then a brother I knew came and touched my arm. "I have to talk to you."

He didn't have to say a thing. I knew what was to come and I knew what had been said already. The news of their brother's suspension had gone public. I looked around and saw brothers in various corners looking at me askance, serious and defiant. I had been labeled "evil." I was given an apologetic, yet insensitive, warning by my friend that I should leave. "People probably won't be too nice to you," he said. I relayed the story to a woman with whom I came. As we spoke, a member of the house I did not know appeared next to me, arms crossed, and angrily and impatiently demanded, "Don't you think you'd better leave?" I explained I was speaking to my friend. "Well you can speak to her *outside*," he said, and left. So did we.

Since that incident, there have been rumors, confusion, mixed stories, apologies, attempts at reconciliation. A public apology was issued from the house, strongly against the actions of the several brothers who asked me to leave. For this, the community of Belmont College should be grateful. However, the effects of what happened that night can never be changed, even by truckloads of apologies. No matter how irrational the response of the brothers is now admitted to have been, the fact that it *happened at all* scarred me as a sad testament to what Belmont has become.

My one mistake in the affair was not locking my door to my single the night of the rape. The night I was thrown out of the fraternity as well, I knew exactly where mistakes were being made—within a group of irrational fraternity brothers who were backing up a rapist simply because he was a *brother*. Few rapists will openly admit their crimes, so when Jim denied his guilt before several of his brethren, his word was taken as the gospel truth, with no consideration of the facts. What facts? Facts that convinced the college judiciary board to hand down a three-term suspension. These brothers accused the board of being a faulty and laughable method of justice. They may be right. Had they looked further at my case, they would have found that the police were all but foaming at the mouth to have me bring formal charges to a state court. I didn't have the strength to go through this process, but town detectives were slapping each other's backs at the station for finally getting a case that could successfully be argued in a state court. *The facts were that clear.*

But nobody else chose to look that deep. I was socially condemned because the brothers preferred to shut their eyes rather than take a good solid look at one of their golden own, who had been punished for *raping a woman*. There was no thought, just gut response to the threat I posed to

their stability. They did not think about their responses to a rape victim, just as Jim had not thought about the rape. They just weren't thinking.

I knew from the outset of that first glare across a fraternity basement that I was up against a fundamentally flawed wall. I felt vindicated that I had turned in a rapist but all I felt in response was palpable animosity from every direction I turned. My trial was between me and another individual. However, I soon discovered that by accusing an individual so tightly connected with a collective group, I was perceived as attacking both the fraternity and the Greek system. One student, in a different fraternity, that I considered a close friend, responded to news of the sentence by asking a friend, "Did you hear what Heather *did*? She got some guy kicked out for *three terms* . . ." with no concern for what had actually happened to me. It became my fault that he was punished. There was unmistakable fear in his response. Fear that now a face is attached to that nebulous twenty percent increase in reported sexual assaults at Belmont last year. Fear that I was one of four cases reported to the town police. Fear that they knew of a similar scenario, one that went unreported, and fear of the threat I posed to their fraternity brothers by exposing their crime.

It is very real to me that the ties of brotherhood (politely called "camaraderie") transcend even the basest levels of human respect. When I experienced institutional backlash, I realized what the frat system is all about. The fraternity basement is a place to go where brothers do not have to think. The brothers do not have to think about consequences for their actions because of the contrived support of the system. The system legitimizes their violence by fostering group-think. The excessive drinking, the forced drinking, the iron-clad bonds of brotherhood erase the necessity for individual thought, and the capability to accept individual responsibility.

From my perspective, by asking me to leave, the fraternity had provoked an all-out war against me, my friends, and the women of Belmont. How can I now love a school so dominated by a system that has publicly condoned such a violation against me? Sure, the college justice system stepped in, but whose finger is on the pulse of Belmont's character? The Judiciary Board or the Greek system? How can I fully appreciate all that the school has given me, when an institution supported by the school strips me of my privacy? How can any woman feel anything but alienation from a system that so inhibits thought and ignores reality? How can I feel a part of a community when my speaking out against a student is so mortally threatening to a brotherhood and its "security"?

I no longer see any value to Belmont's social environment. The Greek system, the weekends of colossal drinking, the fraternities that pride them-

selves as the last "bastions of maleness," can only be legitimized by traditional blindness alone. When I first arrived at Belmont I latched onto anything I could learn about these traditions. I found the newness of college fascinating. I accepted the social hegemony and overlooked the negatives. On April 26, 1992, the negatives of Belmont's social life ceased to be a mindless tradition and became acutely and painfully real.

A few individuals took personal interest in me and my case. They came to me like guardian angels and extended concern. Against the animosity I felt from the Greek social environment, the sincerity and friendship of a few professors and administrators was so unexpected that they jump-started my recovery process. Their wholly unsolicited interest in my well-being saved me from cynical oblivion. By recognizing my physically obvious depression and responding to it, they gave me a glimpse of faith that I thought I had lost and helped me take my first infant step back from isolation. In retrospect, I realize that these very personal encounters taught me more in a few conversations than in two years of trying to find a place within the contrived, impersonal Greek social system.

I left the college for six months after these events and spent much of this time at home. I had to rest. Everything at school reminded me of events I did not want to believe. While I was home, I held my parents at a distance and they complied. I did not want to talk or think about the rape. For four months, they had listened and offered advice over the telephone. They originally wanted to fly out from California, but I asked them not to. I wanted them to know, but that was all. I knew that they had to struggle with their daughter's rape on terms that I could not understand, but I couldn't help. I wanted to leave my rape behind. I could not make the rape go away—it had become part of my history—but I wanted the exhaustion, the weight, the pain to leave. I went home to escape. I wanted my strength back.

Escaping gave me what I needed. The environment outside of an isolated college reopened my eyes. I met people who did not know me, did not know the Greek system, did not need to drink themselves into incompetence to be accepted. By removing myself, I gained perspective on the events that had been shoved down my throat at school. At college, I assumed that what I saw around me was the way everybody behaved. Outside of school, I realized that people are arrested and thrown in jail for public drunkenness, drinking and driving, sexual assault, hazing.

I thought about transferring schools, but my terms away gave me new perspective. By identifying the wrongs that I observed on campus, I redefined my personal "rights." I always knew I was right by speaking out

against a rapist, but by reaffirming my perspective in the world outside of college, my strength returned.

To see the writing on this paper, the ink on this page, is a sigh of relief for me. I want people to hear this story. I *need* people to hear my story. The more I tell it, the further I distance the "experience" from myself. It becomes more my *story* and less my *rape*. k. d. lang sings "I've been outside myself for so long, any feeling I had is close to gone." Within the college social system, I tried to find a new self by fitting into the social institutions around me. When I was raped, my "self" disappeared and I was reduced to an object. Anything resembling "me" was nullified and I became a shell of a person, numb to those around me. Not until I regained and redefined my perspective, my personal worth, and my sense of self could I find value in anything around me. Before I left school, I was scared, exhausted, and very sad. By the time I returned I was no longer a victim. I had been reaffirmed outside of the abysmal college social system.

I was angry and I knew I could fight.

7

When Rapists Brag

Brenda Niel

On a warm spring night in California seven friends and I prepared ourselves for a girls' night in. We considered ourselves fortunate that Debbie's parents were away, out of the country this time. We had grown accustomed to weekends spent sneaking liquor from her parents' liquor cabinet, and the plan was the same for this night. We were sophomores in high school, and relatively inexperienced drinkers. Because we did not know any better, we consumed large amounts of hard alcohol—vodka if we were lucky enough. We did not know that a glass of straight vodka is really equivalent to six or eight mixed drinks. This trial by fire often resulted in an unexpected, rather intense drunkenness, but since no one had to drive and there was no danger of Debbie's parents coming home, we drank with abandon. Since it was just us girls, we could be silly, vomiting drunks, and no one would care. Just about everyone drank at our high school, and we figured Debbie's house was a safe place to try it. We were not "bad kids"; we all did well in school and we were experimenting with alcohol, like most other sixteen year olds.

At some point that evening, the doorbell rang. Debbie's sister had bragged that their parents were gone, and now about fifty high school students were at the door with a keg, looking for a place to party. Debbie thought it best not to let them in, so we locked all the doors and turned out the lights. We were afraid that if we let them in, the party would get out of control, as most high school parties were broken up by the police. Kevin, the ringleader with the keg, was not easily deterred. He encouraged the growing number of students to simply occupy the backyard where he tapped the keg and began collecting money.

At that point, Debbie panicked. We reasoned that it was a safer bet to let them in; by containing the party inside, the noise was less likely to bother the neighbors, and attract the police. The party started. Already somewhat drunk, I began consuming beer along with everyone else.

The brain is a mysterious thing. I am sure that in trying to protect myself from the memory of being raped my brain has blurred my memory of it. I have vague, funny memories of colors and sounds, as well as static moments in time, but none of the whole picture. So now, seven years later, I can only tell you what little I remember.

Prior to the rape, I was drinking beer by the stereo in the family room. I remember thinking that the music was getting too loud. Debbie was my friend and I really did not want her to get into trouble, so I turned down the volume just a bit. The music was still too loud for my taste, so I left the family room and went into the quieter living room. The living room was dimly lit and there were a number of couples taking advantage of the low lighting to "get to know each other better." I was uncomfortable there as the only person alone in a room full of people kissing and petting. I did not want to go back to the family room because it was a loud, hot party, and I was drunk. I needed a place to sit down, maybe to lie down. I went to the back of the house by the bedrooms even though Debbie did not want us to go back there. It was empty, and while I needed some space, I decided I did not want to sit in a room by myself either. As I made my way back to the front of the house, I passed the bathroom, and there were a number of people in there, so I went in to see what was going on.

Some people had been pushed into the pool and wanted to dry their clothes and the washer/dryer was in the bathroom. I am totally unaware of how I came to find myself alone in that bathroom with Kevin. The next thing I remember is lying on the bathroom floor with my feet toward the door and Kevin on top of me, missionary style, fucking me. It is possible that we spoke before this happened, but I do not think I would have voluntarily kissed him because I was not attracted to him. There was no pain, his penis was small, and I was not a virgin. I distinctly remember that there were two bath mats on the floor and that I was lying on top of one, not on the cold linoleum, and for this I was thankful. The two bath mats are in my memory in photographic form; I can picture them exactly. Kevin's loyal friend Mike was guarding the door. Because I had been raped before, I was trapped and I knew it, so I tried to just get through it as quickly and painlessly as possible. I was consciously trying to make the experience more pleasurable for Kevin so he could quickly reach climax and I could get out the door. By this, I mean that I squeezed his butt. I just wanted it to be over.

When Kevin finished, and I thought I would be allowed to go, Mike came in to fuck me while Kevin guarded the door. I did not move from my position on the floor, and I did not know that Mike was coming until he closed the door. I simply felt resigned to getting the whole ordeal over.

Frankly, I do not think that I ever considered screaming or fighting as an option. Mike spoke only to Kevin. While he was having sex with me, Mike made a joke about how come he had to have the "sloppy seconds," and Kevin whispered through the door, "Hurry up, man, people need to go!" Kevin also asked, "What's taking so long?" I knew that I was nothing more than a receptacle when Mike talked with Kevin about how he was having a hard time ejaculating because he was so drunk. Finally Mike finished and left. He pushed the lock on the door so that I was alone in the locked bathroom, and could leave when I wanted. That way we did not come out of the room together. I cleaned the semen from my vagina and left the bathroom. I felt ashamed and thought that cheap sex would not be something to brag about, but Kevin and Mike did brag about getting laid. I left the party and sat outside for much of the night.

Within weeks, I became the slut of the school. Rumor had it that I had sex with nine guys that night. The real grudge was from Mike's "girlfriend" who thought it was her duty to tell the world what a slut I was. I lied to everyone. I said, "I can't believe you think I did that!" With my friends, I took the offensive and denied that *anything* happened at the party. I simply ignored everyone else. I avoided Kevin and Mike at all costs, but at a small high school of about 400 students, this proved to be an impossible task. The following Monday at lunch time, Kevin whispered a lewd comment into my ear which I do not quite remember. It was something to the effect of "I have a friend who wants to get laid." A year later in the gym, Kevin asked if he could sign my yearbook. I curtly replied, "I don't think so," and Kevin had the nerve to ask why I hated him so much. I answered, "I think you know." The look on his face told me that he did.

People argue about what rape is, and although I had been drinking, probably even flirting, I did not consent to sex with them. I did not fight them or scream; Kevin was on the football team and he was probably the biggest guy in our school. While there was no explicit violence, the implied violence was enough to scare me into submission. I did not want people to know that it happened. I did not immediately define my experience as rape. I knew I did not want to have sex in the bathroom with Kevin and Mike, but like many women, I wondered what *I* had done wrong. How convenient for rapists that most women go through a stage of shame and self-blame at least long enough for all the good physical evidence to be destroyed. I thought that rape was something that strangers did to you, and since I was not a virgin at the time, I classified this experience as "bad sex" that was forced upon an unwilling, but not violently struggling partner.

By asking myself simple questions, I began to understand this experi-

ence as rape. Did I want to have sex with them? No. If they had asked, would I have consented to have sex with them? No. Did I feel trapped? Yes. At that time, I thought rape always included a violent struggle, but now I know that my experience was in fact rape. I came to realize this as time went by, and I could not get the experience out of my mind. I know that sex is not always great, but the bored feeling I have sometimes during mediocre sex is nothing like the dread and disgust I experienced that night.

After the rape, I was afraid to go to school. I was so ashamed; people made comments to me in the halls about what a slut I was and asked me if I liked it and if I wanted it again. I implored my parents to let me transfer to boarding school, but they did not understand why, and I was too ashamed to tell them. I only told them that I was unhappy at school. It was not easy talking to my parents about sex; they were very religious and while they did teach me about birth control, it was clear that they would not have accepted my decision to have sex. At school, I was the butt of many jokes and I essentially dropped out, quitting my extra curricular activities, only attending classes. I dated outside of my high school, rarely attending school functions. I had my friends, but to this day I wonder why they were my friends. I was an outcast at a school with a very mean, vindictive, and brutal dynamic. I wondered if my friends worried about being cast out as well. I think my friends knew that the rumors were not true. I don't remember any of my friends speaking to me about the rumors or asking me if they were true, and always ashamed, I never wanted to talk about it.

Today when I bump into people from my high school, I still want to run. Our reunion is soon and I am afraid to go. I know what my old classmates think of me, and it bothers me. Not only because they are wrong, but also because I feel shame and guilt for the part I played in my rape. I know this is a controversial point, and I am torn between the belief that I did nothing to encourage or allow my rape and a more tempered approach about rape prevention. On the one hand, I think it is important to recognize that there is no justification for rape and rapists should accept responsibility for their crimes. On the other hand, I was not in the best shape to resist or make my wishes known or even to be aware that I was getting into a dangerous situation. I was at risk because I was drunk, but I did not put myself at risk because I did not know that all of those people were going to show up at Debbie's house. I think there must be a compromise that does not blame the rape victim but allows for women to strategize about being less vulnerable. Even though women should not be expected or required to alter

our behavior or clothes or routes or behavior, we are fools if we do not face the fact that we must, for our safety.

I also understand that people may question whether Kevin and Mike knew my wishes. After all, I was not kicking and screaming, and I even facilitated their orgasms. I recognize a legitimate concern for men who do not understand how they can know what a woman wants if she does not speak up. But if a man cannot engage in a simple conversation about sex, he probably shouldn't be having sex. There are so many forces working to silence women that when we get in sexual situations, speaking out is difficult, if not impossible. I needed the space to make my wishes known. Simply asking if I would like to have sex would have given me the freedom to say no. The silencing forces such as being trapped in a guarded bathroom and Kevin's size worked on me; I kept silent and still. I am sure that some readers will question my classification of this event as rape since I was trying to make it more pleasurable. I would be willing to bet that Kevin and Mike believe that they did not rape me.

When I reflect on the major events of my life, being raped is not one of the events that stands out, but the effects of the rape shape my personality. I always feel like I have something to prove: that I am not a slut, but a person worthy of being treated with respect. I want to be the best at everything I do to prove that my high school peers mislabeled me. I internalized that label, and I am sometimes ashamed and feel as though I do not deserve good things. Now I am working toward my Ph.D. at one of the top 10 schools in the country. Everyone thinks I really have my life together, but sometimes I think I am only doing all of this just so I can have the last laugh on all of the people who believed the lies years ago.

Being raped made me reconsider what I wanted from my sexual/romantic relationships. I went from being a flirtatious party girl to a woman wanting serious long-term relationships. While this was probably partially due to maturity on my part, I think I grew up fast after the rape. One year later I met the man who would become my husband. I was glad to get out of the dating scene, because I still harbored a fear of men, as well as a fear of becoming the slut people told me I was.

The rape has also left me with a need or desire to sometimes overpower men with my "desirability." Not my husband so much, but I love to watch men who think I'm attractive look at me. I am glad if they approach me because I feel once a man has hit on me, the power and control I lost during my rape are returned to me. To some extent I think all women must feel this. Street harassment, sexual harassment in the workplace, invasive

glances, and comments all take power from women dozens of times throughout the course of any given day. Given this social fact, attempts by women to recapture their stolen power are not surprising to me. I recognize that my behavior is not always appropriate, so I try not to indulge myself. Usually, I try to identify my real motives when I want to do this. Without exception, this behavior manifests when I feel out of control in some area of my life, such as my studies or my relationships.

What I wonder about the most is if Kevin and Mike perceive that what they did to me was, in fact, rape. Not in any legal, could-I-prove-it-to-a-jury sense, but did they know that I did not want to be having sex with them? When I ask myself this question, and I ask it regularly, I always consider their need to guard the door. People do not usually guard the door if two people are in a locked room engaging in consenting sex.

8

Revising Rape Law: From Property to People

Jessica Oppenheim

Jessica Oppenheim is an attorney for the State of New Jersey, Division of Criminal Justice.

Society is obligated to define what constitutes criminal behavior. The decisions we make as a society are taken by legislators and made into the laws which govern our actions. The courts, then, must interpret the goals of the law, so that behaviors society wants to punish are, in fact, punished. Over time, our concept of what constitutes criminal activity changes, and the law must be changed or interpreted to fit the new social mores of the time.

So it has been over the centuries with the crime of rape, or criminal sexual assault. As our ideas of what acceptable and unacceptable sexual behavior is change, rape laws and our interpretation of them change too.

The 1970s saw the women's movement flower, and with that newfound strength of purpose came a clamor to reform centuries-old rape laws which were based primarily on the ideas of women as chattel, or property, and on very rigid concepts of social propriety. The worth of a woman was identified by her virtue, purity, and chastity, and these valued characteristics formed the basis of rape law. As the concept of a woman as the property of her husband or father changed, the laws reflecting that needed to be changed as well.

In New Jersey, the laws pertaining to sexual assault remained virtually unchanged from the Elizabethan statute enacted in 1576 and brought to this country from England. Rape law was not gender neutral, assuming that the victim was always a woman and the perpetrator was always a man. Furthermore, the State was required to prove that there had been "carnal knowledge," forcibly, against a woman's will, in order to prove the crime of rape. Those three elements—carnal knowledge, use of force, and affir-

mative proof that the act was against a woman's will—remained the requirements for a rape conviction in New Jersey until 1978.[1]

Under such laws, women testified against men in a criminal prosecution at their own peril. The courts perpetuated the well-entrenched myth that women in rape cases were suspect witnesses, prone to use a cry of rape as a weapon against men, to say "no" when they meant "yes," or to cover up consensual intercourse. The famous nineteenth-century jurist Lord Matthew Hale wrote that a woman must be of "good fame," suffer signs of injury, disclose the assault immediately, and "cry out for help" in order to be believed.[2]

The perpetuation of these myths reinforced the concept that women bearing witness against men in the aftermath of a rape lacked credibility. The solution to the credibility problem was the requirement that a woman resist the assault to the utmost of her ability. "If sexual intercourse is obtained by milder means, or with the consent or silent submission of the female, it cannot constitute the crime of rape."[3] A woman, then, was required to place herself in serious physical jeopardy, for without actual signs of struggle, her claim of rape would be discounted.

Feminists and other critics of the law attacked this "resistance requirement," which required a woman to risk physical injury or death to be considered a credible witness in a rape trial. In order to combat the myth that no crime occurred unless the victim fought back, researchers provided empirical data which demonstrated that women who resisted forcible sexual advances often suffered far more serious injuries as a result of their struggles.[4]

Requiring resistance underscores the misconstruing of sexual assault as an act of sex, rather than a crime in which the actor is seeking to control or violate the victim. Rape had its origins in laws designed to protect the property rights of men to their wives and daughters.[5] In that context, a woman was entitled to the protection of the law only where she had fought to protect her chastity. By misconstruing the act of rape as a form of sex instead of a crime of violence and control, the courts looked to a woman's behavior to gauge the evidence of the crime. If a victim had acted in an "enticing" manner or placed herself in a compromising position, the law would not protect her from the consequences; conversely, the perpetrator would not be subject to punishment, since, after all, he had been drawn into the act by her enticement.

That rape was seen as sexual activity—and not like any other assault against the person—is demonstrated by the failure of the old law to protect a woman testifying in a rape trial from attacks on her prior, unrelated sex-

ual activity or on her "reputation." A criminal rape trial often turned into a trial judging the woman's chastity and character. Nothing prevented the airing in open court of any prior sexual activity on the part of the victim, or of any perceived sexual activity.[6] A woman who had consented to sex once was not entitled to say "no" ever again. Victims of rape would not be protected if the system perceived them as anything but virtuous.

After lengthy debate, a bill was passed which changed the New Jersey rape law. After a number of reform statutes failed, a coalition of feminist groups finally created a successful draft with the assistance of the National Organization of Women National Task Force on Rape. The NOW bill, which was adopted virtually unamended, was modeled after the 1976 Center for Rape Concern Model Sex Offense Statute.[7] In hindsight, it is difficult to imagine the impressive grassroots organization and political savvy required to pass a law which was at the time controversial, signaling a marked departure from years of prior law.

On a superficial level, the statute reflects a change in thinking by drafting the crimes in gender neutral language. The word "rape" has been abandoned, replaced by the less visceral phrase "criminal sexual assault." In addressing other outdated beliefs, the drafters eliminated the "spousal exception," which had precluded a husband from being charged with the assault of his wife in circumstances where intercourse or sexual touching were accomplished without consent. Also, in a victory for victims' rights, the statute precluded the introduction at trial of any evidence pertaining to the victim's prior sexual experiences, thus providing real protection for a victim's privacy.

Further, the "resistance requirement," which had so long focused the courts on the behavior of the victim, was eliminated by removing the phrase "against her will," which made resistance by the victim an element of the crime. A separate section of the statute was passed as well which specifically precluded the need for evidence of resistance by the victim against the actions of the assaulter.

This massive restructuring of the law clearly intended to move away from a focus on the victim's actions, focusing instead on conviction based on the actions of the assaulter.[8] The purpose of the statute is to severely penalize a defendant for the coerced submission of another into unwanted sexual intercourse. The statute also punishes an actor for types of sexual contact other than sexual penetration. Of utmost importance in the prosecution of a criminal sexual assault is that the emphasis for determining whether the act is criminal is placed squarely on the assaulter, not on the response of the victim.

In crimes other than sexual assault, it is given that whether or not the act is criminal will be determined by the actions of the perpetrator. *Only* in the area of sexual assault was a centuries-old judgment made that placed the responsibility of this crime with the victim, not the perpetrator. The new statute remedies myths which limit criminal prosecution for sexual assault.

Interestingly, the New Jersey statute did not include a definition for "physical force." The drafters did not want a definition which might narrow the use of the statute. Instead, they left the courts to determine their own definition of "physical force" based on the facts of each case.

The changes which took place in New Jersey law were mirrored throughout the country. These changes were tested in 1992 when the New Jersey Supreme Court was faced with a criminal case involving a crime known as "date rape."

In a small town in southern New Jersey, a juvenile delinquency complaint was filed against M.T.S.[9] for second-degree sexual assault.[10] Because M.T.S. was 17 years old and a juvenile at the time the crime was committed, there was no jury; M.T.S. was tried before a judge. The basis for the complaint was an assault which occurred upon 15-year-old C.G. by M.T.S.

C.G. was living with her mother, her three siblings, and a number of other people. M.T.S. was also living in the house (temporarily, due to an arrangement between the mothers), as was his girlfriend. C.G. and M.T.S. had developed what C.G. believed to be a friendly, flirtatious relationship in which M.T.S. would jokingly say that he would surprise her with a nocturnal visit to her bedroom. C.G. did not take his comments seriously.

One night, C.G. went to bed, wearing shorts and a shirt. She woke up at 1:30 to use the bathroom, and, as she did so, she saw M.T.S. standing in her doorway. Coming back from the bathroom, she went past him and got back into bed. M.T.S. got into bed with her and they began to kiss. He then penetrated her vagina with his penis without her consent. C.G. hit M.T.S. and pushed him away. Scared and in shock, C.G. did not scream when he penetrated her. After he left her bedroom, she cried herself to sleep.

The next morning, C.G. got up early and went to her mother; she told her what had happened. C.G.'s mother called the police.

M.T.S. told a version at trial which was not all that different from C.G.'s story. He stated that their relationship was "leading on to more and more." He testified that they had had petting sessions and had discussed having sexual intercourse. He stated that the visit to her room during the night had

been C.G.'s idea. He further testified that he got into C.G.'s bed, they undressed each other and continued to kiss; that M.T.S. got on top of C.G. and penetrated her with his penis three times. He then testified that at that point she pushed him off her and slapped him. She said he had taken advantage of her and began to cry. M.T.S. then told C.G. "I'm leaving . . . I'm going with my real girlfriend . . . I don't want nothing to do with you . . . don't tell anybody about this . . . it would just screw everything up."[11]

The trial, held before a superior court judge, lasted for two days and resulted in a finding of delinquency on the charge of second-degree sexual assault.[12] The delinquency adjudication was reversed by the appellate court. The court determined that the crime required "physical force," despite the finding of the lower court that C.G. had not consented to sexual penetration. The court went on to say that the crime requires some physical force over and above that needed for sexual penetration unless there is a "definite expressed refusal" on the part of the victim and the penetration overcomes that expressed refusal.

By deciding the case this way, the appellate court looked to the victim's behavior to gauge the criminality of the defendant's act. This is precisely what the drafters of the statute hoped to avoid. In light of the appellate court's decision, the case was appealed to the New Jersey Supreme Court.

After lengthy decision, the supreme court reinstated the finding of delinquency. The court was clearly cognizant of the difficulty of the task.

> The issues in this case are perplexing and controversial. We must explain the role of force in the contemporary crime of sexual assault and then define its essential features. We then must consider what evidence is probative to establish the commission of a sexual assault. The factual circumstances of this case expose the complexity and sensitivity of those issues and underscore the analytic difficulty of those seemingly-straightforward legal questions.

In reaching its decision, the court looked to the purpose behind the abandonment of the old law and the intent of the new legislation. The court noted that "with regard to force, rape law reform sought to give independent significance to the forceful or assaultive conduct of the defendant and to avoid a definition of force that depended on the reaction of the victim." By reviewing the history of the law of rape and the evolution of the reform law, the court sought to settle upon a definition of physical force which properly reflected the goals of the law and delineated for the public the be-

havior which would not be tolerated and which would result in punishment as a crime.

The Court emphasized that what the legislature sought to punish was sexual contact which results in either a physical injury or an offensive touching. In other words, any unauthorized touching or penetration is prohibited and subject to criminal prosecution. The court held that "any act of sexual penetration engaged in by the defendant without the affirmative and freely-given permission of the victim to the specific act of penetration constitutes the offense of sexual assault." In determining whether that permission had been given, the court understood that the facts in each case would have to be reviewed carefully.

In reviewing the facts of this case, as appellate courts must do, the supreme court looked to the trial judge's findings. The trial judge had determined that the act of penetration had occurred without C.G.'s consent—in other words, a crime had been committed.

It has been argued that this decision requires the use of consent forms, requiring a defendant to produce the signature of the victim on a document to prove that he or she had in fact consented. Of course, permission to the contact or penetration can be inferred from the surrounding facts. The court argued that

> insight into rape as an assaultive crime is consistent with our evolving understanding of the wrong inherent in forced sexual intimacy. It is one that was appreciated by the Legislature when it reformed the rape laws, reflecting an emerging awareness that the definition of rape should correspond fully with the experiences and perspectives of rape victims. Although reformers focused primarily on the problems associated with convicting defendants accused of violent rape, the recognition that forced sexual intercourse often takes place between persons who know each other and often involved little or no violence comports with the understanding of the sexual assault law that was embraced by the Legislature. Any other interpretation of the law, particularly one that defined force in relation to the resistance or protest of the victim, would directly undermine the goals sought to be achieved by this reform.

The evolution of the law of criminal sexual assault in New Jersey demonstrates the changes the legal system must incorporate for criminal penalties to reflect the social mores of the times. Such evolution culminates in the courts, which have the task of interpreting the law in accordance with the lawmakers' intent.

In the case of criminal sexual assault, and, more particularly, assaults

which fall under the aegis of "date" or "acquaintance" rape, the necessary change was brought about by the social movement of the time. The work of feminists culminated in sweeping change which has allowed the recognition of a type of physical assault once left unpunished. Every state made some change to the sexual assault statute which had been in place, though not all states incorporated the degree of change found in the New Jersey statute. Also, not all states have reached the same decision as the New Jersey Supreme Court. In May of 1994, the Pennsylvania Supreme Court reached the *opposite* conclusion in a date rape case, reversing the rape conviction[13] and holding that where there is a lack of consent, but no evidence of physical force, no crime has occurred.

The difference in these decisions demonstrates the fluidity of the law. Different judges sitting in different locations reviewing different facts will draw opposing conclusions. Nonetheless, the law itself, drafted by legislatures with the input of political and social groups, will, over time, reflect the social mores of the populace. The changes made to sexual assault law reflect this conclusion: a victim of a sexual assault can now testify in open court and have that testimony weighed for its truthfulness and credibility like any other witness. The decision as to whether a crime has been committed will be made where it should be—by a jury or judge.

Notes

1. Leigh Beinen, Rape III—*National Developments in Rape Reform Legislation*, 6 *Women's Rights Law Reporter* 170, 207 (1981).

2. Matthew Hale, *History of the Pleas of the Crown* 633 (1st ed. 1847).

3. *State* v. *Brown*, 83A. 1083, 1084 (O.T. 1912).

4. *Elimination of the Resistance Requirement and Other Rape Law Reforms: The New York Experience*, 47 Albany L. Rev. 871, 872 (1983).

5. Susan Brownmiller, *Against Our Will: Men, Women and Rape* at page 377 (1975).

6. Every State now has some form of protection against the unfettered use of prior sexual conduct by the defense to impeach the credibility of a victim testifying in court.

7. Beinen, *Rape III—National Developments in Rape Reform Legislation, 6 Women's Rights Law Reporter* 170, 207 (Spring 1980).

8. *Forcible Rape: An Analysis of Legal Issues,* National Institute of Law Enforcement and Criminal Justice, March 1978, p. 5–6.

9. In cases where the criminal defendant is a juvenile, under the age of 18, the

Courts always use initials to identify the defendant, in order to protect the privacy of the juvenile. Initials are also used for juvenile victims, for the same reason.

10. In New Jersey, descriptions of all crimes and potential punishments are compiled in a Penal Code. The section which describes the crime of sexual assault is divided into two levels of seriousness—aggravated sexual assault, in which the perpetrator uses a weapon or inflicts serious physical injury, and sexual assault, in which there is no serious injury or use of a weapon. Aggravated sexual assault is a first-degree crime, which means that is is punishable by a term of imprisonment between ten and twenty years. Sexual assault is a second-degree crime, punishable by a sentence of imprisonment between five and ten years.

11. *State of New Jersey In The Interest of M.T.S.*, 129 N.J. 422 (1992).

12. In criminal cases where the defendant is an adult, the jury or judge reaches a verdict of guilty or not guilty. When the defendant is a juvenile, the judge finds the defendant to be a delinquent or not.

13. *Commonwealth of PA* v. *Berkowitz, A.* 2d—(PA 1994).

9

"Choo-choo!": Surviving a Frat Train

Sara Pasqualoni

"Sara, I found out what happened to you Thursday night," my friend Karen said.

It was Sunday night, and Karen was trying to get my attention as I unpacked from my weekend away. We were freshmen in college then, and had gone to a Pike fraternity party together that Thursday night. Neither of us had very clear memories of the night's events.

It started with a drink in my dorm room while we were getting ready to go out. Once at the party, we both took a prefilled beer cup from the bar because the line for the keg was too long. I felt pretty buzzed after that beer, but simply attributed my buzz to drinking it too fast. Later, when people who were at the party that night described my behavior, I became suspicious that my beer had been spiked. My friends actually stated that I was acting "drugged out." According to them, I spent most of the night propped against a wall, staring at the floor, and not speaking with anyone. One of my friends could not even get a yes or no answer out of me without shaking me to attention. Unfortunately, despite the suspicious nature of my behavior that night, I will never know what exactly was in that beer.

The next thing I remember clearly is waking up in my room, still in my clothes from the night before, and with a very heavy head. I went for a long hot shower, not quite yet awake or really aware of my lack of memory from the night before. When I returned to my room, dressed only in my bathrobe, I found two men, smiling smugly, sitting on my bed. They were SAE brothers who lived on my hall. Still feeling somewhat foggy from the night before, I tried to cover myself as best I could and asked them what they were doing in my room. They explained that they just wanted to apologize for "last night." It was then that I realized that I really had no memories of the night before. I asked them what they were apologizing for, and

93

they said that "things happened last night that should not have happened." Before I had a chance to gather my thoughts, they left the room.

I remained in my room, rather dumbfounded, for a few minutes and then went across the hall to see if Karen could tell me anything about the night before. Unfortunately she could not, and I became nervous as she explained to me that she also had no memory of the previous night, and that she woke up that morning in the hallway of the fraternity, with her bra in her hand. I tried to console her, thinking that she must be very upset about this. She was in denial of what had probably happened to her, however, and just wanted me to leave so that she could go to bed.

I spent the rest of that morning mulling over what could have happened, anxiously searching for memories that just were not there. The less I could remember, the more those men's words began to turn my stomach: "things happened last night that should not have happened." I tried to comfort myself, to convince myself that it could not be anything serious, but I had a terribly bad feeling about it all. I decided to go away for the weekend with my friend, Michele, to help clear my head. Looking back now, I believe that I just wanted as much physical and emotional distance as possible between myself and those men.

"Sara, I know what happened to you Thursday night," Karen repeated, jerking me back to the present. She paused when I did not respond. "Sara, it's bad."

I did not want to know what happened. If I never found out, I would never have to deal with it. However, I knew deep in my heart that eventually I would have to face that night, and I *would* have to deal with it. I nodded to Karen in silence and dropped my stare to the floor. I could not bear to look at her while she delivered the upcoming blow.

Karen took a long, telling breath. "You were acting crazy at the party, drugged out. You could barely hold yourself up, and you would not talk to anyone. You walked back from the party alone. One of the SAE brothers on the hall saw you come onto the floor, and he took you to his room. Then he got two of his fraternity brothers who also live on the floor, and brought them to his room. Seeing the condition that you were in, they figured it was their 'lucky night.' One would mess around with you, one would watch, and the third would stand guard at the door. Once one was done with you, they would switch. Sara, you had sex with two fraternity brothers, and seriously messed around with the third."

I continued to stare long and hard at the floor in front of me, in total disbelief of what I had just heard. I cannot justly describe the feelings that swept through me upon hearing that news. My hands were trembling, my

ears were ringing, my head was spinning, and my stomach was churning. I felt like everything that had ever meant anything to me—my sense of self, my belief in a just world, and my trust in others—had just been taken from me, never to be returned. I began to sob, but Karen continued.

"Laura and Rachel [two women who also lived on our floor] went to the fraternity brother's room that night, and the one standing guard told them to go away because there was 'bad shit' going on in the room. Laura and Rachel were concerned, and asked John [the resident assistant] to check out the situation. Unaware of what was really going on in the room, John then told the three men to get rid of 'whatever problems they had to.' You stumbled out of the room and down the hall. Once you were gone, the fraternity brothers began parading up and down the hall, chanting about the 'train' they had had going on with you."

My sobs became stronger, more painful. The story continued.

"John then told the men that what they did could be considered rape, and that they should apologize to you before everything got 'out of hand.'" Karen paused and looked at me, probably searching for some kind of response, some sign of whether or not she should go on.

All I could think of was that word, rape. Rape was something that happened between strangers, in the dark, with the threat of physical violence. Surely I was not raped!

Karen continued, "One of the men supposedly went to apologize to you that night. Instead he had sex with you again in the stairwell." She paused for a long time and looked at me. "That's it. Are you okay?"

Okay? The one thing that I knew at that point in time was that I was not okay. Rape. The word kept ringing in my ears, playing with me, taunting me. I tried to run from it, hide from it. It was my fault. I took the beer. I let them do it. Maybe I did not even say no. I felt cheap, worthless and humiliated, like it was my fault. It was much easier for me to blame myself for what had happened than to admit to an unjust and cruel world. A world that could blindly strip people of all that meant anything to them. A world that could rape. A world that raped *me*.

Karen touched my shoulder in support. I withdrew and curled up in a tight ball, my position of safety. "I need help," I said. I wanted to talk to John and find out if Karen's story was really true, to find out if all this had indeed really happened. What I really wanted was for someone to wake me up and tell me that this was all just a dream, a very bad dream.

Karen got John, and he brought a female resident assistant, Jenn, with him. I could sense that John felt uncomfortable with this situation, almost as if he was betraying his friends (the SAE brothers), but he confirmed

Karen's story in as compassionate a manner as possible. After hearing the story, Jenn then tried to explain to me why what happened to me was rape. I remember fragments of her explanation, but I could not comprehend it. Words such as violation, intoxication, and consent went in one ear, and out the other. I felt as if my mind was trying to pull away from my feelings so that I could understand what Jenn was trying to say to me, but it could not. I was tired and overwhelmed. I just wanted to run away, to escape the confusion and the pain I was experiencing. But I could not. Instead, I curled up even tighter into my little ball of safety, withdrawing into my new world of suffering.

At that point I felt as if things could not get any worse than this. I was wrong. Jenn proceeded to tell me that because of what had happened to me I may have contracted a venereal disease, or be pregnant. She thought I should go to the college infirmary to be examined, and treated if necessary. I agreed and Jenn called campus security to escort me to the infirmary.

At the infirmary I was asked to tell my story to a rape crisis counselor, then a campus security officer, then a physician. Although all were empathetic, I was tired and overwhelmed, and each time I told the story I felt as if I lost small parts of me, parts that I would never recover. After relaying my story to these people, I was told that the rape protocol next called for the collection of evidence. Despite the nature of what had happened to me, I had to expose my body to a stranger, the physician, so that she could look for and document any evidence of physical harm. Samples were also taken from my fingernails and my vaginal area looking for skin, semen, and other signs of physical struggle. In fact, the whole protocol for evidence collection seemed centered around the search for signs of physical struggle. No blood tests were done to look for drug levels. There was no documentation of signs of psychological damage consistent with being raped. No consideration was given to explaining or documenting my state of mind and my ability to consent that Thursday night. The final aspect of my examination was the pelvic exam, and the tests for sexually transmitted diseases and for pregnancy. I was also given the morning-after pill, just in case I was pregnant. Little conversation was exchanged between myself and the doctor. She was very good, and explained when and why she was doing what she did. But I just wanted to close my eyes and drift away. I was confused. Too much information. Rape. Sexually transmitted diseases. AIDS. Pregnancy. What was next?

"Sara, we would like you to press charges against these men." I opened my eyes. I was still in my johnny on the exam table, but a tall security officer had taken the place of my doctor. I pulled the flimsy sheet up to my

chin, embarrassed and frustrated that yet another stranger had seen me practically undressed. "What those men did to you was wrong. We would like you to press charges against them so that this does not happen again," he said.

I closed my eyes again. Press charges? I did not even believe that what had happened was really rape. It was my fault. I was stupid. I was bombed. I was easy. How could I hold them accountable? How could I really call it rape? I could change my behavior. I could not change theirs. Words began to run into each other in my mind. I could not think about it any longer. I told the security officer that I could not make a decision just then. However, John, Laura, Rachel, the three SAE brothers, and other witnesses who had been out in the dorm hallway that Thursday night were brought in for questioning anyway—just in case.

I remember the next week best as varying shades of pain. I withdrew into the only world that I knew to be safe, my own. I skipped classes and stayed in Karen's and Michele's room because I could not stay in mine. I felt as if it had been contaminated by the two SAE brothers who had been there, sitting on my bed without a worry in the world. Also, my roommate practically never slept in our room, and I was terrified by the thought of facing the dark, and the terrible nightmares it brought with it, alone. I only ventured from my safe haven when I had to. Just outside the door to Karen's and Michele's room, in the halls of my own dorm, I was faced with long cold stares from people that accused me of crying rape simply to save my reputation, people that whispered behind my back that I was asking for it, people who I had previously thought to be my friends. I felt hurt and betrayed by these people, and often wondered if I would ever be able to trust anyone ever again.

I also remember avoiding my family and my boyfriend from home that week. I was struggling to understand the nature of what had happened that Thursday night, to find a voice with which I could express my pain, my anger, and my sense of loss, and to find the truth as to who Sara Pasqualoni really was. That week the truth that I saw seemed far too ugly, far too painful to share with the people I loved. So, I told them that I was very busy studying for midterms, and ignored their phone calls. However, deep inside I really wished that my parents knew and could just take me in their arms and make all my pain go away.

After a week of seclusion in Karen's and Michele's room I became restless. I knew that I could not hide from the world for the rest of my life. I decided to take a seemingly small and simple step. I went for a walk. I was not even one hundred yards away from my dorm when I heard someone

yell. It was the third SAE brother, the one who did not come to apologize to me, and he was yelling "Choo-Choo!" from his window. Suddenly I realized what kind of person he and his brothers were. I realized that yes, these men did do something wrong. It was not their "lucky night" simply because I was bombed, or drugged, or in whatever condition I was in. They had violated my basic rights as a human being. They were sick men if they considered that a lucky night. That day I officially charged them with rape, in both the college and the criminal justice systems.

The next obstacle to get over then became telling my parents and my boyfriend what had happened. I had forced my hand by pressing charges, and had to tell them now. Although I loved my parents and my boyfriend very much, I felt incredibly anxious about telling them my story. Even though I knew that what these men did to me was wrong, I still had not been able to rid myself of any guilt. I was still struggling with my role in what had happened that Thursday night. I was struggling with how to tell my parents about my drinking, and how to tell my boyfriend that I could not remember if I ever really said no to these three acquaintances who had sexual relations with me.

I called for a meeting at school with my mother, my father, my boyfriend, and my dorm advisor, with whom I had become very close. I began to tell my story. As it unfolded my family and my boyfriend reached out to me, and held me. We cried together. Despite what I had done, despite what had happened to me, they still loved me and supported me. Their unconditional love carried me over yet another hurdle in my journey toward recovery.

Word quickly spread of my charges of rape, and the campus soon became divided. Rape in and of itself was a controversial issue, never mind a case which involved alcohol, a potential drugging, and the Greek system. Many victims and concerned peers came to my support with letters of sympathy and advice, campus-wide drives for rape education, and sometimes controversial demonstrations of their anger at what had happened to me. Many more people, however, flocked to the cause of the "persecuted" fraternity brothers. The persecuted men who, although charged by a grand jury with a felony offense, were still allowed to attend classes, eat in my cafeteria, and live on campus in the fraternity house. The men who, although avoiding direct verbal contact with me, began to spread vicious rumors about my sex life and try to destroy my character. The men who goaded their peers into intimidating and humiliating me by shouting obscenities at my window, and whispering behind my back. These "perse-

cuted" men were the people who had torn my life apart in just one night, without a second thought.

As the campus activity surrounding my case swirled around me, I was left to struggle with my remaining questions as to what had truly happened that night. While many people told me that not being able to remember that night was a blessing, I was still plagued by the question of guilt, the question of consent. I knew that my healing process depended largely on my ability to understand what had truly happened to me as rape, to be able to attribute my feelings of guilt and to express my feelings of anger appropriately. What I did not know then was that the justice system was not the vehicle through which I would be able to reconcile those feelings.

The campus judicial board hearings were held first, approximately two months after I had been raped. Generally, judicial board hearings consisted of a five-member board of students and faculty hearing charges brought against students by campus security and/or the dean of students office. The students were advised by a self-appointed faculty member, and attorneys were usually not allowed to sit in the hearings.

Not in my case. Since these men were charged with a felony, they could have their defense attorneys present at the hearing to help keep them from incriminating themselves in the face of an impending trial. The defense attorneys were supposed to remain silent, and to counsel their clients only if deemed necessary. They were, under no circumstance, to have any verbal contact with anyone other than their clients. However, due to the prowess and the intimidating tactics of the defense attorneys, the inexperience of campus security in pressing charges of rape, and the incompetence of the student administration in maintaining any semblance of integrity during the hearings, the defense attorneys essentially ran the hearings themselves. For example, although a Howard hearing—a criminal court hearing in which the judge rules as to the admissibility of a rape victim's past sexual history in trial—had already been heard in my case, and the judge had disallowed any mention of my past sexual history in the criminal trial, the defense attorneys effectively pointed out that victims had no such protection at the college judicial board level. Night after night they were allowed to put people in front of the board who essentially lied about my past sexual history, painting a fiercely inaccurate picture of me as a wild, sex-craved animal who thought nothing of anonymous gang-bang sex. However, when other campus women with stories similar to mine involving these three men presented themselves to the judicial board, the defense attorneys quickly and effectively protested. Although these stories strength-

ened my belief, as well as many others, in these men's guilt, they were not heard due to the ignorance and the incompetence of the judicial board process.

After two weeks of frustration and humiliation, a verdict was returned after less than two hours of deliberation. Guilty of lewd and indecent behavior—for their references to me as a "train" and for the "incident" in the stairwell. One semester suspension. Not guilty on all other counts.

Although there was no precedent for such an action, my father and I worked on an appeal for a rehearing, citing the incompetence of the judicial board and the blatant disrespect shown by the defense attorneys for the hearing bylaws. Upon submitting the appeal, I was informed by the dean of students office that if I tried to push the appeal, charges of lewd and indecent behavior could also be brought against me for having sex in a public place—for the rape in the stairwell. I was dumbfounded. I was frustrated and angry with the dean's incompetence, and felt betrayed by my trust in the judicial system. I had no legal recourse, and no way of restoring my now shattered reputation on campus. If I tried anything, charges would be brought against me. The whole process was absolutely unbelievable. It was about that time that I decided to transfer to another college, to a college with a more reputable administration. Previously, I had steeled myself against letting these men run me off campus. After the hearings, however, I decided that I wanted no part of a college whose administration was as ignorant and ineffective as this one was. I wanted out.

Supporters—mostly friends, family, and other rape survivors—were also outraged with the outcome of the hearings, and with the manner in which they were held. Rallies and mock trials were held in demonstration of their belief in me and of their anger with the system. The message was still heard loud and clear though: boys will be boys, and girls should learn to live by men's rules. If they do not, they deserve whatever happens to them, and will be persecuted for it.

Although angry and disappointed with the college hearing, my supporters and I turned our energy toward the criminal trial. The grand jury had been held in criminal court, and probable cause against the three men was found. That meant that the jury believed that there was sufficient evidence to actually bring these men to trial for rape. Despite numerous six-hour-long depositions by the defense attempting to discredit me, my character and my story held strong. Unfortunately, the originally skittish prosecutor was even more hesitant to proceed with the case given the outcome of the college hearing. He met with me and my family to discuss our feelings about offering a plea bargain. Trial was scheduled for September, just

about the time I would be starting a new semester at a new college. All I really needed from the criminal justice system was to hear these men plead guilty to some form of sexual assault. We agreed to offer a plea bargain in which the men would plead guilty to misdemeanor sexual assault versus felonious aggravated sexual assault, and would serve only suspended time in jail. The defense tentatively accepted the offer.

As the summer progressed I passed further depositions by the defense with flying colors, and further witnesses came forward testifying about my condition that Thursday night. This helped strengthen my case because the defense was unable to discredit me, or to paint a picture of me as a willing participant in the sex acts that took place that night. I was unable to consent due to my obviously impaired condition. Because of these developments, the prosecutor also became increasingly confident in his ability to obtain a conviction in trial. Without discussing it with me or my family, he withdrew the plea bargain and decided to go to trial. When I heard, I could not believe it! I had made plans for a new life at a new school, based on the assumption that I was going to be able to move on from this monster, leave it behind me. Now I was faced again with the dread of trial, and the publicity it would inevitably carry. Not only did I feel as if I would never be able to start over, I also felt stripped of any control that I may have had over the course of my recovery.

I begged the prosecutor to offer another plea bargain, to keep my case from trial. Eventually, after much arguing, he did. This plea bargain, however, was stricter and more satisfying than the first. It involved twelve months in a detention facility with six months suspended; a handwritten apology note to me; a fine (I cannot remember the amount); one hundred hours of community service work in a women's organization; and most importantly, a guilty plea to misdemeanor sexual assault.

While many of the people around me felt that justice was not served by avoiding trial and the consequences that these men would have to face if found guilty of felony sexual assault, I still believe that accepting the plea bargain was best for me at that time. I heard my rapists plead guilty to sexual assault, I received apology notes from them, and they did serve six months in a detention center and one hundred hours of community service with a women's organization. Most importantly, however, I was able to move on with my life. I transferred and graduated from college summa cum laude, and expect to graduate from a well-respected medical school in just a few months. I became actively involved in many women's issues, and established a student organization dedicated to sexual assault education at my alma mater. As a result of my work with other women, there

have been many changes at both colleges that I have attended, all of which I am very proud.

On a more emotional level, it has taken years for me to resolve much of my pain and anger regarding what happened to me. I honestly believe that being raped is something that I will never be able to completely leave behind me, no matter how far I move on. I also strongly believe that I could not have come as far as I have without the support that I received from my family, my boyfriend, and my friends. My family's unconditional love and support for me gave me strength, and helped me to believe in myself again. I believe that my rape brought us closer together than we ever would have been had it never happened. Also, although we broke up about a year after I was raped, my boyfriend then was also very important to my recovery. His caring spirit, his ability to alternately support me and give me space, as well as his love for me helped me to reestablish some kind of faith in men. While I still have a lot of difficulty trusting men and staying in relationships with them, I will never forget all that my boyfriend did for me then, and I will always love him for that. Finally, my friends were the ones who made my survival possible during the hardest of times. They were the ones who were there at all hours of the day, and through all my stages of pain and anger. I unfortunately lost touch with Karen and do not know if she ever was able to face the probability of what happened to her that night. I just hope that if she does, she has people that care for her and support her the same way that she did for me.

As it has taken much time for me to heal emotionally, it also has taken many years for me to be able to actually look people in the eyes, and tell them with conviction that I was raped. I still do not remember that Thursday night, and thus carry the burden of doubt as to what really happened. I oftentimes wondered what if, what if I was a willing participant in all that these men say happened that night? Despite my education and despite my understanding of the nature of consent and of rape, I still wondered what if I was not really raped. To be quite honest, I am not really sure what happened to erase my doubts, and to strengthen my conviction that what happened to me really was rape. Perhaps sharing my story and educating others has helped. Perhaps time has helped. Most probably it has been a combination of things that I will never be able to thoroughly understand. But now I truly believe that I was unable to consent, and rather than respect my body, my privacy, and my sense of self three men chose to take advantage of my impaired condition and raped me.

I now understand that I was not only raped by these men, but also by the Greek system, the college judicial committee, and even by the criminal

justice system. Because of the myths and biases surrounding rape, I was forced to defend my worthiness as a victim over and over again. I had to fight against fraternity brothers throwing obscenities and accusations concerning my character. I had to fight against an ignorant and incompetent administration which allowed my character to be carelessly persecuted while they staunchly defended the rights of my rapists. And finally, I had to fight with a judicial system that forced me to defend my character in order to have a case worthy of trial, that allowed the prosecuting attorney to offer and withdraw plea bargains without my consent, and that molded a prosecuting attorney who several times actually told me that what happened to me really was not rape. Because of my anger with how the system works, most of my work now centers around educating my peers, thus helping to change the system that defends the accused and persecutes the victim.

Despite all that has happened to me, I do not tell my story today from the perspective of a victim. I tell it as a survivor. And while I have met great difficulty attempting to put my feelings on paper, I hope that you have felt to at least some degree the pain, the frustration, and the loss as well as the light and the hope in my story.

10

Living Through the "Limelight": Deflecting Suicide and Suing for Rape

Dr. Jennifer Palmer with Liza Veto

Back in 1984, I was 17 and a junior in high school. My best friend at that time was a senior named Lisa. Two days before her graduation, we attended a small party thrown by David, Lisa's crush. I knew all of the people there at least slightly because I came from a small high school and was in many senior courses.

Some time after midnight, Lisa and I were in the kitchen doing shots of rum (after drinking beer for most of the evening). I remember going into the living room and flirting with a guy named Jay. We were drinking and talking. Jay left at midnight, and I recall walking him out to his car, saying goodnight and going back inside.

This is where it gets fuzzy. At some point I ended up in the kitchen with Lisa, Jodie, and Adam. Jodie called me a bitch so I called him a bastard. I thought we were joking around but in light of what I know now, I think he was serious and couldn't deal with me. The last thing I remember was sitting on the kitchen counter doing rum shots again. I realized I was drinking too much and didn't accept the host glass when it got to me again. Jodie kept bugging me to drink so I finally did, just to shut him up.

The next thing I remember I was lying on my back in a bathroom. My shirt was on, but I had no underwear on. I felt it before I saw it—pressure around my vagina. It didn't hurt—I was really relaxed from all the alcohol. I tried lifting my head, which was incredibly heavy, but I managed a few inches, and I saw Adam on top of me propped up on his hands. My eyes were level with his chest, and I could see three faces peering down from behind his shoulders. I lifted my head further and saw his penis thrusting into me. My legs were propped up and spread. All of this happened in a

few seconds, and I was in that limbo state when you're not asleep, but you're not really awake either. I can recall trying to move my head—shaking it NO! NO! I was trying to say no, but I was so drunk I felt like I had a fat, hairy tongue in my mouth, and I ended up mumbling something, and then I blacked out. I think that as soon as I realized what was going on my mind snapped. I don't think I thought of it as rape.

When I woke up in the morning, I was on the couch with an afghan covering me. I was naked from the waist down. Lisa and my friend Scott were looking at me, and I felt very foolish and embarrassed. I found my underwear on the couch and my shorts on the floor. I think I asked them to turn around because I was ashamed for them to see me naked. I pulled on my clothes and Lisa and I left. She didn't say anything about the rape, and neither did I. I could tell that she was worried about returning to her place, and what her parents would say. We walked down to the pool and I sat on the edge and dangled my legs in the water. I was still buzzed; I don't know if it was from shock, or all the alcohol. It's hard for me to describe my thoughts. I think that ignoring what happened made it easier for me to think that it just didn't happen. If I didn't acknowledge the rape, it didn't happen. I was in a severe state of mental shock.

I'm not sure if you'll understand this, but I didn't immediately call it rape. I realize now that my denial was my way of surviving. I was not mentally prepared to deal with this heinous attack. If my mind or body or whatever hadn't protected me, I'm sure I would have killed myself because I almost did two days later. I don't have any memory of what happened between the time Lisa and I walked back to her house and two days later at a postgraduation party held by another one of her classmates.

Even though I didn't immediately think of it as rape, I knew *something* had happened. I asked Jay, a guy who was at the party, if there was a chance that I could be pregnant and he said yes. So I asked how many times and he said twice. At that time I was more concerned about being pregnant than having been raped. Jay told me who had sex with me and that I enjoyed it, and that I was saying Jon's (my crush's) name during it. I don't recall any of that. I started bawling and went back to my car and cried. There I admitted to myself that I had been raped. I cried from embarrassment and shame and horror. I was embarrassed because they saw my vagina. I was ashamed because I got drunk, and I was furious because they said I enjoyed it. I was mad because they took away my virginity. I felt guilty and ashamed because sometimes I would masturbate and think about Jon. I didn't realize until recently that I had been blaming myself for being raped because I was "bad" and masturbated. The most powerful

emotions I had about the whole thing were shame and guilt. I had no idea what to do. I was so scared and ashamed and embarrassed and all I could think of was why me? what did I do? why did I drink so much? was I pregnant? I felt I had nowhere to turn. My belief of "goodness" and any trust I had in people had been irrevocably shattered. I didn't trust going to the cops. I figured they'd say I was drunk and wanted it, and I didn't want any more people to know. I was too ashamed to tell my parents; I felt that I had let them down. That's how horrible my rape was and still is: I couldn't even trust my parents and that makes me absolutely livid at the scum who raped me and those who stood by and let it happen.

Anyway, I sat in my car for a while, crying. After I felt stable enough to drive, I went home. The route I took is a narrow, windy, twisty road that borders a river. I was flying on this road and I wasn't in the most calm frame of mind. I very seriously considered just yanking the wheel and plunging down the embankment into the river. If the car didn't explode, I thought, maybe the impact of crashing would knock me out and I would drown. I was rapidly approaching a section of the road where the trees and shrubs were a lot less dense, where I thought I could probably make it down to the river when—and I don't know if this is just coincidence or if God or Allah or Zeus or whatever stepped in—Rush's song "Limelight" came on the radio. That song was my favorite (and I had a crush on the lead guitarist), so instead of driving over the cliff, I listened to it and kept on driving. I wanted to die. But if I were dead, I would never be able to hear Rush again. That song has never failed to put me in a better mood and by the end of the song I was still alive and determined NOT to kill myself because that would be letting the scums win, and I wasn't about to be beaten by them.

All I remember about the next two weeks was that they were pure hell. I think I got by by playing guitar during the day and crying at night. Then I got my period, and boy was I happy. I told myself—OK Jen, you're not pregnant, you have no apparent injuries, move on with your life.

And I did a good job of it for seven years. I eventually came to a point where I admitted that I had been raped, but I denied that it had any effect on me. I remember reading an article in *Glamour* about rape victims and I felt superior to the women who said how emotionally devastating rape was. After all, I had been raped and I was fine, no problems. I was in severe denial. I am still amazed that I was able to function so well for so long.

I denied that anything had ever even happened that night at the party in 1984, until around September of 1991. By that time I was extremely

stressed out from school and I was having trouble sleeping. I was in a major depression. I had lost interest in school, and once that happened I lost all motivation. I was having serious doubts about being a veterinarian. I hated my face, my body, myself. I started eating compulsively. I'd get down on myself for something then chow on ice cream or brownies or whatever I had in the house. Then, I'd feel so guilty and ugly that I'd practically starve myself for the next few days until I binged on something else. I'd gain ten pounds and then starve. Gain. Starve. I had also been withdrawing from my boyfriend. I lost all interest in sex, and it got so bad that I even hated to kiss him. I thought there was something wrong with me.

So finally, after one particularly rotten day, I stopped by a professor's office to talk with her about a project. She has a master's in psychology, and over the years she'd become the person I would go to when I was having problems. I ended up crying because I was so stressed out. She suggested that I go to a counseling center on campus, ostensibly to work on stress management. One of the questionnaires I had to fill out asked me to check all the statements that applied to me. Rape was one of them so I figured, what the hell. By this time I had begun to wonder if the rape maybe did have something to do with the problems I was having with my boyfriend. I finally saw a counselor and I told her I was there to work on stress. She looked at the paper I had filled out, and she said, "So, you've been raped?" I guess I needed to hear it from someone else's mouth because I totally lost it. I started bawling. I knew immediately that the rape was my problem. I had been raped seven years previously, but I hadn't been ready to heal and recover until right then. I don't know if being in my first long-lasting relationship with someone triggered this or not.

I think my boyfriend Doug was an important part of my early recovery, but I had felt horrible about myself long before I even met him. I truly believe that I was meant to remember and begin recovery when it happened, and Doug just happened to be with me at that time. I was in therapy a few months before I told Doug. We had been having problems for about a year. I wasn't interested in sex, and I didn't want him to kiss or touch me. I finally told Doug about the rape and being in therapy because I felt he deserved to know; I know he blamed himself for our problems and I wanted him to know why I was withdrawing from him. When I told him, Doug was very supportive. He believed me, and he did everything he could to help me. He listened to me, he cried with me, he left me alone when I asked him to.

My rape therapy was and has been really tough on my relationship with Doug, because I needed to make my healing process my number one pri-

ority. I took some time off from school because it was too much for me to handle, so for a few months I did nothing except read books about rape recovery and go to therapy. We've both agreed that the best thing for now is for us to be totally platonic. I am unable to meet his needs—emotionally and sexually. We're both confused, and I believe that for us to have a life together I have to be happy with and love myself first.

I eventually told my parents, about one week before I dropped out of school. I was relieved to finally tell them. They were shocked, and I wished I had been able to tell them sooner, because they were very supportive. I think they blamed themselves for sending me to my high school where I encountered such scum.

I've been going to therapy, and every day I am more and more amazed at what I have done since being raped. I figured I was raped because I was bad and worthless and deserved it. How wrong I was! I know now that I am not bad and worthless because I was raped, but that I felt worthless because of the rape. There were reasons for the ways I felt and all my feelings were valid—but my original reasoning was wrong.

My rape wasn't about sex. It was about control and violence and a total devaluation of another human being. I was nothing but an object to them, a plaything. My feelings were ignored, and my body and spirit were violated. After the rape, sex became something I had to "get through." Now, I can look back and see just how completely being raped affected me.

Recovering from this is absolutely horrible. It's probably going to be the worst thing I'll ever go through, but I'm determined. Once I recognize all of my self-defeating attitudes and behaviors that originated with the rape, I can change them and become a person whom I love. It makes me sad to think about what could have been had I not been raped. But it also makes me mad. Mad as hell. How dare they do this to me!

I still cannot believe not one single person tried to help me, that all of those people, including my friends, did nothing to stop my rape I have no idea what they were thinking. They probably thought it was funny and erotic. I don't think they realized it was rape, but that does not make their violence forgivable. At least now I realize why I don't trust anyone, why I can't just enjoy myself. I'm constantly criticizing everything and everyone, because people I thought I knew and who I thought cared about me did nothing to protect me. Can you blame me if I would much rather stay home alone with my cats and watch TV or read?

But my day is coming. With Doug's love and support, as well as my parents', and for my own healing, I decided to to seek justice. I filed suit against them, hoping maybe they would go to jail. By pressing charges, I

felt I was finally taking back control. The day after I filed charges there were articles about me and the suit in the papers back home. When I first spoke with my attorneys, they suggested that I call Lisa and find out her version of my story. It was hard to call and ask her, but I did it. She confirmed most of my story, but she saw something else that I did not remember. She saw me lying on the couch with no pants on with a group of guys standing around. They had a broomstick, and they were shoving it inside me. What Lisa said horrified and terrified me, and I felt even more shame. I came very close to killing myself again. God only knows what else they did to me that Lisa didn't see. Sometimes I wish I knew, but what I do remember is bad enough. I have a very hard time believing that humans could do something so violent and demoralizing to another human. The bastards deserve to be killed.

Lisa called me on Thursday to tell me the article about my case had hit the local newspaper. I think that I was genuinely happy for the first time in a long time. I couldn't believe how empowering it was. Just imagine: Scum wakes up Thursday morning and gets ready for work. Mom and Dad of scum get up, and the maid brings in the paper. There, over a nice cup of coffee, they read that their son is being sued for rape. A minute later the phone rings in scum's apartment and Mommy and Daddy are quite upset. Scum goes to work and everybody shuts up and stares at him because he's an alleged rapist. What a slime! What a loser! God this feels good! Nice little fantasy, huh?

I have another fantasy where I use my veterinary surgical skills to maim and torture them. I am so pleased that I am taking control at last. And everyone who I know and who he knows, knows! The principal of my high school was interviewed, so I'm sure my teachers know, and if they thought I was something special back then, my God!

I filed a civil suit against my rapists using a recently amended state statute. To the best of my knowledge, mine was the first case to use this statute. Unfortunately, the case was dismissed on a technicality, a lousy definition. It's really frustrating that even though one of the rapists admitted to his family and lawyers that he had raped me, legally I could do nothing. I tried bringing a criminal suit, but the state decided not to take the case—not enough evidence, even with an admission of guilt. How pathetic.

All in all, although I didn't get the justice I wanted, I am glad I pressed charges. I knew it was a long shot, but I wanted to try and I wanted their crime to be on record somewhere. The most difficult thing about pressing charges was having to deal with an incredibly slow and unfair legal system

where rape survivors are treated more poorly than the rapists. To add insult to injury, I later found out that the original amendment to the statute I used was much more general, and as a result, my case wouldn't have been dismissed. Our wonderful politicians decided that if passed, the law would have resulted in too many suits being filed and would therefore overwhelm the legal system. So at least in Florida, rape survivors are sacrificed for convenience. Luckily, attitudes, beliefs, and laws are changing, albeit slowly. I am going to keep abreast of new laws and if there is ever a chance I can nail the scum, I will. At least I know I'm not crazy for feeling the way that I have for so long. I'm just sad that seven years of my life were wasted.

Suing my rapists was one of the most difficult things I've ever done and I am very proud of myself for doing it. Although I still get very depressed sometimes, I know that I did the right thing. I've told them that I know that it was RAPE and they're RAPISTS and they did not get away with it. I don't feel like that's enough, however. My mom says that I did a lot of damage just by making it public and maybe when I'm older I'll fully appreciate the courage it took for me to do this.

I wanted the whole world to know what sleaze Adam and Mike are as well as the others who watched and didn't stop them. I did nothing wrong. I wanted anyone else who has been raped by them to come forward and press charges too. I wanted to make it known what a horrid crime rape is. I wanted to end rape everywhere. I also wanted to do it for my own peace of mind—I didn't want any "if I had only . . ."s hanging over my head. I wanted to send them to jail and let them see how it feels to be raped. I especially wanted their families to know and have their names tarnished. I wanted REVENGE! and legally, pressing charges was the only thing I could do. I believed that pressing charges would help my healing process in the long run.

It has taken a lot of courage and strength and perseverance to do what I have done. I can see a big difference in myself from when I first began therapy and now. I am much more attuned to my body and what its needs are. I have become much more confident and I like myself better than I ever did. I don't think "recovery" will ever be reached, but at some point I hope to fully integrate this experience into my life and make something good come out of it. I am finally acknowledging that what I've accomplished so far is unbelievable: I am stronger than I ever thought I was and that gives me enough confidence to keep going.

11

Understanding the Difference Between Acquaintance and Date Rape

Dennis M. Dailey, D.S.W.

Dennis M. Dailey is a professor in the School of Social Welfare, the University of Kansas, an adjunct clinical professor at the Karl Menninger School of Psychiatry and Mental Health Sciences, and an adjunct professor at the Union Institute Graduate School. He is certified as a sex educator, sex therapist and supervisor, and has a limited private practice. He hosted a weekly radio talk program called "Let's Talk Sex" for teens and young adults and regularly appears in the print and broadcast media.

It is common to see the experience of rape broken down into separate categories: stranger rape, acquaintance rape, date rape, and marital rape. In fact, I use a categorization much like this in both my teaching and clinical practice although I also include friendship rape, and committed relationship rape. The latter group includes persons who are married, engaged, living together, or in some form of relationship that implies seriousness, commitment, or exclusivity.

Stranger—"a person who is neither friend nor acquaintance—someone previously unknown; unfamiliar."

Acquaintance—"knowledge of a person acquainted by a relationship, less intimate than friendship—a person or persons whom one knows."

Friend—"a person whom one knows, likes and trusts."

Date—"an appointment, especially an engagement to go out socially with a member of the opposite sex." (Note the heterosexist bias.)

Committed Relationship—"giving in charge; entrusted—a pledge to do something—the state of being bound emotionally or intellectually to a course of action."

What distinguishes these rape experiences is not the extent of coercion, or the depth of hurtful consequences, or the particular sexual behavior that constitutes the interaction. The distinction between different types of rape is one of how well the survivor knows the person who is coercing her, how involved they are together, how intimate they are emotionally. Out of this variation in attachment, closeness, involvement, intimacy, and trust, the differentiation between rape categories begins to make sense.

For this reason I am particularly bothered by the fact that acquaintance rape and date rape are often lumped into the same category. Date rape and acquaintance rape are not the same. True, they both are hurtful, involve sexual interactions, and are coerced. But there are some subtle differences between them that are profoundly important for me in my clinical work with survivors, and go to the heart of the pain in rape experiences.

The easiest way to capture that difference between date and acquaintance rape is to clarify the use of one word, the word "YES." "Yes" is used differently in acquaintance rape and date rape. When someone considered to be an acquaintance (a lab partner in a class, someone who lives across the hall, someone you see at work regularly) asks a woman if she wants a ride home, her "yes" is to the ride home, and not to any continuing relationship. When a prospective date asks the woman mentioned above if she wants to go to a movie and then for pizza afterwards, her "yes" is probably to both pizza and a movie *and* potentially to some sort of consensual romantic involvement. To date is to begin or to continue to nourish a relationship that could lead to something more serious—something even committed or exclusive. While acquaintances often go to movies together, they probably will clarify in some way that they are not on a "date," because "date" means something special and different. When two friends do things together, it is often made clear that they are not dating. And when friends or acquaintances move their relationships to dating, they understand and recognize their new relationships as something different, something special, something having to do with relating in a different manner. A romantic "dating" relationship usually involves attraction; something more than just liking, although it may start with that, and in some mysterious way the search for someone special, for a mate, or for a life partner. Since a dating relationship is very different from an acquain-

tance relationship, the "yeses" which occur within them are also very different.

The core of a rape experience is BETRAYAL. When a "yes" to pizza and a movie turns to coerced sexual interactions, much of the hurt comes from betrayal. It is my observation that the internal experience of betrayal increases as the relationship context becomes closer. The feeling of betrayal in acquaintance rape is real, but usually less than in a dating context, and the betrayal in date rape is very real, but less than when rape occurs in the context of a close friendship. When dating and friendship are closely entwined, the level of betrayal increases.

This betrayal has two very subtle facets. One facet is the sense of having been betrayed by another person. In all of the rape categories, except stranger rape, someone thought to be safe, where some level of trust existed, ignored a "no" and coerced an unwanted sexual interaction. As relationships move from acquaintance, to date, to friend, to committed relationship, the sense of being betrayed by another intensifies.

The other facet of betrayal a survivor may deal with is the sense that she has betrayed herself, by her own inability to make judgments about others. This is the source of much of the self-blame and blame-the-victim attitude that I see as a sex therapist working with rape survivors. Many others may blame the victim for not protecting herself, for walking alone at night, or for going out with him in the first place. So the survivor may also blame herself for somehow not being able to predict or prevent her own rape. This is clearly double jeopardy, the two facets of the betrayal experience that so often arise after being raped. With acquaintance rape I often hear: "I guess I should have known that it might not be safe, since I didn't know him that well." In date rape I hear: "I guess I should have known" and "I really thought he was a nice guy or I wouldn't have gone out with him." In friendship rape I hear: "I can't believe he did that to me; I trusted him; I thought he was a good friend." I hear the increased level of both facets of betrayal as the intensity of the relationship increases; healing from this betrayal is the central issue in working through and past a rape experience.

I suspect that this dual sense of betrayal is at the heart of why so few women report their rape experiences, especially rape that occurs in the context of closer relationships. With the increased sense of betrayal by another, and especially the sense of betrayal by oneself, an internalized self-blame overwhelms the desire to speak out and name the experience. I am in awe of the tremendous number of women who have been date raped but never name their experiences rape. Contemporary research suggests that

as many as one quarter of college women will experience date rape or a seriously attempted date rape (see, for example, Mary P. Koss's nationwide study). Yet nowhere near that number report their experiences. Many women who I work with as students or patients say that their reluctance to report arises out of their own internalized betrayal of self, which adds to their initial fear of not being believed or taken seriously. It is as if because they said "yes" to the date they are somehow culpable in their own rape.

Being raped or coerced by someone with whom a woman shares a primary bond (marriage, living together, engaged) must be particularly burdened with betrayal, given the closeness of the bond. It is tragic that coerced sex in close relationships is probably the most frequent rape experience. In close or committed relationships, rape is often rationalized (duty, rights, "after all, we are married"), negated (marital rape is not illegal in all states), or denied (thought to be impossible). In my work with couples who struggle in their dysfunctional relationships, I am struck at how often this betrayal experience has undermined fundamental trust and has been slowly toxic to the relationship. For many women in this circumstance it feels as if they are living continuously in the context of betrayal.

Likewise, in my work with women, especially college students who have been raped in a dating context, the struggle to cope with the internalized betrayal is intense and hurtful. Often they are surprised at how much it hurts, but when their experience is placed in the context of betrayal they can often come to grips with the hurt and the fear and the confusion.

By highlighting the enormous psychological hurt that arises out of the dual facets of betrayal, I am not suggesting that rape at the hands of a stranger is not frightening and hurtful. What I am highlighting is the additional issues that arise when rape occurs within some form of relationship, and in particular I am concerned that acquaintance rape and date rape not be treated as the same experience. In betrayal terms they are not the same experience, even though the coercion, hurtful outcomes, and sexual interactions may have been the same. There is no hierarchy of badness in rape in my view, just the subtle differences that add to the complexity of the experience.

It may not seem like a big deal, the differentiation between date rape and acquaintance rape, but I do truly believe that to miss the impact of internalized betrayal is to miss the reality of the experience. To miss the reality of the experience is to negate the impact of betrayal, the recovery of trust, the empowerment from within, and the movement through the healing process.

12

True Love

Christine Kim

It took me two years to admit to myself that I had been raped. I was nine-teen years old and a sophomore at a small, private college in New England, when this realization struck me. I was sitting in a sexual assault awareness meeting required of all sorority and fraternity pledges, and by the end of the discussion, I had confessed to myself that I had been raped. What I heard at that meeting jarred memories I had tried to keep hidden from myself for the past two years. Until that moment, rape had been a nebu-lous idea in my head, something that couldn't happen to me, something that *wouldn't* happen to me. At that discussion, I learned the definition of rape. One of the speakers had said that anyone—father, brother, boy-friend, or friend—could rape a woman. Someone you knew, someone you loved, someone you trusted, could be a rapist. This idea countered my pre-vious belief that rapists were strangers who attacked women in the dead of night, jumping from the shadows into the lives of unknowing, innocent victims.

Thinking about someone close to me violating me in such a way made me remember a time in my life that I had been violated by an ex-boyfriend. At the time, I hadn't considered his actions to be rape. I was ignorant of my rights as a woman—the right to say no, to scream, to fight back. In high school, no one talked about rape. No one discussed issues of sexual assault and sexual harassment with me. I thought that it was normal for a man to disregard a woman's voice when it concerned sex. A girl saying no to her boyfriend didn't mean that she wouldn't have sex with him. If a boy continued to pressure his girlfriend, I thought it was inevitable that she would say yes after some persuasion. However, I excluded myself from this group of women who fell to the pressure of their boyfriends. I lived under a double standard. I thought that *my* boyfriend would never pressure me to have sex with him.

As I listened to the two speakers, I felt an absurd urge to laugh, to cry,

to run out to somewhere far away. I couldn't believe that what had happened to me so long ago was haunting my thoughts years later. I was hysterical inside, but trying to keep a calm exterior. I gripped my hands tightly in my lap. The voices of the speakers echoed in my head, and I wanted to clap my hands to my ears and stop hearing what they were saying. I hurt inside, and I wanted the hurt to go away. I wanted to be alone, forget about this meeting, and not think about being raped by my ex-boyfriend. I had to listen to people who were talking about something that I, myself, had experienced in the past, and in the crowded room of students, I cringed within myself, trying to stop my tears that threatened to fall.

I sat huddled in my chair, wondering if I could last the entire discussion. Other students squirmed in their seats as if they, too, wanted to get away from the nauseating subject of rape. I wanted to go home and crawl into bed, hide under the blankets, and pretend that it hadn't really happened to me. I thought maybe I was being paranoid, making up silly stories in my head, being an alarmist. I was afraid to tell myself that, yes, I had been raped, and up until now, I was too scared to admit it.

The summer after I graduated from high school, I went to a university language program to learn Korean. My parents hadn't taught me my native language for fear that I wouldn't be able to speak English as well if they taught me both Korean and English at the same time. As a result, I knew little Korean other than the names of a few Korean dishes and words such as "eat" or "go." By my senior year in high school, I was ashamed that I couldn't read or write in Korean, that I spoke my mother tongue with an American accent. I wanted to end my illiteracy, my inability to communicate with other Koreans, so I attended a small, intensive language program. At the university, I was the youngest in the group of students, so I spent most of my free time with several closest to my age.

While I was there, I met Paul Kim. He was a senior at a state university nearby, at the program to improve his already almost-fluent Korean. I saw him the first day of orientation, sitting a few desks away from me. He looked very young. I thought he might even be younger than me, but something about him caught my interest. He had sad eyes that looked straight into mine, unwavering, unafraid. He was slightly built with a thin, attractive face. He was the first Korean man in whom I took more than a passing interest. We introduced ourselves later that day, and from that first introduction, I began to fall in love. I never believed in love at first sight before, but after I met Paul, I knew that what I felt was a new, intoxicating first love. He was intelligent and funny and personable to everyone. I wanted to

be with him all the time. I thought that everything he said was interesting because he often talked about the status of first- and second-generation Asian Americans in the U.S., and I respected him for his knowledge and opinions. It didn't seem to make sense how much I was taken by him, how much that enamoredness grew every day I was with him. I was in love with someone I had just met, and I had lost myself to him within the first few days of our introduction.

Paul and I spent most of our time with four other students—Andrew, Natalie, Diana, and Mark—and the six of us stayed up many nights talking until morning, watching the sun rise before we fell asleep. Every night, I found myself wanting to know more and more about Paul. He was sincere and candid, often staying up alone with me, the two of us talking while the others slept. I felt a closeness to him that I had never experienced before with anyone else. I had never loved anyone before, I had never been *in love*. Paul was the first person to win both my heart and mind. I wasn't able to forget him for a moment. I was incapable of controlling my growing feelings for him. I was young, I was innocent, and I laid all fears aside—fears of rejection, attachment, and vulnerability. Only because I was caught up in my emotions did I allow myself to wallow in my newfound love and disregard the dangers of letting down my guard.

A few weeks after Paul and I met, we went up to the roof of our dormitory with Natalie, Andrew, Diana, and Mark, and got drunk on Rolling Rock beer and Mad Dog. After a few hours, Paul and I left the group and sat by ourselves on the gated ledge of the building. We sat with our heads almost touching each other. An aching pain gnawed at my heart, and I wanted to say something brilliant and profound to impress him, but I remained silent, afraid for myself, afraid for the way I felt when I was with him. I looked at Paul with watchful eyes, hoping, waiting for him to kiss me. At the same moment, he leaned over with his neck outstretched, and holding my face in his hands, he brushed his lips against mine. I forgot the others, left the sounds of the street below us, and drifted in a wave of complete happiness and contentment.

After that night, Paul and I spent most of our time together, sleeping in each other's rooms and sneaking out before the other students woke up for morning classes. I was euphoric. Paul filled a piece of my heart which had been an empty void before I had met him. He was everything to me, and I loved him desperately, foolishly, stupidly. I had just turned eighteen, and Paul was twenty-four when we first started seeing each other. I didn't think a six-year age difference was a problem with us because we related so well to one another, and I felt completely comfortable around him, but later in

my life, I realized what a difference in maturity levels six years actually make.

I was still a virgin when I was seeing Paul, and I wanted to remain one until I married. We had talked about premarital sex many times before, and Paul never disagreed with me when I spoke of me "saving" myself for my husband. Instead, he said that he admired me for what I believed in. We spent every night together and made out before we fell sleep, and as we got to know each other physically, we became comfortable with one another's bodies and stopped wearing clothes when we went to bed. I became used to my nakedness, Paul's nakedness. Although we slept together with our clothes off, Paul and I never had sex. I knew I wasn't ready. I knew that I *did* want to wait until I got married because despite my growing love for Paul, my convictions about premarital sex were too strong for me to push aside.

Late one night, a few weeks after my birthday, Paul and I were in bed fooling around. We didn't have our clothes on. He was leaning over me, his two fingers moving inside of my vagina, and I was breathing in short, quick gasps. My eyes were closed. He stopped moving his fingers inside me, moved his body around slightly, and started again. At first, I thought everything was normal, but then I realized that something was different. Something *felt* different. I didn't know what was happening. I was scared, and I reached a hand down to feel what I thought was his hand touching me.

Paul was inside of me—not his fingers, but his *penis*. He had removed his fingers and inserted his penis inside of me without letting me know, without asking me for my permission. He was inside of me, moving in and out in a jerky, sporadic rhythm. I said no, no, and I tried to push him away from me. He wouldn't listen, too intent on his motion, too intent on having sex. I didn't know what to do. I was terrified. He was having sex with me, and I couldn't stop him.

I tried to push him away again, but he ignored my efforts to get his body away from mine. He had his eyes closed. My eyes were wide with fear and shock, and feeling his body hitting against mine made me feel sick with disgust and shame. I lay still, trying to ignore what was happening, trying to forget what was being done to me. I was petrified and unable to help myself. I wanted him to stop. I felt powerless because even when I told him to stop, he wouldn't. He was my boyfriend. I loved him. What was he doing to me? Did he know what I was feeling? Did he know that I didn't want his penis to be inside me, that I was frightened and unwilling to do what he was doing? As I asked myself these questions, Paul came, his

body trembling as he got off of me and lay down by my side. I closed my eyes, beginning to cry, the hopelessness and degradation pouring down my face.

In one cruel, animal-like act, Paul stripped me of my dignity, my self-worth, my virginity. *I was no longer a virgin.* He realized that I was crying and put his arms around me, holding me while I cried. I wept for myself and my lost virginity, for what he had done to me, for loving him even after he did it. I lost a part of myself that I wouldn't retrieve for years: the ability to fight, the ability to defend myself. Only after two years of denial would I be able to pull myself back together again and regain that lost confidence and strength.

I never thought that it could happen to me. How could I be raped? A boyfriend couldn't rape his girlfriend. Or could he? I wouldn't believe that what had occurred had been rape, and because I didn't want to believe it, I pretended that it had never happened, that I wanted to have sex, that Paul didn't know that I wanted to remain a virgin until marriage. I forgave him, blaming myself instead for having been unclear that I didn't want to have sex. I thought that if I had been more adamant about my refusal, rather than saying a weak no, no, that this wouldn't have happened to me.

I cried for the rest of the night. Paul held me the whole time, telling me it was all right and to not be sad. I didn't think Paul knew what he had done, or maybe, like me, he just pretended that he didn't know. I didn't know if he was holding me to console *me* or to console *himself* and his guilt. I couldn't ask him why he did it, why he didn't ask me first. I gave up. After my tears subsided a little, he kissed me, and we had sex again. I cried the entire time he was in me. I thought that since I had already lost my virginity, it was all right to do it again. I thought that maybe I felt the way I did because it was my first time, and because I didn't know what it would be like, I felt this humiliation and regret.

I tried to make myself believe that everything was fine, that Paul was a wonderful boyfriend for understanding when I cried after the first time. I wanted to forget, and the best way for me to do that was to deny my pain and my sadness. The day after I first had sex with Paul, I woke up with excruciatingly painful cramps. At first, I couldn't get out of bed, and when I finally did, I could barely walk to Natalie's room next door to get her help. Everyone was worried about me, Paul most of all. He stayed by my side the entire day and through the night to take care of me until the cramps went away. Later, I told Natalie parts of the night before, and she wondered aloud whether Paul was so concerned about me because of his feelings for me or because he felt guilty, knowing that he had taken away my

virginity the night before. I ignored Natalie's words and concentrated on Paul's dedication and faithfulness to me when I was sick.

Everything changed a few weeks later. My relationship with Paul ended soon after the night I lost my virginity. Maybe it was because he knew what he had done to me and felt guilty. Maybe it was because he wanted to have sex with me, and once he had, he lost interest in me. Whatever the cause, Paul broke up with me, and I was left alone and still deeply in love with him. It was a difficult time for me—coming to terms with my first experiences with sex and trying to combat the loneliness I felt without Paul.

I left the language program a month later. I changed inside—the way I thought about men and sex and relationships—but no one noticed except me. I became secretive about how I lost my virginity. I would tell my friends only parts of that night, leaving out when I had asked him to stop and when he hadn't listened to my pleas. I kept the entire experience secret, hidden within me, and I couldn't share it with anyone else. I tried to forget how I lost my virginity. I made myself forget. Even though I couldn't tell anyone else, I sometimes thought about my experience, wondering whether it was rape, but never admitting to myself outright that it had been. This was always a question that lingered in my thoughts. I still loved Paul for months after I had left the program. I couldn't help myself, but after several years, I realized that Paul never truly loved me. I admitted to myself what he was—an older man who took advantage of a young girl's stupidity and naiveté. I will never forgive him for what he did to me that night or how he affected the first two years of my college life.

When I arrived at college, I was distrustful of men, thinking that all they wanted from me was sex. Every time I met a new man, I was aloof and unapproachable. Most men thought I was a snob, that I thought I was too good to talk to them. They were wrong. It was difficult for me to be friendly to men because I was afraid of them. I didn't want them to think that they could take advantage of me the way I realized Paul had. I thought all men were like Paul, and for that reason, I was afraid when I was alone with a man, whether he was a stranger or someone I knew. I trusted no one because I knew that however implausible it may have seemed, any man could be a rapist. I didn't like to hang out with men when they were really drunk. It made me nervous, especially when I was alone with them. I knew that alcohol could make people lose control, and I didn't want to risk having what happened to me happen again. Because of my fears and insecurities, I gave off an image of someone strong, hard-as-nails, in complete control of her life because I didn't want to show my vulnerability to others.

The way in which I handled relationships with men also changed significantly after my relationship with Paul. In high school, I had been trusting and hopeful at the onset of every relationship, giving myself completely and selflessly to the person with whom I was going out. However, after Paul, I had my guard up for months before I started to trust someone. I tried to control my feelings whether or not I was successful in doing so. I realized that I was blind when I was with Paul. I didn't see the lack of respect that Paul showed me by raping me until much later. I didn't want to be so stupid like that again. I was afraid to fall in love. Although I've let myself fall in love with people I've met after Paul, it is still difficult for me when I feel I am losing control of my emotions. I hate the feeling of vulnerability, the possibility of getting hurt again, and that fear haunts me in every relationship I enter.

Sex is something I treat casually in my relationships since Paul. I don't sleep around, but I don't necessarily have sex with a man because I love him. Sex is not as important or as "bad" as I thought it was when I was a virgin. It took me some time to realize that for me, sex is sex. I know that having sex can form an emotional attachment between two people, but I have had several experiences in which I have felt nothing for a person after sleeping with him. I'm not afraid of sex because I was raped, yet neither do I sleep around as many people believe rape survivors do. I am more wary of men than I am wary of the act of having sex.

I didn't tell anyone for two years that I was raped. I couldn't because not only did I not really know *myself*, but I felt ashamed and weak and stupid for what I felt was a foolish act on my part. I didn't want other people's pity or their disbelief. It was a secret that I kept inside me. I thought that it would go away if I forgot it, if I tried not to think about it. I didn't want anyone to know—not my family, not my friends, not anyone. If I told, then I would have to admit that it had actually happened.

I thought I was strong enough to absorb it into myself, not share it with my friends, and live with it alone. I waited months after the sexual assault awareness program before I told my roommate about being raped. I needed to tell someone, to let out all the emotions that I had let fester inside me. When I told her the story, she was shocked and silent and didn't know how to help me. That night, I cried, remembering every detail of that night, wishing that I could forget all of it and leave it behind me. I was angry, I was trying to deal with pain that I had carried for several years with no release, and I hurt . . . again. Thinking about Paul and being raped made all the bad feelings come back again. It was painful to relive my experience, but talking about it helped me put it behind me. Going over every

detail of my experience made me realize that it wasn't my fault. I didn't blame myself anymore. It took me a long time before I could talk about being raped without crying, but all the tears gave me the strength to face my experience, evaluate it, and examine myself and how the rape had affected me. I still think about being raped by Paul, and it still hurts, but it doesn't overwhelm me with sadness the way it did at first.

Only my sister and my closest friends know that I was raped. I told my sister three years after it happened. She was shocked and hurt and angry at Paul, and she wanted to be able to help me, but she didn't really know how. She supported me by telling me it wasn't my fault, that Paul was to blame, that I could get over this experience with her help and the help of my friends. She gave me the courage to talk to a counselor about my experience. Going to a stranger to talk about being raped was difficult for me. It took me several months before I could actually make an appointment, but when I went, the counselor helped me to see all the things I hadn't seen before—my fear of being alone with men, my attitude toward relationships, and the changes within myself as a result of being raped.

My parents don't know that I was raped. They will never know. I don't know how I could ever tell them because I don't think they would understand how I got into the situation I was in while I was going out with Paul. I'm afraid they would blame me for being raped, and I don't know how they would deal with such knowledge. At times I want to tell them everything, but something stops me. I am not only concerned about their shock, anger, and pain, but I am also afraid of how they will view me as a person, as their daughter. I don't want them to think that I can't take care of myself. I don't want them to think that I was raped because I was stupid or foolish, and because of these fears, I cannot open myself up to them and admit that I was raped. I want to spare my parents the pain of knowing what happened to me. I have gotten over my experience. I will always feel twinges when I see a rape on television or in a movie, I will feel that familiar pain when I read about women who are sexually assaulted, but I have gotten past the worst. I know that it would kill my parents to know that I was raped because they would learn that they can't always protect their daughter when she most needs their help. The last thing I want is for them to feel they can't shield me from unhappiness and pain. I love them and want them to be happy and not to worry about me any more than they already do, and because I feel this way, I will not tell them.

Paul taught me what it felt like to have someone physically overpower me. I felt the shame, pain, and anger of being raped although I didn't call

it rape at the time. I don't know why I still loved Paul even after he raped me. I sometimes wonder why it took me so long to tell someone about it.

I now can admit that I am a survivor of rape to myself, to my sister, and to my close friends. Although it was a truly horrible and heartrending experience, it made me strong. I think that if I can get through this, I can get through almost anything. Before I was afraid of everything—meeting new people, starting relationships, being alone with men. Realizing that I had been raped, accepting that realization, and getting on with my life made me understand the strength that was still inside me. Several years went by before I was able to gradually overcome the past, but now, I feel a new courage that helps me overcome my day-to-day fears. I'm not afraid to be in a strange environment meeting new people. I'm not paranoid that every man is a potential rapist. I am careful and on my guard with men, but not overly so, and I have learned to trust *myself*. I have confidence that I can avoid bad situations, take care of myself, and not back down in the face of intimidation. I don't live in fear, afraid at every moment that I will be raped again. I have become more cautious. I am a better judge of character, and I realize with whom I feel safe and whom I distrust. I have learned how to fight back. By taking a women's self-defense class, I have learned how to scream and yell and hit when someone tries to make me do something I don't want to do. If I feel uncomfortable or threatened, I will fight back by telling the person to stop. If someone uses their physical strength to intimidate me, I will leave or retaliate. I have no qualms about protecting myself with aggressive action. I will use physical force if I feel it is necessary.

Once one of my friends and I began to argue about whether or not my women's self-defense class was worth the time and money I had put into it. To prove his point, my friend wrestled me to the ground and pinned me to the floor. At first I thought it was funny, but after asking him to let me go and him saying over and over again, "See, I'm right. You didn't learn shit in that class," I became frightened because it reminded me of my rape. I couldn't make this man listen to me. I felt helpless and trapped in a nightmarish déja vu. Then, it struck me that I could fight back, and my fear quickly turned to anger. I told him if he didn't get off me, I was going to hit him, and I was serious. He started laughing, thinking I was joking around, and then I pulled my right arm free and punched him hard against the side of his head. He rolled off me, holding his temple and saying that he'd just been kidding around and why did I have to punch him so hard. He was angry at first, but I very calmly explained to him that he provoked me and that if he had gotten off when I had asked him to, I wouldn't have had

any reason to hit him. I was angry at him for a few days, but after profuse apologies and much repentance, I forgave him. We're still friends, but he knows better than to repeat his former actions. After that incident, I felt empowered. I realize that although being raped was a difficult experience for me, I learned to protect myself because of it. I feel more confident and more independent now because I have learned how to protect myself *by myself.*

I lived through a difficult experience alone, and somehow I managed to survive. I was cruelly stripped of my virginity by Paul, and because of my relationship with him, I disregarded the violence of his actions and pretended nothing had happened. I compromised my feelings for Paul's. I have learned from that mistake and know I will never do it again because I must take care of myself first and foremost for me to be able to take care of everyone and everything else in my life. Now that I understand what rape is and can admit to myself that I have been raped, I can move forward in my life and release myself of this burden I have been carrying for the past few years. Being raped is a painful, humiliating, and terrifying experience. I have to live with those memories for the rest of my life, but *that is my point—I will live with them.* At times, I didn't know whether or not I was going to be able to get through the depression, the degradation, the feeling of being completely helpless, but *I did.*

What I went through happens to many women, and I hope that every woman who has been sexually assaulted can overcome her fear, her anger, and her resentment without harming herself. It's difficult for a woman to get over such an experience alone. Survivors of rape need support, and talking over their experiences with others can help. The feelings, problems, and changes rape victims undergo *can* be overcome. What I learned through my own experience was to accept what happened in my past, incorporate that into my life in a positive way by teaching myself mental, emotional, and physical self-defense skills, and get past the nightmare rather than dwell on it for the rest of my life. I know what it's like to be raped, I know what it's like to deal with the pain of those memories, and I know what it's like to *overcome that experience.* I believe in the strength of *women.* I have faith that no matter what a woman has gone through, she will be able to survive it *and* its repercussions intact.

13

From Prom Date to Stalker: Breaking Up with My Rapist

Theresa Waldon

I met Jim at my church's youth group when I was fifteen. I was a sophomore and he was a senior from another high school. When he asked me to his Senior Ball in May, I didn't even know his last name. Although I didn't know him personally, I felt secure with people in our church group, and, because we often gathered in settings other than the church, his invitation was not out of the ordinary. The friendly people in our youth group instilled in me a feeling of trust and security. Because no one in my sheltered life had ever betrayed my trust, it didn't occur to me that Jim would.

In order to get to know each other better, Jim and I went out on a casual dinner date before the ball. We got along fine, but our date was not the thrill of my young life. Going to the ball with Jim, however, was delightfully exciting. Because he was older and from a different school, the people at the formal seemed to constitute a sophisticated and enticing crowd. I admired them and was flattered to be accepted. I felt privileged to be included, but I was cognizant of Jim as my liaison into the group. In high school, my self-esteem was more often based on others' perception of me than on my own perception of myself or my own achievements. Jim was blatant with his affection toward me and he brought me into a wonderful new world of exciting people. I confused my excitement about being part of this new group with my feelings for Jim. Would these people have opened their arms to me if I had entered their domain unescorted? I did not dare ask. Instead, I chose to embrace the entire package of Jim and his social circle.

Jim and I went to an unchaperoned party after the ball. Eventually, as some of the couples left or went to sleep, I found myself alone there with Jim. We began to fool around and it was obvious that he wanted much

more than I was willing to give him sexually. I felt pressured by his advances. He was kissing me harder than I liked and I had to repeatedly remove his wandering hands from my body. It was the first time anyone had been so aggressive with me and I didn't know how to escape gracefully. Fortunately, I was able to stall until my curfew, when we both knew I had to get home.

After the ball, Jim continued to ask me out on dates and I continued to accept. While I knew that he liked me as more than a casual companion, that was all I really valued in him. I liked what Jim represented—an older boyfriend at another school with exciting friends—more than I liked Jim himself.

On the Fourth of July, a friend of Jim's had a small party with a lot of alcohol. Everyone drank too much. Even the "designated drivers" got drunk. With no way to get home, the party turned into a sleep over. Around three o'clock in the morning, everyone had either passed out or gone to sleep.

I remember the rest of the evening as a series of realizations. They are like photographs in my mind:

— I realized Jim had made sure we had a room to ourselves
— We were making out on the bed
— I was lying naked with him
— I felt some part of him touch me between my legs
— I thought it was his penis
— I said NO! and pushed him away.

Jim and I had fooled around before. We had even been naked before. I had, however, been very clear that I did not want to have sex with him. I had repeatedly told him, "I will not have sex with you," and he seemed to understand. When I said no this time, he laughed at me and said, "That was just my hand; can't you tell the difference?" I felt really stupid. We resumed kissing and when I felt something between my legs again, I assumed it was his hand. But this time it was not his hand. When I felt a sharp pain, I realized we were having sex. I froze. With me pinned beneath him, Jim was occupied with "sex" without regard to me, my feelings, or desires. Streams of tears began running down my face which Jim never noticed.

When he was finished, I was in shock. I didn't know what to think or what to do; up until then I thought he loved me and would never hurt me: he was my boyfriend. I thought he understood that I did not want to have sex.

I felt confused, angry, and afraid that people would find out. I was terrified when he got up to use the restroom, naked. I was afraid if someone saw him they would know that we had had sex; I didn't want anyone to know my shame. My emotions created a knot in my stomach. I turned my back to Jim and, in the fetal position, cradled my knot.

In the morning, I had a horrible hangover; my emotional hangover, however, was far more painful and lasting. The rape had been physically painful—that was part of the shock. The pain I still felt in the morning reminded me that I was not a virgin anymore. I was nauseated and felt very dirty. I wanted to take a shower but I could not get away from Jim.

Jim and I did not talk when we got up. I had to get out of the room we were in; I didn't want to be alone with him. Under the pretense that the fresh air would help me feel better, we went out by the pool, where the other party-goers were recuperating, My anger and confusion came out in my words and actions. I was bitter and cutting toward Jim. I wouldn't let him touch me and wouldn't sit near him. No one else seemed to notice, but Jim acted hurt by my comments.

I was confused more than anything. I felt guilty, like I had done something wrong. Had I not made it clear to Jim what I wanted and did not want? It occurred to me then that what happened the night before might have been rape, but I didn't want to believe I had allowed something like that to happen to me. I also didn't know much about date rape. I did know that I had not wanted to have sex with Jim, and that my being naked with him was not consenting to sex: he knew that I felt I was too young to have sex, he heard me say no again that night. At the same time, I didn't want to acknowledge that I was a rape victim. I truly thought Jim understood that I did not want to have sex. If it was not consensual sex and I was not a rape victim, then how could I think of it?

Because I didn't know what to do, I did nothing. I didn't break up with Jim. I told no one what had happened. I pretended that nothing had happened at all.

Jim assumed that because we had already had sex, we would just continue to have sex. I continued to say no. He tried to convince me that sex was never good the first time, that sex was wonderful and only got better. I tried to tell him that I had not wanted to have sex the first time, that I still didn't want to, that I felt I was too young to be having sex, and that even if I *had* wanted to have sex the first time, I didn't like it and it wasn't what he said it would be. He persisted.

I continued to say no for two or three weeks, but I still didn't break up

with him. I believed that if I had sex with someone, I should be in a relationship with that person. I desperately wanted my first experience with sex to be a good one, even though it was not. Pretending that I did love Jim, I finally gave in to his pleadings and we had "consensual" sex. But if it weren't for the rape, I know I never would have had any sex with Jim.

I went out with Jim for almost a year. Because he left for college at the end of that first summer, the relationship lasted much longer than it would have had he stayed in town. Not facing him every day meant also not facing the emotions and pain I was suppressing.

I didn't break up with Jim because I wanted there to be a good reason why I was not a virgin anymore. The rape made me feel out of control, so I tried to rewrite history, placing myself back in control. If I could make myself believe that I had really wanted to have sex that night, then I could believe that I was not a rape victim. By keeping Jim as my boyfriend and consenting to have sex with him, I allowed myself to fabricate a new version of the Fourth of July, in which I had actually wanted to have sex all along. I wanted to make the rape go away and I could not do that if I confronted Jim and broke up with him. I tried to believe that if I continued to see him, I might have come to love him and we eventually would have had consensual sex anyway.

After the rape, there wasn't anyone that I wanted to talk to about my mixed-up emotions. Even after I started having consensual sex with Jim, I didn't tell anyone for months. I didn't even tell my best friend, Hanna. I didn't want to share the shame I felt, but I also didn't want to share the lie I had created. Talking about the rape would have exposed my fabricated memory for what it was: an invention to help me cope. I didn't believe that anyone would understand.

Now I wish I had talked with someone immediately after the rape. If I had told a friend on the fifth of July, the whole event and its aftermath might have been very different for me. But I wasn't open about my feelings because I couldn't understand them myself. I didn't want to recognize that I had a problem, and I wouldn't allow myself to need support or rely on others.

Obviously, I could have used some support. Every time I tried to decipher my feelings, I was so overwhelmed that I would shut down. I was not able to coherently come to a conclusion about how I felt, so I denied my emotions entirely. If I had talked to someone that next day, perhaps it would not have taken me so much time to admit that I had been raped.

I did eventually tell Hanna that Jim and I were having sex, but I didn't want to discuss it further; I just let her know. I tried to pretend that I en-

joyed sex and that I was happy with "my" decision, but I knew I was not very convincing, and when she would ask about our sex life, I would never go into detail. If I were really happy about losing my virginity and sex with Jim was wonderful, I would have told her the exciting news right away. Instead, I felt obligated to tell her because she was my best friend.

One day Hanna told me about her own rape and I, in turn, told her the truth about the first time that Jim and I had sex. Telling her made me face that there was something wrong with me and what had happened to me. It also made me realize that I needed to talk. I told her about how I thought his hand was his penis, how I said I didn't want to have sex, how he laughed at me, how that made me uncomfortable and made me feel stupid, and how I didn't know until it was too late that we were having intercourse. She said to me, "That's rape. He knew you did not want to have sex, you said no, that is nonconsensual sex." I began to admit that I had been playing mind games with myself. I faced up to the facts that I was not happy in my relationship with Jim, that I was not enjoying sex, and that I no longer wanted to be dating a rapist.

When I did break up with Jim, I didn't bring up the rape, I just said that I didn't love him anymore. Jim didn't want to accept the breakup and didn't handle it well. He became obsessed with me. A clean breakup would have allowed me to walk away and work through my emotions on my own. Instead, his ceaseless phone calls and requests to see me constantly reminded me of my nightmare. Because I believed I should be nice to everybody, I tried to pacify Jim by being friends with him even though I didn't enjoy our friendship and felt very uncomfortable around him.

Four months after we broke up, Jim was still calling me constantly. In my attempt to be friends with him, I agreed to go to lunch. While driving, he wanted to talk about what went wrong with our relationship and why I "didn't love him anymore." I finally said, "Look, you raped me. I did not want to have sex that first time—you knew how I felt and you went ahead and did it anyway."

My statement seemed to shock him. He responded, "I don't know what you are talking about. How could you think that?" It was difficult enough for me to say what I already had and I knew that it would be futile to try to convince him that what I was saying was true. He would never admit to what he had done. I didn't have the fight in me to pursue the issue. I was silent for the rest of the car ride and I made him take me home immediately, without further discussion.

He called me incessantly after that. For the most part, I would avoid him. But occasionally, I would go to lunch with him just to appease him

and to absolve myself of guilt for evading him. I still believed that I shouldn't make enemies; I had been taught to be pleasant to everyone. It was becoming increasingly difficult to adhere to this social rule, however. I had felt uncomfortable with my relationship with Jim in the past, but it had reached the point that just thinking of him made my skin crawl. He started to stalk me, watching me come and go from my job and my home and leaving anonymous flowers and notes on my car when I was at work.

I tried to forget about Jim and move on in my life. I avoided his phone calls and no longer accepted any invitations. Instead of facing the issues surrounding the rape and my relationship with Jim, I, again, tried to bury the past and advance into the future, attempting to regain some of what I had lost due to the rape. I had become a very closed person, rarely sharing my inner feelings with anyone. I could protect my increasingly fragile self-esteem and lack of trust by keeping my problems to myself and putting up an "everything is okay with me" front. I had several friends who would tell me their problems, but I never shared mine; these single-sided relationships were an attempt to reestablish my lost sense of control. Although I have tried, I still can't help feeling that I will never be able to fully describe how the rape impacted my life in a way that would make people who have not been raped understand.

The following year, I mistakenly believed I could erase the bad relationship I had with Jim by having a good one with someone else. I agreed to have sex with my next boyfriend, not because I really wanted to or because I was in love with him, but in order to feel like I was making a conscious decision, that I was in control. Again, I was pretending. Making a decision to have sex did nothing to wash away the fact that the decision had been taken away from me before.

Having sex with someone else did not erase the past and make everything better. Instead, it made things worse. The combination of wanting sex to be the cure that it was not and suppressing my feelings about being raped affected my sexual life—I had problems allowing myself to be vulnerable and feel sexual pleasure. It was close to impossible for me to have an orgasm.

I broke up with this new boyfriend once I recognized that no one other than me would be able to heal me, that covering up the past would not make it go away. I realized from this unsuccessful attempt that having sex with someone else, no matter what kind of sex it was, would not make my painful memories disappear.

Years later, I reached a place where I was comfortable with my past and my present. I felt that I had finally addressed all the conflicting emotions

surrounding the rape and the time I spent with Jim afterward. I was able to admit to myself and to others that I had been raped and I believed that I was "over it." I had begun to date someone who I was very excited about. Bill, my new boyfriend, and I had a great time together and we could also talk seriously. He was exactly what I needed, a good friend who accepted me for who I was. We were still getting to know each other but I felt very comfortable with him and I even felt some of my lost trust coming back.

One night when Bill was over, there was a knock at my door. I looked out the window and was shocked to see Jim's car in my driveway. My stomach suddenly was in my throat. Although I had reconciled a lot of my own emotions and thoughts surrounding the rape, I had not confronted Jim. It had been a while since the last time he had called and I had no idea why he was at my house that night. I ignored his knocks, hoping he would believe no one was home. I didn't want to talk with Jim. I had accepted the fact that he had raped me, but I wasn't ready to face him. I especially didn't want to confront him in front of Bill.

Jim must have known that I was inside. Perhaps he had watched Bill and I arrive together; maybe he had seen Bill's Mustang parked out front. Jim didn't leave when no one answered the door. Instead, he began banging on the door and yelling, "I know you're in there!" I was scared and felt captured in my own home. Feeling victimized again, all the old doubts and fears came rushing back to me. What had I done wrong to solicit this type of behavior? Why wouldn't he just leave me alone?

I didn't know what he would do next, but I wasn't about to open the door. I knew that I should feel no obligation to let Jim inside my home, but at the same time it seemed wrong to me not to open the door to someone on your front step.

I apologized to Bill for the incident and tried to explain. I don't know if he understood but he realized I was upset and tried to comfort me. Thankfully, Bill did not try to take the situation into his own hands and confront Jim himself.

The knocking and yelling eventually stopped but when Bill and I left the house later, we saw that Jim had strewn oleander flowers all over my doorstep and had put one flower on my mailbox and one on Bill's car.

Jim's actions made me very nervous and uncomfortable. I felt like I was constantly being watched and I questioned whether I was doing something wrong to bring on this bizarre, frightening behavior. This, in turn, made me question again what I had done to be raped in the first place. Although I was becoming a confident woman, Jim still made me feel like a little girl.

I confronted Jim once about the flowers and the anonymous notes.

When he admitted to leaving them, I exploded at him. I wanted him to know how furious I was and how bad his behavior made me feel. "Don't ever pull those kind of stunts again! They do not make me feel good, they upset me and make me feel watched. I don't want this kind of obsessive behavior on my doorstep, Jim. I do not want to feel like I am being watched!"

The stunts stopped after my tirade; it took longer for the calls to cease. I remember well the day I put an end to his calls. Toward the end of the summer, four years after Jim and I broke up, the phone rang. My room-mates and I were all sitting around in the living room laughing, and I picked up the phone: it was Jim. My heart sank and my face changed. Everyone looked at me because they knew something was wrong. I panicked, I just didn't want to talk to him. "I'm kind of in the middle of something, Jim, can I call you back?" He agreed and gave me his number, but I didn't even write it down. I hung up with no intentions of calling him back; Jim never called me again.

It has been eight years now since I was raped. I have only confronted Jim about that night the one time in the car. Hanna still runs into Jim every once in a while, and says the only thing he'll talk about is me: where I am, what I'm doing. When I see Jim's friends, they also say that Jim still talks about me, and they always mention what a special person I was to Jim. I think only Hanna can appreciate what Jim put me through, and why he will never be that "special" person to me. I have not heard from Jim in four years, but I still fear running into him some day.

Although I don't want to confront my rapist again, I have accepted the rape as a part of my life which I have learned from. I know that it will always be a part of me. I have since grown into a strong woman, but because there was once a point when I had no control, like everyone, I sometimes doubt my strength. The vulnerable girl is still underneath my adult exterior.

Most frustrating of all is the realization that I may still not understand all the repercussions that my rape has had for me, both as an individual and as a partner in other relationships. I have, however, accepted this as part of the package. I still feel some of the original shame, anger, and confusion, but each year it lessons. I am finished pretending, and am no longer a slave to ridiculous social niceties. I have taken responsibility for myself and my healing.

Once I became true to myself, I was able to be true to others as well. I am now in a very loving relationship with a wonderful man. I am able to

be open with him since I have gained back much of the trust, self-worth, pride, self-esteem, and control I had lost. There may be repercussions from the rape still with me today, but I am now a normal person, leading a normal, happy life.

Special thanks to Liza Veto, who put the original draft together from an interview for me to edit. Without her, my story may never have materialized in written form.

14

Why "Real" Men Rape Women

Paul Kivel

Paul Kivel is a cofounder of the Oakland Men's Project, a nationally recognized community education and prevention project focused on issues of men's lives and violence. He is the author of Men's Work: How to Stop the Violence that Tears Our Lives Apart *and the* Men's Work *video, audio, and workbook series (Hazelden, 1992/93), and, with Allan Creighton, the co-author of* Helping Teens Stop Violence *(Hunter House, 1992).*

As I read the stories in this anthology I keep asking myself "Why do men rape women?" First I thought about the easy answer: rapists are sexual psychopaths.

In fact, research shows that most men who rape women are not personally or sexually much different than most other men.[1] Nor are they crazy. Most rapists are sane, rational, and lead socially acceptable lives. Rapists are not sexually frustrated. Many men who rape women are in stable sexual relationships. Although the assumption that rapists are insane was the first answer that came to mind, it didn't answer my question.

Many of us put a wall around rapists, separating "them" from "us." This wall excuses us from looking at our own behavior and the behaviors of the men close to us. If we're male, we want to believe rapists are different than we are. If we're female, we want to believe rapists are different from the men we know. But this wall won't protect us from the reality that men who rape and men who don't are often similar in many ways. Any answer which tries to explain why men rape through individual psychology or pathology won't help us understand the systematic, routine, and widespread persistence of sexual assault.

In our society we train boys to be tough, aggressive, in control, not to express their feelings, not to cry, and never to ask for help. The definition

of masculinity is a set of rigid male role expectations that every boy is constantly reminded he must live up to in order to be a "real" man.

The training begins early. Many parents stop holding, kissing, and hugging boys when they're four or five in order to toughen them up. We tell them to act like a man, not to cry, to go out there and take care of themselves. Many boys are sexually assaulted, hit, yelled at, teased, and goaded into fighting to prove they're tough and can take it. Each part of this masculinity training teaches boys that they will be violated until they toughen up, must learn to protect themselves through the use of force, and will be able to take their pain and anger out on others the way older men have done to them.

Our society trains boys so well, so young, that by the time they go to school they can police themselves using names and fights to keep each other in line. "Wimp," "fag," "mama's boy," "girl," "sissy,"—each taunt acts as a reminder to act tough. Feeling constantly challenged, boys look for power and control. Because those who have greater power such as parents, teachers, or police are usually out of reach, the best available targets for aggression are girls and younger boys. When a boy or man is challenged, he can prove he's a man either by fighting the challenger, or by finding a girl or younger, more vulnerable male to demonstrate how aggressive he is. Although anyone will do, hitting girls is especially good because it establishes our heterosexual credentials while it relieves any anxiety that we may not be tough enough. Hurting girls becomes both a sign of our (heterosexual) interest in them (we're paying attention to them), and a symbol of our difference from them (we're in control).

This relationship to girls seems perfectly natural because boys are taught that women are primarily sexual objects. A boy will see literally tens of thousands of visual images during childhood of young, blond, blue-eyed, thin, and beautiful women who are promised to him if he's rich enough, if he's powerful enough, if he has the right material possessions— if he's "man" enough. Many men come to believe that a woman is just another material possession that comes with the car, stereo, clothes, gun, education, or job.

Men are trained to think that we need and deserve women to take care of us physically and emotionally, and to service us sexually. I remember thinking as a teenager that as long as I did my part, girls should do theirs. If I initiated dates, paid for our time together, arranged transportation, and protected them on the streets, then girls should show their appreciation by taking care of me emotionally, setting their own concerns and interests

aside, and putting out sexually. I think this unspoken contract is one that many heterosexual men assume.

But when we expect that a woman will provide sex for us, if we don't buy her services either directly through prostitution, or indirectly through pornography, we have to strategize to get what we feel is our due. We know we "deserve" sex because we're men, but we also know that she has been trained to protest our sexual advances to show that she is a "good" girl, not a slut. We learn that women really want sex—after all, that's largely what we've learned they are for (besides taking care of the kids, cooking, cleaning, etc). They might say "no," but they really mean, "yes, just try a little harder, show me how much I'm worth to you." We give ourselves license to use absolutely any tactics to get women to give in to sex. We might negotiate, bargain, cajole or demand, manipulate, inebriate, threaten, bribe, intimidate, or simply attack.

However, we are also taught that the more powerful we are as men the less force we should need to use. There are vast differences in the resources we have to command women's sexual and caretaking services depending on our race, class, job, and education. The more "male power" we accumulate or are given by class or racial birthright, the more we can rely on money, status, power, and control (instead of physical force) to get sexual attention from women. The more force we have to use, the less entitlement we feel and the more angry and impatient we become. So we always start out, hoping and expecting it to be easy, with lines like the following:

- Have another drink.
- You look tense. Let me give you a massage.
- Relax, you'll enjoy it.
- Don't you like me?
- Show me you love me.
- You know, there are lots of other women out there.
- I spent a lot of money on you.
- It's time.
- You got me all excited.
- You are special; you're different from other women.
- You don't know how good it can be.
- I can't live without you.
- I'm not leaving.

Since by definition "real" men naturally end up having sex with women, there is no limit to how much pressure we might be willing to apply to get

what we think we need and deserve. If a woman is pretty or smart or rich, we justify what we do as a challenge with phrases like:

- She thinks she's so . . .
- Who does she think she is?
- She probably thinks I'm too . . .
- I'll cut her down to size.
- I'll show her.

If our manipulations fail and we end up raping her then we have to blame her so that we can deny our aggression and keep our self-esteem and self-image intact. Men blame women using phrases like the following:

- She's fucked up.
- She's frigid.
- She's too emotional.
- She shouldn't have said that.
- She knew that would make me angry.
- She asked for it.
- She said no but she meant yes.
- You should have seen what she was wearing.
- She was really drunk.
- She was all over me. She wanted it.
- She's a tease.

If she is less educated, poorer, or not "good looking," or if we're white and she is not, these factors can be used as justification for treating her abusively because we've been taught that she doesn't deserve any better.

In the final analysis, we never do see women as independent human beings with feelings, concerns and perspectives of their own. Because we have pre-explained women's needs, thoughts, and actions according to our male projections, it invariably comes as a surprise to men that women are hurt by and angry about men's sexual assaults. We respond by minimizing and justifying our actions with phrases like the following:

- I didn't know.
- I didn't mean . . .
- You're too sensitive . . .
- It was just regular dating behavior.

- That's the way guys are.
- You shouldn't be so angry.
- It wasn't such a big deal.
- Women are just too . . . anyway.
- What can you expect?

Many men feel set up. We spend years learning the male code for sexual conquest and think that we are just following the rules. In a sense we *have* been set up. We have been set up by the gender roles we were trained in and the expectations about women that we were led to believe were true.

Why *do* men rape women? The answer is complex. Because we have been trained to. Because there are few social sanctions against it. Because men are trained not to see women as people, nor to empathize with the powerful and sometimes detrimental effects that our actions have on them. Because we live in a society where it is acceptable to exploit people with less social and personal power.

Whatever the reasons for male violence, men are responsible for rape, and for stopping rape. Our male training and expectations of women have been defined, passed on, and enforced by both individual men and a male-dominated society. Therefore, it is particularly powerful when men challenge men about rape and other forms of sexualized violence, contradicting the myths that it is natural, inevitable, or inconsequential for men to abuse women. This is truly men's work—to reclaim our own humanity, and stop all forms of male violence and exploitation.

Men's work is on a variety of levels. This work is:

PERSONAL: Look in our own lives at any ways we are controlling, abusive, or disrespectful toward individual women. Do we objectify women, tease women, tell demeaning jokes, use pornography or prostitutes, or sexually harass women? Do we expect our sexual partners to put out for us, do what we want, and put our needs first? Do we force or manipulate women into having sex with us?

INTERPERSONAL: Reach out to other men and challenge the culture of rape which allows sexual assault to continue. Too many times we are silent when the comments are made, the jokes told, the pornography pulled out, the conquests recounted, or the harassment carried out. Part of men's work is to challenge other men.

PARENTAL: Model for and teach our sons and the other young men in

our community positive ways of relating to women which are based on re-
spect, mutuality, equality, and caring.

SOCIOPOLITICAL: Challenge the systematic mistreatment of women
and girls which makes them vulnerable to sexual assault, child abuse, in-
cest, date and marital rape. Job discrimination, routine harassment, lack of
police protection, and cultural objectification all put women at risk. Men's
work is to become allies with women in the struggle to stop the violence,
end the mistreatment, and to work for justice for all women, children, and
men in our society.

Notes

1. See for example, Groth, Nicolas, *Men Who Rape* (Plenum Press, 1979);
Beneke, Timothy, *Men on Rape* (St. Martin's Press, 1982); and Kivel, Paul, *Men's
Work: How to Stop the Violence that Tears Our Lives Apart* (Hazelden, 1992).

15

How a Hockey Player "Scored" and I Lost My Virginity

Savannah Talbott

I remembered it when I was in the middle of having sex with my first lover. We had been together about a year, and I was twenty-one. He was the first person that I officially had sex with, and I considered myself a virgin before him. He was on top of me holding my hands and arms above my head. We had been seeing each other for several months, and I had built up a great deal of trust with him. We had certainly had sex in this position before, but suddenly an awful feeling of powerlessness overwhelmed me, suffocated me. I became engulfed in a wave of fear and I started crying and screaming for him to stop. At the time, I didn't know what had triggered my reaction, and he was scared and shocked, thinking that he had hurt me.

I was seventeen when I first entered college. I specifically chose to attend a university located a few hours away from home so that I could meet new people and experience more freedom away from my parents. I went out several nights a week, and enjoyed staying out late with no curfew to worry about. Looking back I am struck by the events of the evening that it happened. It began like so many other nights—I was out in a bar with a group of my girlfriends. I started talking to a hockey player and we went to another bar together. I went with him primarily because the hockey team was very popular on campus, and it made me feel "popular" to be seen with a hockey player. Perhaps I hoped that this chance meeting would lead to something bigger, more exciting, and permanent. I was also a member of a sorority, and wanted to have a lot of dates to impress my sisters.

I was drinking heavily and so was my date. By the end of the evening we had outlasted all of our friends and just the two of us were still out. After the bar closed we were both hungry, but neither of us had enough

money to eat at a diner. He suggested that we go back to his apartment to cook breakfast. I agreed to his suggestion and we walked back through town to reach his place. While it might seem dangerous to go to the home of a new acquaintance so late at night, it was common among my group of friends, as with many college students, to go out to eat or back to a friend's apartment after partying until the wee hours of the morning. I had grown up in a close-knit, suburban community, and had transferred my attitudes from my home environment directly into my new life-style at college, without really shifting gears or questioning if my judgment was still valid. Our campus was small, and I was naive and drunk enough to feel safe in the company of a relative stranger. I had assumed that I might start dating this man, and throughout the evening he gave no indication that his behavior would not remain civilized the rest of the night. Once we arrived at his apartment, he showed me the kitchen. I made myself at home and started preparing a late-night snack of Kraft macaroni and cheese. He said he had to go to the bathroom and left the kitchen. My back was to him and I resumed cooking.

When he came out of the bathroom he was completely nude. I was stunned at the sight of him and simply stared. He advanced toward me, spun me around, locked his arms around me from behind and started touching me and trying to kiss me. I remember thinking—*this guy is crazy, I have to get out of here.* I still did not realize what was going to happen however; I was more startled than frightened. I tried to laugh off his behavior by telling him to stop, that I was hungry and wanted to eat the food that I was cooking. I don't know how he did it, but the next thing I remember he had dragged me into the living room adjacent to the kitchen and he was on top of me. I was on my back and he would not stop touching me and when I resisted him he grew more forceful, holding my arms down with one of his hands until I could barely move. I didn't want to be there with him on top of me—he pushed me down on my back and physically held me to the ground with the weight of his entire body. I struggled underneath him and the carpet scraped my face each time I twisted to try to squirm away from him. Still holding me down, he tore my jeans open with one hand and pushed them down around my knees. He was hurting me—I was still struggling against him but he managed to pull down my underwear and stick his fingers inside me. Then he began trying to force his penis in me. I had never been penetrated before and I was terrified. At that point I was screaming and crying. He couldn't push inside me because I was so dry. He quickly got up, went into the kitchen and got a stick of butter. I was still in shock and before I could move away or even pull my

jeans up he came back and used it to force himself inside me. I was crying and telling him to stop. It hurt terribly and the weight of him on top of me was numbing. I felt completely powerless, physically and emotionally. I could not stop him.

Afterwards he acted like nothing had happened. I was still lying on the floor and crying and he quickly got up and went into the next room. I pulled up my jeans and crouched in a ball, still crying and shaking. When he emerged from the other room he was dressed and said that he would drive me home. I must have been in shock because I still do not think that I had any idea that I had just been brutally attacked and raped—all within the space of a few minutes. It was bitter cold outside and I sat in his car hunched up next to the door shivering and shaking. Mercifully my dorm room was only a few minutes from his apartment. We pulled into the parking lot of my dormitory and he turned to me and asked, "How old are you?" I responded that I was seventeen. He looked at me and said contritely, "You're only seventeen? I'm sorry." I looked at him and replied, "Why are you sorry? Do you have a sister who is seventeen? Would you like her treated this way?" He looked down at the steering wheel and answered, "Yeah, I do have a younger sister." I got out of the car without another word.

Returning to the warmth and safety of my dorm room, everything was as I had left it hours before. There was an amazing succor in the knowledge that I was safe there, that nothing had changed, at least in my little room. I stared at my face in the mirror and it was covered with mascara where my tears had smeared my makeup. At that time I had never heard of date rape and looking back I don't believe I fully understood what had just happened to me. Sadly, it never occurred to me to file charges or to even accuse him of rape. The next day I acted as if the night before had simply been any other late night.

I never told my friends about my rape. I simply did not want to believe that anything as awful as rape could happen to me, or that I could let a "mistake" like that enter into my life. I was a good, smart girl from a nice family. I just didn't think that things like rape could happen to me. But an underlying shame that something so awful *did* happen to me prevented me from confiding in anyone and helped to block out any memory of the event.

Although I did not discuss the evening with anyone, throughout the next few weeks I thought about the incident and tried to process it. I knew that something terrible had happened because I was no longer a virgin, and I had been taught from the time that I was a little girl that losing your vir-

ginity before marriage somehow made you a "devalued" female. I ratio-
nalized that because I did not have a say in losing my virginity that I really
hadn't lost it. My self-esteem was very fragile. I still believed that the rape
was my fault because I had allowed myself to be caught in a situation
where I could not control when a man could take advantage of me sexu-
ally. I deserved what had happened. I blamed myself entirely for the event.
Finally, because guarding my virginity was such a priority, and facing the
fact that I had lost it because of poor judgment was so difficult, I simply
blocked out the entire night from my memory.

I later learned through other sorority sisters that this hockey player was
infamous for his mistreatment of women and that my attacker had gone on
to sexually assault another young woman on campus. He was obviously a
chronic abuser of women, but even that knowledge did not help me cate-
gorize my abuse as date rape. At that point I still did not understand that it
was he who had been wrong, not me, and that I had the option of taking ac-
tion against him. My self-esteem was so fragile that it never occurred to
me that someone might say "it wasn't your fault—he is the one who did
something wrong."

I simply went on with life as usual, or so I thought. I continued to have
dates and see men but I never had intercourse. It was also several years be-
fore I was able to establish a real level of trust and emotional intimacy with
a man.

It amazes and scares me that this memory forced itself back into my
consciousness while I was having sex. In effect, it was four years after my
rape that I fully remembered what had happened that night. And after that
memory, it was years before I was able to admit to anyone other than my
lover that I had been raped. When I explained to him why I had begun cry-
ing and shaking during sex he didn't believe me at first. He said, "You
enjoy sex too much to have ever been raped." Such a response from a man
who was usually a very caring and sensitive individual, and to whom I had
trusted enough to divulge my terrible secret, was almost as painful as the
actual rape. I questioned him and we examined my memory together. He
eventually did come to believe that I had been raped, but he really did
not know how to help me overcome my feelings of shame and guilt. I
also think that he viewed date rape as not really rape since no one jumped
out of the bushes with a knife and forced me. Since I made the decision
to go home with a stranger, he believed the consequences were my re-
sponsibility.

My lover's response caused me to examine and reexamine my memory
to try to figure out if I was remembering something incorrectly, and I ques-

tioned myself constantly. Had I enticed the hockey player or made him think that I was promiscuous? Did I intimate in any way through my behavior or conversation that I was going home with him to have sex? Was I crazy? Had it really happened to me? And if it had really happened, was there something wrong with me because I was able to physically enjoy sex now? Maybe it had been my fault. Wasn't I mature enough to know that going home with a stranger could be dangerous? In addition to an intense period of self-examination, I had also learned a valuable lesson from my lover's response: that people might not believe me if I told them about my rape. I decided to keep quiet.

I had learned how to submerge my feelings so well that I still didn't seek counseling or any support. Although I continued to date the same man for three more years, our relationship slowly deteriorated until we no longer even had sex. After him I had several relationships with other men, but none that lasted more than a year. It became increasingly difficult to open up with each new relationship, and I knew that I would need to get some help.

I am now thirty years old. It has been thirteen years since I was raped and nine years since I remembered and realized that what had happened to me with the hockey player was, in fact, rape. For the past two years I have been seeing a male therapist and the date rape and emotional aftermath has been one of the central issues of my therapy. I began therapy because I could not establish a trusting, caring relationship with a man, and I knew that I needed to try to uncover and get over my intense feelings of distrust with men. It was very hard to admit to my therapist that I had been raped and I have never told him the details. I am still struggling with the effects the rape has had on my self-esteem and how I feel about myself as a sexual being. I continue to search for links between my rape and my subsequent relationships with men.

My healing process has been a long one, with several phases. First, I needed to remember the details and admit that I had been raped. I also had to learn about violence against women, and place the responsibility for this violence with men. My attacker had learned from many parts of society that violence against women is acceptable.

Being able to tell other people what had happened to me and having them be supportive, not judgmental, was a big part of working through my feelings of shame and guilt. However, the transition from blaming myself for what happened to actually believing that it wasn't my fault took several years. Going through the process of understanding that rape is rape— whether it is date rape or stranger rape—was integral to my healing. Sim-

ply because I had met my rapist a few hours before the attack did not make his actions less of a crime. In fact, I think that victims of date rape have an incredible trust problem to overcome. I emerged from the incident not only afraid to have a man touch me, but truly untrusting of the actions and the motives of all men. I was also angry. This man in one brief, violent episode had taken away many aspects of my youth, trust, naiveté—and of course, my virginity.

I am no longer angry, but dealing with the physical aspect of the rape has for me been an insidious aspect of the recovery. In the aftermath of the rape I behaved in two completely different ways in my relationships: I either did not want to be physically intimate with a man, or I would have a very physical relationship as if to prove that the rape had no effect on me. This aspect of recovery has been a tough one for me. Once I did start choosing to have sex, I definitely used sex in a controlling way. I didn't trust men, and often felt powerless. Through the rape I had learned that sex could be used as means of control and was a powerful tool. I assessed a relationship in terms of power and control. I had what men wanted, and I could choose to give it to them or not. It was also very important for me to be "good" at sex, and to enjoy it. For several years I put pressure on myself to have a lot of sex. Therapy has helped me analyze the power dynamics of my sexual activity since I was raped. I have learned that in a mutually trusting, caring relationship no one needs to be in control. It has been difficult to build up a trusting emotional and physical relationship with a man again, but I am currently involved in a long-term relationship with a very caring partner. We talk openly about our feelings and emotions, and share all decision making, particularly as it concerns sex.

I remain both fascinated and frightened by the extent to which one event affected my life for years. I was privileged to grow up in a home and community that sheltered me from the reality that people deliberately hurt each other. Something terrible happened to me and I learned that people can and do act abominably. I also learned, slowly, to pick up the pieces and get on with my life.

I am still haunted by the fact that the rape was not my fault. Why did I blame myself for so many years? Certainly there are several components that shaped my perception of myself and my place in the world: my family background, how I was raised to believe women should act, the status of women in general, and the social stigma inherent in rape.

Our culture has been bombarded with books and articles about "victims." I don't feel like a victim anymore. I am not the passive woman I once was. I was a naive, trusting young woman when I arrived on my col-

lege campus. I was a self-contained, mistrustful young woman when I left. It took years to pull down not only the walls of shame and guilt built up from the rape, but also the walls our society has put around what is acceptable behavior for women. The rape was the incident that forced me to focus on many other confusing feelings that I had about the role of women in our society, and issues of women and sexuality. I continue to expand my own expectations of myself as a woman, outside of what my family and society as a whole have taught me. Most importantly, I refuse to let a violent man take away a part of my life. By reclaiming the part of me lost for so many years, I have become a stronger, more purposeful woman.

16

Rape Enforced by Society: A Feminist Perspective of Date Rape

Laura Beth Nielsen
Catherine R. Albiston

Laura Beth Nielsen is the executive editor of the Berkeley Women's Law Journal and is a doctoral student of jurisprudence and social policy at the University of California, Berkeley. She is currently writing her dissertation on rape and street harassment.

Catherine R. Albiston is the editor in chief of the Berkeley Women's Law Journal and is a member of the California bar. She holds advanced degrees from Stanford (M.A. Sociology) and the Boalt Hall School of Law, University of California, Berkeley (J.D.). She is also a doctoral student of jurisprudence and social policy at the University of California, Berkeley.

"I thought it was normal for a man to disregard a woman's voice when it came to sex."

—Christine Kim
"True Love," Chapter 12

The scenarios in this book are not what we usually think of when someone says rape: a stranger jumping out of the bushes, raping a woman with a knife at her throat. Although these stories are all as different and varied as the survivors themselves, themes reoccur among them. For example, why don't the men in these stories stop when the women say no and resist? Before Catherine Lyons was raped, she said no, pulled back, cried, told him to stop, and asked, "What are you doing?" Despite her protests, the man

Catherine was with insisted she wanted to have sex with him and raped her (Chapter 1). Scott Stewart gives a date rapist's point of view: "I thought that deep down, most women wanted sex as much as I did, but that guilt forced them to offer at least token resistance. Sex was playful, and not until a woman said no a couple of times—when she really meant it—did I know it was time to stop" (Chapter 4). How do Scott and others learn to distinguish when a woman "really means it"?

Furthermore, when men force sex on women, why do women consistently fail to identify what happened to them as rape, although they know that they have had sex against their will? Christine Kim explains that it took her two years to admit to herself that she had been raped, despite the fact that her boyfriend had agreed with her decision to remain a virgin until marriage—and despite her pleas for him to stop. Even though she resisted her boyfriend's unexpected actions, saying "no, no, and . . . [trying] to push him away" (Chapter 12) Christine did not immediately perceive the incident as rape.

In stranger rape, a woman's "no" or nonconsent is assumed. Usually, we define forced sex with a stranger in an alley as rape and consider the rapist's actions damaging, deviant. But after even the briefest meeting between a man and a woman, such assumed nonconsent is lost and consent may suddenly be a possibility. A stranger who flirts with a woman in a socially appropriate place is rarely considered a true stranger.

Who taught us that forced sex by a friend or acquaintance is not really rape? Who taught Scott and other date rapists that the women really mean yes when they say no and resist?

While all of the rapes in this book did not occur on actual "dates," none fit the prototype of stranger rape. These rapes are labeled "date rapes" because they had the social expectations of a date imbedded in them; they occurred within a social context where it was acceptable for a man to make sexual advances toward a woman, whether the advances were wanted or not. If there was no surprise, no dark alley, no weapon (alcohol is not considered sufficiently incapacitating, even if the woman is unconscious), the experience is usually not considered real rape, stranger rape. To fully understand date rape, therefore, we must be willing to critically examine a society in which men believe they have a right to sex with women without consent. We must be willing to examine a society in which a man can force sex on a woman without fear that she will send the police looking for a rapist.

Date rape, like all other social interactions, takes place in a social con-

text. Each move, word, and thought by both the victim and the rapist is shaped by their ideas about love, sex, and what it means to be on a date. The "social script" (psychological blueprint for social activity) for a date is determined by our society and culture. Social scripts provide our basis for understanding and behaving appropriately in a situation familiar to us. Social situations seem familiar to us (even if we have never been in them previously) because they are blueprinted by scripts which we have enacted or seen enacted by others many times before. Social scripts can be translated into social expectations; we expect that people will act within the bounds of our social scripts. For example, sociologists James Check and Neil Malamuth explain the genderized scripts which legitimize coercive sexuality:

> The traditional sexual scripts with which men and women are frequently raised dictate that women are not supposed to indicate directly their sexual interest or to engage freely in sexuality. Men, on the other hand, are taught to take the initiative and to persist in attempts at sexual intimacy even when a woman indicates verbally that she is unwilling to have sex (presumably because of the male belief that a woman's initial resistance is only token).[1]

This is clearly the script that Scott describes in his essay ("I thought that . . . most women wanted sex as much as I did, but that guilt forced them to offer at least token resistance"), and is probably the script that many of the other men mentioned in this book used to interpret the actions of their female dates. Although there are certainly deviations from the prescribed gender roles in dating situations, these deviations are recognized as deviations; for example, a sexually aggressive or forward woman is recognized as such, and is sometimes negatively labeled a slut. Social expectations about how men and women "normally" interact influence their activity on a date and in the date rape context.

Because date rape is a socially constructed event, to understand date rape we must understand what shapes our conception of gender and social scripts. The media is certainly one way which we learn about social scripts, influencing the way that men and women interact with one another. Images of men, women, and their interactions surround us in modern society, confronting us whenever we turn on the television, go to a movie, listen to the radio, walk down the street and see a billboard, read a magazine, look at an album cover, or see a poster on the side of a bus. The media serves as a constant reminder of "normal" male-female interaction, re-

flecting actual social relationships while influencing the norms of social interactions. Love stories on television and in the movies may not be "real," but the way that the men and women interact is perceived as believable. The media provides a model for normal male-female interaction, helping to create a status quo.

Slowly and unconsciously, people absorb the images so frequently seen. Many more movies than we may realize contain a rape scene. We may not realize it because sex forced on a protesting woman is often portrayed as normal, erotic sex. Movie rape runs the spectrum of force. Some movies contain obvious rapes—the woman is badly beaten or there is a weapon—while others contain coerced sex which is more subtle. Unless the movie is about rape specifically, forced sex in movies usually is not considered rape despite the level of force used by the man to gain sexual access to the woman.

Consider the uncomfortable scenes in "Nine 1/2 Weeks" in which John (Mickey Rourke) forces Elizabeth (Kim Bassinger) into a series of sexual situations which clearly make her uncomfortable. The first time that John blindfolds Elizabeth he asks her, "Does this frighten you?" She says yes, but he does not stop. Later, they fight and John tells Elizabeth, "You've been a very bad girl, Elizabeth. I want you to face the wall and I want you to raise your skirt because I am going to spank you." Elizabeth is indignant and attempts to leave, but John grabs her and rips her panties off as she strikes him, forcing his penis inside of her. Because she is happy and contented by the time he is through, the rape is transformed into satisfying sex, mending their broken relationship. This transformation teaches male viewers that resistance is something to be overcome, not just for their own sexual gratification, but also for the sexual and emotional gratification of the woman.

The failure to name forced sex as rape is also captured in "Basic Instinct." When frustrated main character Nick (Michael Douglas) returns home to his girlfriend, he slams her against a wall, rips her clothes off and forces himself inside her, despite her protests. When Nick has finished, Beth accuses him, "You weren't making love to me." Nick responds, "Who was I making love to?" Beth replies, "You weren't making love." The scene shows us what we know is a rape: Nick engages in violent intercourse with Beth despite her protests. Beth, a psychiatrist, also identifies Nick's actions as forced, and yet she fails to identify the event as rape or to cease her relations with Nick. Both Beth and Elizabeth are the girlfriends of the men who rape them; because of their "girlfriend" status, their consent is assumed by Nick and John. Movies like these influence the

way young women perceive their boyfriend's actions, causing the perception that forced or unwanted sex is too trivial to call rape.

Movies are not the only form of media which influences our social and sexual scripts. The advertising industry exists solely to create and influence social understanding. Advertising attempts to create certain desires, to make people want a certain shirt or car or beer. In addition to creating these (sometimes false) needs, the constant barrage of images affects the way we understand ourselves and each other. When sex is a part of those images, advertisements are playing a role in shaping our sexual scripts, including scripts which legitimize date rape.

For example, consider an advertisement for Miller Beer. Opening to a hot desert scene, a young, good-looking man wipes the sweat from his brow and purchases a Miller. The jealous storekeeper looks on as his customer opens the thirst-quenching can, and it begins to snow only on the Miller drinker. Out of nowhere, a spandex-clad beauty appears to share the Miller with the young man and they leave together. From the look on the storekeeper's face, we know that he envies not just the beer and the sudden snow, but the woman that also comes with Miller. As viewers, we know that a beer is not the only thing the woman will share with the Miller drinker.

The woman in this advertisement appears for no reason other than to serve as sexual companion to the man (all men) wise enough to choose Miller. She is not a person with individual desires; she is instead an object that's sexual availability and consent to sex can always be assumed. This beer advertisement, like so many others, also assumes consent of female companions: if you drink our beer, women will appear for your sexual disposal.

Men learn from these everyday advertisements, and women become accessories to their beer drinking. Complete strangers become potential sexual partners, and individual women with individual desires become nameless objects. Since their consent to and availability for sex is assumed, their protests—already questionable by our social scripts—become meaningless.

Consider Leslie's story (Chapter 17): When Leslie repeatedly told Eric not to touch her genitals, he responded by saying that he wanted to make her feel good and continued his advances. Her message was clear: his touching her genitals would not make her feel good, but he ignored her. He "knew" (from movies, advertisements, TV he'd seen) that she would "come around," eventually "enjoying" his forced advances. And her desires may have been irrelevant; he wanted to make himself feel good, and

she was instrumental for his desires. By ignoring Leslie's wish to be left alone, Eric denied her ability to have or express feelings as an individual person. Leslie became nothing more than a receptor for his penis, a plaything. Like in "Nine 1/2 Weeks," it didn't matter that she was saying no, it was a part of the script, that was her role. His role was to ignore her protests, overcome her resistance. Leslie's ultimate consent to sex was assumed (he knew what she would like) just as Elizabeth, Beth, and the Miller woman's consent are assumed.

Advertisements in which women are portrayed as existing simply for the pleasure of men are only one social force which shape our perceptions about "normal" male-female interaction. The social script for resistance as portrayed by the movies above does not include the man respecting or paying attention to the woman's resistance, and constant exposure to acquiescent women in the media makes it unbelievable to male viewers that the women they are with are sincerely resisting their sexual advances. And if the women they are with do resist, it doesn't really matter because the women will thank them later for being so persistent.

When women are in sexual encounters that have escalated to uncomfortable or unintended levels, they don't have a script which allows them to say no and mean no. Although she blatantly and repeatedly told the man she was with that she was not going to have sex with him, to the point where she felt silly, Montana O'Riley's message still was not believable to her rapist (Chapter 2). The lack of a "no" script makes confrontation especially difficult because men are likely to assume that resistance to their unwanted advancements are token and can be ignored. To complicate things, young women may not know the difference between consensual sexual activity, pressured sexual activity, and forced sexual activity due to a lack of sexual experience. J. M. Alexander's story illustrates this confusion: "the hands press more and my head is going down and I'm nervous because I want to feel sexy, I want to be sexy, is this what being sexy is all about?" (Chapter 20).

Furthermore, when a woman recognizes sexual activity as forced, there can be confusion between a desire to preserve the intimacy gained (or at least not to make a fool out of herself) and an attempt to escape the horror of the situation. Despite her desire to get out of an uncomfortable situation, Theresa Walden explains her inability to do so. "It was obvious that he wanted much more than I was willing to give sexually and I felt pressured. He was kissing me harder than I liked and I had to repeatedly remove his wandering hands from my body. It was the first time anyone had been so aggressive with me and I did not know how to escape *gracefully*" (Chap-

ter 13). A quick knee to the groin is not part of the social script of a date, and Theresa's story illustrates the problem for women who have exhausted "acceptable" methods for calming an overzealous date.

For some women, resistance to sexual assault seems futile from the outset. In addition to messages sent by the media about men's unlimited sexual access to women, myriad other social messages subjugate women. Interactions in which the woman is unable to control or stop the incident, such as street harassment, can create a feeling of resigned acceptance to the inability to retain control over access to our own sexuality. The unconscious acceptance of sexual harassment and sexual assault as normal or as an experience which must be tolerated as part of being a woman leads to a gradual desensitization of the horror of sexual assault. Writes Susy Struble:

> When I was first approached about writing about my rape I forgot to mention the sexual assault. Why? Do I just lump it in with all of the other sexual abuses that have happened to me over the years? The discomforting stares, unwanted groping, rude and threatening remarks from strangers, "overzealous" dates, drunken attacks in bars and on the street? (Chapter 3).

The ease with which men are permitted sexual access to women may make women give up before even trying to resist, knowing that resistance would be futile. "Kevin's loyal friend Mike was guarding the door. Because I had been raped before, I knew I was trapped, so I tried to just get through it as quickly and painlessly as possible," writes Brenda Niel (Chapter 7). Because she had been raped before, been harassed before, and seen the images in the media of herself as a women without the ability to control her sexuality, she knew that she was helpless. Her failure to resist was not consent, but an understanding and internalization of the normalcy of rape in our society.

Looking at rape in this context, it becomes easier to see why people do not consider date rape "real rape" and why victims have a hard time naming what happened to them as rape. Media images teach men that it is acceptable to treat women as objects for their pleasure, to be controlled at their whim. Those same images teach women that it is common and acceptable to be treated in this way. The perceived normalcy of these relations creates confusion in women's minds when sexual assault occurs. Women learn that they do not have independent, autonomous identities, so invasions of their bodies do not seem categorically wrong. As a result, many women do not blame their rapists, but instead rationalize their lack

of control in date rapes by blaming themselves. We think, "perhaps I shouldn't have invited him in after the movie," as if inviting a date in for a drink were the equivalent of consenting to intercourse. Often a victim will reanalyze her every move and word to consider what she may have done to indicate her consent, when her consent was already given by media-enforced sexual scripts. What actually happened becomes confusing: she may know that he forced her to have sex, but if he thought she consented, how could it be rape?

And most victims don't want to name what happened to them as rape when they can think of what happened as a normal social interaction. "I couldn't even say the word *rape*. I would refer to it as 'the whole thing,' or 'what happened,'" writes Sadie Stoddard (Chapter 22). Likewise, Jennifer Palmer explains why she could not describe the incident she experienced as rape: "I didn't immediately call it rape. I realize now that my denial was my way of surviving. I was not mentally prepared to deal with this heinous attack" (Chapter 10). Instead of defining unwanted, forced sex as rape, women often cope with what happened to them by denying that it was rape. Women often define their experience as not-rape because they believe that nobody will recognize their harm, their pain. And often, they themselves don't want to confront their own pain: conscious acceptance of one's victimization means accepting the powerless and vulnerable position of "victim."

A woman's denial of her rape transforms her experience into something familiar. Violation is familiar to women because they are constantly bombarded by images of themselves as props, tools, and ornaments. It is easy for victims to categorize an experience as not-rape when they recognize the application of the label sex to interactions we know are forced. Defining her rape as normal or recognizing it as familiar allows the victim to continue to believe that she has control over her own body and sexuality, especially in a society which steals this identity, exploiting it to sell products, television shows, and tickets to the movies. By defining her experience as anything other than rape (bad sex, normal sex, love with sacrifice) a victim preserves her vision of the way that society works. When she defines her experience as rape, however, a woman must come to terms not only with her violation, but also with her society, and with a person she presumably trusted. In reexamining the way that she interacts with everyone she meets, a woman may be forced to realize that she must be cautious and distrusting of all people in order to be safe from the threat of sexual violence. The psychic cost of this change in worldview often outweighs the benefit of identifying her experience as rape.

Unfortunately, it is not just the media which creates and reinforces the social and sexual scripts that influence date rape situations. Instead, this problem is compounded by the incredible number of other sources from which these messages come. When our mother tells us to "give Uncle Lou a kiss" despite our resistance (and the fact that our brother doesn't have to), we learn that our bodies are not our own and that our physical comfort zone is secondary to the socially acceptable practice of allowing a kiss, even when it is undesirable. When our friend tells us to feel complimented by whistles and catcalls on the street, we learn the difficult process of re-defining a negative experience as a positive one, and that threatening situations should be interpreted as positive and even desirable.

Changing these social scripts will require concrete interventions. Individuals must be willing to critically examine the world around them, questioning representations of women that promote their objectification. If an advertisement portrays women for the sexual service of the product buyer, do not buy the product. Write to the company and explain why you will not be purchasing their products. Explain to people the media's powerful effect in shaping social scripts, and how these images directly relate to the pervasiveness of date rape in our society. In your everyday life, send the message that women's autonomy is to be taken seriously, and those who transgress upon that autonomy will face consequences.

Notes

1. James Check and Neil Malamuth, "Sex Role Stereotyping and Reactions to Depictions of Stranger Versus Acquaintance Rape," *Journal of Personality and Social Psychology*, vol. 45, no. 2 (1983), p. 344. From Christine Carter, *Living in a Rape Culture*, (1994) unpublished, p. 110.

17

A Letter to My Rapist's Girlfriend

Leslie

Many nights I lie awake in bed writing this letter, silently, in the dark, in my head. During these countless hours, I relive my victimization and its aftermath.

Dear Sue,

I met Eric at Tequila Jacks at a Phi Kappa Alpha party in December 1989. It was 11:30 when over the loud music, a bartender rang a cow bell and bellowed a well drink special that was good only for the next five minutes. The bar was stampeded by people ready to take advantage of it. New to the bar scene, I was a little confused and I asked the closest person to me, "What is a well drink?" Eric answered and asked me to join him on the dance floor where he had previously been dancing alone. We spent the next few hours dancing and talking over another drink. Before I knew it, my friends were ready to leave. Eric offered me a ride home later with his friends if I would stay. I agreed; after all, his friend was with his girlfriend, and knowing a woman would be in the car made me feel safe. I also derived a sense of security from the fact that I had friends in his fraternity, some who knew Eric. We both attended the University of Colorado, and I didn't believe a peer could be dangerous.

The two of us left TJs at close. We walked for a while and I asked where his friends were. I don't quite remember his answer, but I remember being puzzled by it. We continued to walk in the snow. "Where is your car?" I asked. "It's just a little further down Broadway Boulevard," he said. Then he said that the car was actually parked at his apartment. Writing off the uneasiness I felt about his changes in plans, I accepted when he invited me into his apartment for a while. "OK," I smiled, slightly nervous and feeling

161

that he might have refused me a ride home at this point, "but only for a while." My mind raced to think of an alternative ride home, but it was 3:00 A.M. on a Saturday and my friends were either out or drunk. We sat on the couch together and he moved closer to me. His junior standing and his good looks made me respond to his kisses. I was flattered that he liked me and I wanted to show him that I liked him too. Soon after we began kissing, Eric's roommate Arnold walked in. As embarrassed as I felt by the intrusion, Eric politely introduced us and he sat and talked briefly. Your boyfriend then asked me if I would be more comfortable downstairs in his bedroom.

Before accepting his invitation, my mind raced again, thinking it might be better if he had more time to sober up before driving on the slick roads. I also wanted to avoid another intrusion, as the last one made me feel cheap. I warned him, while making eye contact, that I did not intend to sleep with him. He replied, "I understand." Eric's response made me comfortable enough to be led down the stairs to his room where we fooled around some more. After about an hour of assertively asking him to stop touching me below the waist, he asked me to take my pants off. He said he wanted to feel my skin. Apprehensively, I agreed, as his persistence was wearing me down. I wanted to be there, but I did not want him to get more aggressive. He was going way too fast for me. I firmly told him "no" to touching my genitals, but he insisted. He defended himself, "I want to make you feel good." I unyieldingly repeated several times, "I am not going to have sex with you." Each time he verbally accepted my statement. At one point he condescendingly asked, "What, are you a virgin or something?" I told him in a firm voice, "It doesn't matter." I had no intention of sleeping with him because I had always imagined my first experience with intercourse to be with someone I loved and someone who loved me. I could not love a man who I had only known a few hours. Ironically enough he asked me several times if I had a boyfriend. He never mentioned you, Sue.

Finally, he tried to mount me. My whole body was tight. I clenched my fists and flexed every muscle in my body. I shuddered "no" for the last time. I struggled to keep my knees from allowing his waist to pass. I pushed on his chest. I closed my eyes and felt a sharp pain that echoed from head to toe. My body trembled as he violated me. I was so afraid my tightened muscles went into spasm and I could not utter a word. My eyes filled with tears.

He stopped and said blamingly, "I'm sorry. Why didn't you tell me you were a virgin?" as if that information would have prevented his sexual ag-

gressiveness. He saw my pain and tried to hold me. Shocked with what had just happened, I could only cry. He clearly held me responsible for his assault on me. It was my fault, because I had not told him I was a virgin. I do not believe he could label his actions as rape. According to Eric's tone of voice, it was my bad judgment because I did not confess my lack of a sexual history.

Then, a man barged into the room. Eric quickly jumped out of bed and had a conversation with him. When I heard the angry voice say, "Five minutes!" I realized we were not in Eric's bedroom after all. We dressed and he took me home. That year I lived in the Buckingham quad where you had lived the year before. I was not sure who he was trying to console when he had the audacity to say, "I'll call you."

I ran through the dorm straight to my best friend Rob's room. I cried in disbelief for the duration of the night. I was bleeding. My whole being trembled as I rocked myself in the hallway of Buckingham, my heart numb and simultaneously enraged in pain.

The next time I saw Eric was at a party a few months later where he had the temerity to gather his friends together to point and laugh at me. I was mentally ready for him to ignore me, as that was how I expected him to react to me. His bragging and laughing at my pain enraged me to the point of speechlessness. He made me feel powerless, yet again. What could he have said to make them laugh? Certainly not the truth. The truth was that he set me up and said that his friends would drive me home. When his friends were nowhere to be found, he lied again by saying that his car was down the street. He brought me to an apartment by pretending it was his own, introduced me to a man he called his roommate, and then raped me. Was he proud of his criminal act? I wanted to know what he had said. Did he know what he had done?

It took me a long time to realize what happened. I was raped. This experience has changed my life. If Eric is still a part of your life, I invite him to try and deny this confession. I am defending myself for the night I was unable to, at the party. My sole motive is to let the truth be heard. Eric probably never told you anything about the above mentioned events. I also want Eric to understand that what he did was a crime, not a joke. I want him to accept responsibility for his actions and feel remorse. I want him every so often to regret this on a night he can't sleep, just as I do. I have addressed this letter to you, Sue, in hope that someone might read this long enough to reach the closing. I have only heard good things about you through mutual friends; thus, I have hopes that you will take this seriously and convey it to Eric, as he has demonstrated his inability to listen to me. I was afraid that

if I had addressed this letter to Eric, you and even he would never have had the opportunity to hear my side of the story, the truth. Thank you for your time.

> *Sincerely,*
> *Leslie*

I was a victim of what to me is the worst crime of all—rape. My perpetrator robbed me of my dignity, my body, and my self-respect. Eric carefully set me up for the crime. When I accepted his invitation into what I thought was his home, I did not agree to have sex with him; I only consented to spend time with him. My limits were set even before I entered: I did not want to have my first time having sex to be with a stranger. But my verbal expressions of these limits went unheeded.

The day after my rape, I told one of my roommates about my experience. Her expression was detached. She was unconvincing in reassuring me that it was not my fault, which is what I desperately needed. She attempted to cheer me up and suggested I not contact Eric. I felt her consolation was unfeeling and slightly blaming of me. Her reaction to my rape never affected our relationship but I did not talk about my rape with her again for the duration of the school year.

This reaction was very different from Rob's the night before. Rob was not used to me crying and rocking myself while I told the details of my night. We had a ritual of lying in his bed late on weekend nights and sharing the events of our evenings with one another, more often than not, to songs of Tom Petty's, "Full Moon Fever." We would just about fall asleep together in each others arms and I would go back to my room. We had a very special relationship. He was shocked by my uncontrolled behavior and so helpless in making it better that he cried for me. As always, he made me feel loved; I needed that too.

My attitude was fierce as far as my rape affecting the rest of my life. I would be damned if my schoolwork was going to suffer as a result of my experience. I continued to go out to bars and parties, afterwards spending my late nights with Rob. Nothing changed in my life on the outside, but on the inside I was a mess.

I wanted to encounter Eric face-to-face. I spent countless hours imagining it. I wanted to ask him why he lied to me so many times. I wanted him to know how badly he had hurt me. Two days after my assault, I went back to the apartment where I was raped. Reluctantly, my roommate drove me there. The resident named Arnold informed me that Eric did not live there.

Defeated, I only saw Eric one more time—at the party, months later. After Eric gossiped about me, he walked toward the door of the apartment. I stopped him as he passed me. He intimidated me with a grin to the point that I could not speak. His "shit happens" attitude enraged me! Flustered, I was able to utter, "Why?" as his friend pulled him out the door of the apartment. This interaction did not relieve me of my pain, as I imagined it might have. I needed him to accept responsibility for my pain; instead I remained burdened with it.

I felt he had a power over me. He controlled our brief conversation. I was not able to get my answers, nor was I able to tell him that he hurt me so thoroughly. I was not afraid to make myself vulnerable by letting him know my pain, because I believed that if he knew my pain he would hurt too. I thought this pain could have potentially prevented him from raping in the future. Did he know he had set me up for a rape? If he had, then I could have blamed him and acknowledged my hurt as rape.

Furthermore, it was difficult for me not to blame myself because I have always been a strong woman in my convictions and in my physique. Therefore, I reasoned, I should have somehow prevented my assault. I felt that going downstairs with Eric was my mistake. It was also my fault that I did not jump up and scream, "NO!" instead of merely speaking it. My memories of that evening—so full of self-blame—haunted me; I still did not classify my experience as a rape because I did not say "no" one more time. After all, I originally wanted to be there. It would not have occurred to me to seek any kind of professional help, like a hotline. I did not know what date rape was. The only kind of rape I understood was when strange men jumped out of bushes late at night. My confusion deprived me of the ability to be angry and label Eric as a rapist. I was left only with guilt and self-blame. Because I was unable to stop my victimization, I questioned whether I was really the strong person I had always considered myself to be. Both Eric and my roommate reinforced my self-blame. As time passed, I forgave myself, but I still was not able to assign full responsibility to Eric.

My first real sexual encounter (I refuse to classify my rape as my first experience with sex) was the following summer. It was physically painful. Unable to relax, my insides would tighten up as they had the night of my rape. My friends advised that the pain would subside after a few experiences, but it did not. This problem continued for the duration of my two-year relationship.

I transferred to the University of Florida, as a junior. My rape played a minor role in my decision, although it was based mostly on financial

constraints. Once at UF I finally had the strength to take a stand. The opportunity to start a new college experience in an environment less foreign—my sister was a freshman and high school classmates attended my new university—gave me a feeling of security. Also, there was no chance I would encounter Eric again.

Angry with my victimization, and that of others, I became committed to try and stop this horrible violence through education. I called around the city inquiring about volunteer opportunities and eventually stumbled upon a woman passing out pamphlets for UF's Sexual Assault Recovery Service at the book store. SARS informed me to watch the school paper for an ad seeking volunteers in the next few months. I picked up an application and scheduled an interview shortly thereafter.

I learned a lot through my training to be a peer educator on date and acquaintance rape. I was taught that Eric's actions were not only criminal but all too common, and I discovered that my reactions to my rape were also common. Although I did not hold Eric responsible for my rape before, reading studies on acquaintance rape led me to realize that Eric's act was not only a felony, but was also not my fault.

I realize now that becoming a victim is not the result of a character flaw or a weak personality. My self-concept remains as both a strong-willed individual and a victim/survivor. I know I did not "allow" anything to happen to me. I learned in my rape education training that my paralysis at the time of the attack was a normal response to fear. Saying "no" one last time would not have prevented my rape.

This revelation lifted over a year of suppressed anxiety. This catharsis was the last stage in my recovery. I toyed with the idea of sending the letter to Sue. For the last time I questioned my old roommate where I could find her (as Sue had been her acquaintance). I was looking for both an answer to my direct question as well as encouragement to follow through. I dropped it, as she gave me neither. I never pursued it again.

Although I am not ashamed to admit to my victimization, I do not advertise it. I just feel it isn't anybody else's business. I have confided in only a few close friends, usually after they have revealed their own stories of an assault or attempted assault to me. I've been asked by those I have confided in, "Don't you want to kill him, beat him up?" My answer, "No." Violence is not a solution for me because I detest violence. I do not understand my numbness toward a man who affected me so thoroughly.

My mother was the most difficult person to tell. I was afraid she would blame me for my attack, as I had originally blamed myself. I confided in her two years after my rape. I was brought up with the idea that "Sex is

bad, unless you are married. Men only want to see how far they can get with you. They won't marry you if you have sex before marriage." In addition, she inaccurately believes that if you are in bed with a man, you can not change your mind and say no after a certain point—once the two of you are undressed—as it is unfair to the man. Fortunately, she was able to put aside her convictions and care about me. She cried for me and wished she could have protected me from such an experience. Although her reaction relieved me, I do not know why I told her about my experience in the first place.

It was my mother who insisted I seek professional counseling and I did talk with a counselor a couple of times. I am not sure if she helped me or if I would have arrived at the same point on my own. My progression, however, was learning to truly trust a man in an intimate setting, thus extinguishing the physical pain I had experienced in my first sexual relationship.

Throughout the last four years, my rape has affected me in different ways. Originally my self-blame haunted me, but I eventually confronted my feelings and forgave myself. Next, I learned the facts about rape, allowing me to shift responsibility for my rape to my perpetrator. Now, my victimization manifests itself in yet another form. I re-create rape situations in my imagination when I am alone. These fantasies range in the location of the assault and the success of my perpetrator, based on my actions. I never visualize the act of rape itself, I am just aware if I am raped or if I get away. These fantasies remind me that I can be raped again. This fear keeps me aware of my surroundings and the company I keep. Occasionally, these fantasies make me feel empowered, as I am able to control the situation and stop it.

I am currently a master's student at the University of Miami. I continue to facilitate programs on date and acquaintance rape on campus. I foresee myself volunteering in some capacity about the issue forever. I feel education is powerful in reducing the number of victims, as it may allow a past or potential perpetrator to identify hurtful behaviors. It also allows victims to identify their rapes, which may be the first step in relieving their pain. It was for me.

Writing my letter and essay has allowed me to defend myself and let the truth be heard, even if Sue and Eric never read it.

18

My Own Protector: Reflecting on a Twenty-three-Year-Old Rape

Elizabeth Mae Vaughn

My first sexual experience was a date rape. It occurred when I was fifteen, twenty-three years ago. I was living with relatives in a small town in Illinois during my sophomore year of high school. I had been introduced to alcohol by my older cousins a few weeks earlier. My first drinking experience was pleasant, silly, and safe. Several weeks later I attended a wedding as the date of Joe, an eighteen-year-old friend of my cousin's. It was our first date. Remembering the drunken fun of a few weeks earlier, I did not have to be talked into a few drinks. Several older men were mixing drinks for me, enjoying getting a kid drunk. I drank so much I blacked out and don't remember anything else about the reception or leaving the party. I remember waking up in Joe's car and seeing him on top of me, feeling him having sex with me. I regained consciousness because of the pain: I was a virgin and it hurt horribly. I passed out again while he was raping me. Later, Joe drove me to a local teen hangout where a dance was being held. I woke up as we were arriving. He was looking for my cousin to help take care of me and get me home. He didn't talk to me, just took me inside, found my cousin and turned me over to her, then disappeared. I have a faint memory of walking through the crowd, clothes twisted, hair messed up, pantyhose around my ankles, stumbling drunk. Even in that condition I was ashamed and humiliated. Rather than feeling anger at what Joe had done to me, I was only embarrassed that all those people saw me and knew we had sex. I was sick and bleeding but no one asked me what had happened or if I was hurt. I continued bleeding vaginally for several days and assumed it was menstrual, but I'm not sure now that it wasn't because of the physical damage Joe did while raping me. I felt intense shame and told

169

no one what had happened. Most significantly, I did not tell Joe I knew what he had done. I accepted responsibility for what Joe did to me by not confronting him with anger or outrage, by assuming his actions were part of the bargain when dating, by believing I had chosen it somehow by being drunk and out with him.

I continued to date him, and even had sex with him a few times. Our dates consisted of driving around in his car, parking on back country roads, and getting drunk at parties. We didn't have conversations or common interests. I felt since we had already had sex, that he was entitled to my body; I did not feel I had a choice. Subsequent sex with Joe was rough and aggressive, and while legally it may have been consensual, it was done without my explicit agreement or active participation. He rubbed my breasts very hard; it was painful but I said nothing. I resisted sex by saying no, but when he proceeded anyway, I passively held still while he had intercourse with me. When he hugged me I stood with my arms down and let him, but didn't hug him back. He even teased me about not knowing how to love him. I decided then it was all right to have sex if you were in love with somebody. I dealt with my shame by calling it love, the only context I felt was acceptable for sexual behavior. Joe and I dated until he dropped me unexpectedly after a few months. He didn't tell me he wanted to break up, but showed up on a date with his old girlfriend at the place I worked. We never talked—I just knew he was dating her and that he and I were done. I wanted him back and went looking for him one night, leaving word around town that I wanted to talk to him. He came to see me thinking I was looking for him because I was pregnant, and said he wanted to marry me. I had never considered getting pregnant, but wanted him back badly enough to wish that I was. I thought his offer was romantic. I was young and naive enough to think this was the way love worked. I did not get pregnant and my relationship with Joe ended for good when I moved back to Arizona at the end of the school year.

My shame about having sex was reinforced by my aunt asking shortly after the rape if I was still a "good girl." She had, I'm sure, heard gossip about me from my cousin or someone who had seen me at the dance and was trying to find out if I was still a virgin. She cared more about my reputation than she did about my well-being; it made me feel dirty and bad.

I didn't realize what happened with Joe was rape until several years later, and still have trouble accepting emotionally that I was raped. My realization was gradual, supported by new literature coming out of the early women's movement and the experiences of other women I knew. The first time I remember telling about my experience with the awareness of having

been violated was in a personal growth class for women when I was about twenty. But my emotional healing has been slower than the intellectual. I sometimes minimize my experience because it doesn't fit the stereotypical pattern of stranger rape, that of a violent, terrifying encounter with a stranger. I wasn't terrified and I wasn't attacked by a stranger. My rape occurred while I was on a date and drunk, factors which contributed to my inability to perceive it as an assault.

The date rape I experienced was part of a pattern of violations by boys and young men that I accepted as inevitable and shamefully felt responsible for. I was convinced by a deep sense of worthlessness that I attracted and probably deserved this treatment. My rape can't be isolated from a larger pattern of victimization if I am to identify its effect on my life. I lost all feelings of self-worth after Joe raped me, setting me up for continued abuse. Each following incident further destroyed my self-esteem and my ability to prevent subsequent violations. Though I have thankfully disrupted this vicious cycle of abuse, it continues to affect me.

My sexual identity was constructed early in a climate of secrecy and shame about sexuality. I was naive, knowing only that menstruation, sex, and babies were somehow related. I knew nothing about male sexuality. I had been punished as a child for what I now consider normal curiosity (I lifted my skirt for a neighbor boy to see) and I didn't feel I could approach my parents with sexual questions. By their own example, my mother and father led me to believe that men are aggressive and dominant over passive women. My rape was another example of women's vulnerability that left me unable to respond in any assertive way. I was surrounded by indicators that male aggression was the norm, and my own violations left me more passive, more powerless. One incident I remember vividly was when I was sexually harassed in seventh grade by a boy I was tutoring. He wrote me sexually explicit notes about what he wanted to do to me. I was terrified that he would hurt me, but never asked an adult for help. I felt guilty, ashamed, and dirty, fearing adult blame. I burned his letters, afraid I would be punished if they were discovered. I also experienced sexual harassment when I first entered high school. There was a group of boys who routinely ran by when I was standing at my locker and tried to stick their fingers up my butt. I felt angry yet unable to stop them.

My later dating experiences were humiliating struggles. Boys tried to force me into sexual acts I wasn't ready for and felt were wrong, but couldn't stop. I was grabbed, penetrated with fingers, French-kissed. None of these acts had anything to do with mutual pleasure; I was treated like a passive object. One young man masturbated in front of me after I refused

to touch him; I had no idea what he was doing, only that I felt dirty and guilty, as if I had done something wrong. I once again accepted responsibility for someone else's behavior. I believed because I went out with him I deserved whatever he did to me.

The rape I suffered a few years later was not the last in this series of assaults, but became part of a continuous pattern of abuse. My next boyfriend was not sympathetic when I told him what had happened with Joe, only jealous that I had already had sex with someone else and that I was resisting sex with him. He was able to wear down my resistance with pressure, emotional manipulation, and persistent requests for sex. He pouted and used my past sexual experience as leverage. He bought condoms and constantly tried to arrange opportunities for us to be alone. He eventually told me one night that he was coming over and we were going to have sex; I finally gave up. This pattern of coerced sexual activity combined with escalating substance abuse continued throughout my high school years and beyond. Sex became a commodity, something I traded for attention and companionship. I had no self-worth, no evidence that someone would like me other than as a sex partner. I felt used; I thought I had no reason to refuse further sex. My friends and I began to experiment with drugs during this time and I slipped into frequent use very quickly. Alcohol and drugs removed my shyness and fear and gave me confidence. I was constantly drunk or stoned; it was the only time I felt good. I had discovered a powerful tool for dealing with pain. In effect, the trauma of my rape combined with other sexual abuses caused chronic depression, alcohol and drug abuse, lack of emotional response, and a deep shame that was central to my self-image. I felt worthless and my developing reputation as a "bad girl" perpetuated my self-hatred.

I never made a choice to become sexually active; Joe took that away from me. I made the decision to become celibate eight years ago after an emotionally abusive relationship that left me devastated and willing to face being alone for a while. I had been clean and sober for almost three years at this point and the pain of repeated abuse was intolerable without alcohol or drugs to numb it. My sobriety resulted in elevated self-esteem and the expectation of being able to have healthy relationships. For the first time in my life I was more afraid of being abused than I was of being alone. I wanted to stop this cycle of detrimental sexual activity established so early for me. I wanted to reclaim my power to choose. Very soon after making this decision, I considered acting on an attraction to another man. I remember a deep sense coming over me that I couldn't do it anymore and that it was time to quit. I knew with certainty that that part of my life was

over. This was also my first conscious awareness that I was making a decision to explore more fully my interest in women, something I had been avoiding for many years. I was determined to stay celibate until I was really clear about what I wanted, and I guessed this would take a couple of years. My period of celibacy lasted longer than I originally intended; I have only recently begun to date again. There were times I feared I would never be ready or willing to risk emotional or sexual involvement. I believe the length of time it took for me to feel ready is an indication of the amount of healing I needed.

My process was complicated by my emerging identity as a lesbian. I faced not only being sexual with another person for the first time in many years, but in an unfamiliar way. I believe my sexual feelings for women are surfacing later in my life for several reasons. All my feelings, especially sexual ones, were deeply buried by the trauma of abuse during my adolescence, and twelve years of alcohol and drug addiction. I am not claiming abuse has caused my homosexual feelings, only that it hindered me knowing myself. I never got to grow up, have sexual feelings, and decide with whom and when to act on them. Now I am able to.

I believe the key to my healing is my continued recovery from drug and alcohol abuse. I was unable to stop having relationships with abusive men until I sobered up. The substance abuse helped me survive the pain but also perpetuated the abuse by numbing me to it. I continued to allow people to abuse me because I was not in touch with how much it hurt or aware of my value as a person. I am not responsible for the actions of Joe, who raped me, or anyone else who hurt me, but I do believe my lack of self-esteem prevented me from responding to being violated. My recovery began soon after a friend got help in Alcoholics Anonymous. She shared her process with me and tolerated my denial and arrogance, like when I told her she was being brainwashed. She remained my friend for the year and a half I still drank, and watched my life fall apart. She continued to talk to me about what she was learning and became the person I trusted with my problems. She took me to my first meetings, first Al-anon and then A.A. She introduced me to other support people and became my dear friend over the years as I progressed with my own recovery. I identified strongly with the people I met in Alcoholics Anonymous and knew early on I would find help there. I have been clean and sober for eleven years, and their help has been the foundation for my recovery. After I'd been drug-free for about five years, I started working with two psychotherapists. For three years I did intensive therapy, both personal and family, and also participated in group therapy with a women's group. It was an intense, selfish, healing

time. The broken, lost victim who was me is now mostly a sad, almost un-believable, memory. I am a very different person today.

My fears about becoming sexually active again have little to do with the change in my sexual orientation, and much to do with the fear of losing myself again in relationships. My old pattern was to focus much more on the needs and feelings of my partners than my own. I have given myself away out of fear of being left; my self-esteem came from what others thought of me. The persistent fear of losing my newfound self is not nec-essarily realistic considering the healing I have done. But I won't know how I function intimately until I take the risk and try it. I feel shame about being a thirty-eight-year-old adolescent, about my body, about my sexual inexperience since coming out as a lesbian. I hope I can walk through these fears; I feel ready and am hoping for a partner to grow up with.

Therapy and substance abuse recovery have contributed to my healing, but I have a long way to go. I will consider the process complete when I am able to function happily and wholly in a relationship with the sexual partner of my choosing. I have an intense feeling of sadness for the young woman I was who had no way of learning about safety and sex, and for the thirty-eight-year-old woman I am now whose memories of adolescence and dating are painful pictures of loneliness and abuse. I am a different woman today, with hope and determination to live the rest of my life hon-oring myself by engaging in activities that nourish mind, body, heart, and soul. I have become my own protector.

19

From Wonder Woman to One Out of Four

Irene Julianne Kieser

In nursery school, I was the only female member of the Superfriends Club. Of course, I was Wonder Woman. Visions of strength danced through my head with invisible jets that could carry me from the monsters that crept from the cracks and corners. I was confident that my golden lasso would protect and defend me. Surely one day I would be strong, powerful, independent, able to do anything I put my mind to. As an adult, I have gladly become many things but I never dreamed I'd be one out of four.

One out of four is a statistic used to express the incidence of rape and attempted rape in the United States.[1] I first saw this statistic my freshman year of college, on a poster which read, "Imagine your four best girl-friends, now imagine one of them being raped." One out of four mothers, sisters, lovers, friends, or classmates has been raped by someone they know. But one out of four is not just a hypothetical friend; she is me. In one horrifying hour I transformed not into Wonder Woman but into a statistic; one out of four. All of my pride and sense of self was washed from my body. In one hour I was date raped and left alone on the side of the road to collect my clothes and the pieces of my life.

It was the summer I turned sweet sixteen and like the cliché, I had never been kissed. I had just started to grow out of my awkwardness when I entered driver's education. I had attended private schools for most of my education and this driver's ed class was the first time in many years that I could sit in a class without knowing everything about everyone, and everyone knowing everything about me. When I met Ricardo, he seemed romantically interested in me, which was really exciting and surprising. My mother, the reverend, likes to remind me that I'm rich in the things that count; while I've always been proud of my internal strengths like intelligence, humor, dedication, and creativity, I've never held much esteem for

my external self. I felt ugly, fat, too tall, brace-faced, zitty, and boyish. When Ricardo started to pursue me, I believed I was really becoming a woman.

We first started talking one night when we had both been scheduled for an in-car lesson. We drove around for a while with Bob, our cool driving instructor. Then the three of us decided to play basketball at a little park near the junior high. While we were playing Ricardo kept coming on to me. His come-ons weren't obvious, he was just nice to me. He laughed at my jokes and listened attentively when I talked. It was nice to feel attractive but I hadn't even considered whether or not I was attracted to him. We got back in the car and drove to Ricardo's house. I was driving with Bob in the passenger seat and Ricardo in the back seat. As I drove, Ricardo reached around my left side and fondled my breast. I should have said something right there and then, but I was nervous about driving and incredibly embarrassed. I didn't know what to do. If I said something, Bob would know what was going on and I wasn't sure what would happen next. I wasn't sure if Ricardo's behavior was normal or not. I've always thought I had pretty good street smarts but in the area of sexuality I didn't have a clue. I didn't want to seem like a prude and I didn't want to blow my big chance with this guy. So I just didn't say anything.

When we got to Ricardo's house we were met by his butler and invited in for sodas. Bob had to use the bathroom which left Ricardo and me alone. While we were alone, he came up to me and was talking only inches from my face. Again I was very uncomfortable, but this time I pushed him away. When Bob returned I told them I was really tired and just wanted to go home. I got back into the car and drove to my house.

Along the way, Bob told me how much this guy liked me. He told me that Ricardo had asked about me during their previous lessons and had said that I was beautiful. That was incredible to hear because I had never heard it before. We pulled up into my driveway and I walked into my house stunned. The phone was ringing, and it was Ricardo. He had gotten my phone number from Bob. We talked for a while and he asked me out for a date. After being embarrassed and uncomfortable for the last three hours, I certainly did not want to spend a whole evening with him. I didn't even know how to handle a little flirting; I wondered how I would deal with a date. I tried to say I was busy but he had already found out from Bob that I was scheduled for a lesson that same night. I agreed to go out after the lesson. I had never let fear control my life before and I was determined not to let it control me then. Despite my anxiety, I was excited to be going out on my first date.

Immediately after hanging up the phone, I called my best girlfriends. My closest friends were four of my high school's cheerleaders. Although I didn't share their interest in beauty and fashion, we were all very close because we shared the same sense of humor. They had all been on numerous dates and were full of dating advice. Together we went to Montgomery Mall to select my new date outfit. I was fashioned with a crop-top shirt, a new denim skirt and white lace underwear from Victoria's Secret. One of my friends, who was particularly experienced, tried to tell me about the sexual activities I might be called on to perform, and even showed me how to give head on a popsicle. I just listened to my friends without fully comprehending what they were talking about. They were so thrilled that I finally had a date that it made me feel like I had to change my entire personality so that this guy would like me. We never considered whether or not I'd like him.

He picked me up in his new sports car. We went to see "Moonstruck," ate frozen yogurt at the mall, and talked about the Redskins, music, and mutual friends. I was having a really nice time. I felt comfortable and relaxed. When he suggested we drive to the local park to swing on the swings, I believed that we were in fact going to do just that.

Once we got to the park he stopped the car and kissed me. It was a nice, sweet, tender kiss. After all my worrying, I was relieved that my first kiss was so special. I liked Ricardo. I wanted him to meet my friends and family. Part of me wanted to kiss him back. I smiled at him. He looked at me and said "I think it's the time in our relationship when we should have sex." I was stunned. I told him I didn't think I was ready for that. He seemed to accept my decision and we kissed again. When we stopped kissing he looked at me and said he needed to have sex. Again I said no.

Ricardo became violent. He backhanded me in the face and grabbed my hair. He took my seat belt and wrapped it around my body and around the seat. He reached underneath his seat and pulled out jumper cables. He tried to wrap them around my neck but they kept falling down. I don't know why he felt that so necessary because I was too scared to even move. His first hit to my eye left me a little blurry. When he pulled my hair he had ripped out my earring which made my ear sting. In addition to the physical pain, I was in shock. I remember saying to him over and over again that I needed to get home. He grabbed my hair again and said that he just wanted to have a little fun.

I never thought this would happen. I don't think I even knew what date rape was. As he tore my new underwear off, all I could do was cry. My entire life I had been a fighter, but that night I had no idea how to stand up for

myself. I couldn't hit, kick, scream, or bite. All I knew how to do was cry and say NO! I cried as he bit my thighs, performed oral sex on me, and pounded his penis into me. He first yanked my legs over the gear shift panel. Then he dug his nails into my thighs and thrust his face between my legs. He literally bit me as he performed oral sex on me. When he was done, he told me I was a "good little girl." While he raped me he didn't look at me. He kept his face buried in my neck. I remember him whispering, "You like it rough, don't you baby?" and "Your pussy is so sweet." I looked out the front windshield at the rain while he raped me. It was a gentle rain, so much calmer than what was going on inside the car. I remember thinking about the underwear my friends had bought me and what I would tell them had happened to it.

My thoughts during the rape were scattered. Most of the time I thought about my family and what they would say. I concocted excuses to prove that I wasn't at fault. But how would I explain being naked in this rich boy's sports car? He didn't wear a neon sign across his forehead that read RAPIST. Only he and I knew that I didn't want this. I listened to the rain on the roof. It was so peaceful. I remember hearing the song "Silent Night" play in my mind. I wondered if this was how the Virgin Mary got pregnant; maybe she hadn't asked for it either. I remember crying a lot.

When he was finished he untied me, opened the door, and pushed me out. I lay naked in the mud, bleeding from the bites on my thighs. I got up and looked down at my shirt minus its buttons, my white skirt bloody and soiled, and one shoe separated from the other which was with my underwear on the floorboards of his car. I didn't care though because I was finally out of his reach. It was raining and nearly 1:00 A.M. and my house was easily five miles away. I started walking off to the side of the road in the forest. As the rain soaked my body, I decided that my nightmare with Ricardo simply hadn't happened. I knew inside that I couldn't handle such pain. I decided to just erase the entire experience from my memory.

I got home around 2:00 A.M. I called to my mother and told her that I was home and OK. After taking a long hot bath and putting Neosporin on my thighs, I went to bed. I had a noticeable bruise on my cheek; I told my mother I was hit by a falling shoe box at work and my boss I was hit by a soccer ball. Growing up, I always acted independently and never confided in my parents. I decided to handle this alone too. I love my older sister dearly but in my eyes she had always been perfect. I didn't tell her either because I didn't think she'd understand something as tainted and hurtful as this. The bites healed a few days later and with their scabs went my ac-

knowledgment of the entire event. I knew inside that I had been violated, but I held this knowledge deep within me.

For the next two years, I had to drive past his home every day on the way to school and every time I passed I felt a little less proud, a little less human. It was hard to date again. I vomited on every first date I went on. I didn't fear all men—many of my closest friends are men—but I just couldn't help being scared that the next first date would end up like my first date with Ricardo. I guess part of me still believed that there was something in my actions that had caused his attack. And since I didn't know what I had done, I always feared I would make the same mistake again.

I entered a relationship several months after the rape but I cried through any type of sexual activity. Trevor thought it was him and I didn't have the ability to articulate the flashbacks that invaded my brain. When Trevor and I would become intimate, I closed my eyes and heard Ricardo's voice whispering in my ear. Just discussing oral-vaginal sex was terrifying for me. We went out for a year and a half and I never told Trevor that the reason I cried was because I had been raped. I can't remember when I found out that what had happened to me was called rape but by that time I knew. I just thought that if I talked about it, then it would become real. He often asked me what was wrong and I would tell him that I was crying because I was so happy. I never let him know how much pain I went through. I wanted to feel normal again. I thought that if I told Trevor the truth he would back away. He and his family made me feel safe and loved for the first time in a long time. So I did anything and everything to keep him happy so that he would stay with me. I loved him with all my heart and yet when I closed my eyes, it was not him, but Ricardo I was with. Eventually he told me he felt drowned by my need and broke up with me.

One night during my senior year of high school I got drunk on some old wine with three of my good friends. That night I learned that my friend Connie had been raped in her home by a stranger two years before. I admired and respected Connie for her strength and her honesty. She had gone to the police and had filed charges. She had endured the hell of the rape and the hell of the legal system that seems more concerned about the rights of the rapist than the needs of the survivor. It was wonderful not to feel alone any more. For the first time I felt like I was not alone in my battle and I told them about my rape. I didn't feel scared, ashamed, or embarrassed anymore. I realized that I too was strong and capable just like Connie. Every rape victim chooses to handle her rape differently. My silence had been okay because it was what was right for me.

I met a wonderful man my freshman year of college. I decided to tell
Tim the entire truth about the rape from the start so that he would have a
chance to back out. I knew how screwed up I had become. I was untrust-
ing, angry, and emotionally shell-shocked. I told him about the rape almost
hoping that he would back away and run. I knew that the road to trust was
going to be difficult and painful and part of me didn't want to go through
it. But he stayed and held on. When I told him, he had only known me a for
a week, but he understood me so well. He didn't surround me with a thou-
sand I'm sorries, he didn't say he didn't know what to say, and he didn't
blame me. He listened, asked me if I was okay, gave me a hug, and told me
I was safe with him. From then on, Tim was there for me when I wanted to
scream, cry, joke, or just forget about it. What made his acceptance so
great was that he was an ordinary, Navy ROTC, twenty-four-year-old guy
from Missouri who cared and believed in me. Knowing that someone
would support me in whatever I did gave me the validation I so desperately
needed. Tim supported me, went to rape awareness marches, and listened
to my every scream, tirade, or wimper. Our relationship has had many hills
and valleys during the past three years but the trust we've established has
always remained high. No matter where the future takes us, I will always
love Tim and be thankful to him for helping me to feel like I can trust men
and myself.

In the past three years I have become very involved in "women's" is-
sues. I've volunteered at the Shelter for Battered Women in Columbia,
Missouri. When I moved to San Diego, I interned as a victim's advocate at
the city attorney's domestic violence unit. And now I serve as a sexual ed-
ucation facilitator for Planned Parenthood, Los Angeles, teaching junior
high school students about sex and ways to postpone sexual involvement.
While we call these issues "women's" issues, I've learned that sexual vio-
lence against women should not be the sole concern of women. Women
alone can not make rape go away. These employment positions forced me
to accept that if I want others to act to stop the violence, I have to be ac-
tively involved in educating others, including men.

After nearly five years, the list of people who know about my rape has
grown but remains small. I wear "Let's Make a World Without Rape" and
"Yes means Yes, No means No, However I dress, Wherever I go" T-shirts
and attend "Take Back The Night Marches," but my family doesn't know.
My cheerleader friends know now and I was surprised to find out that three
of them had been sexually assaulted as well. My two best male friends, Jay
and Chris, took it the hardest. They care so much about me that this attack

felt like an attack against them as well. Jay wanted me to tell him where Ricardo lives so he could go beat him up. Knowing that wouldn't solve anything, I refused to tell him. I believe violence begets violence and I didn't want to provoke Ricardo into either hurting me again or hurting someone new. I just wanted to move on. Now I tell people about my rape when they make jokes or act insensitively about sexual abuse because I have found that some people need to attach a face to this crime before they will take it seriously. Many people have a preconceived notion that date rape is really a consenting sexual act and then the girl changes her mind, wishing she had not had sex and covering her actions by lying that she was raped. In reality, rape is about taking power and stripping someone of her dignity and sense of control.

For me, being raped was not just an incredibly horrible physical experience. It was an assault against my spirit. My rape paralyzed the part of me that was trusting, empowering, and self-loving. I did not like myself after that night. I felt humiliated and degraded, weak and powerless. I didn't report my rape to the police that night because I believed if I had been tougher, nicer, stronger, better, or more worthy it wouldn't have happened. I believed it was my fault. I didn't think it was possible for someone to be so senselessly cruel; I assumed that I must have done something to provoke such a psychotic and heartless response from Ricardo.

Date rape forced me into silence. I had once felt like the world was my playground but after being date raped I believed there was nothing good left in the world. I looked at every passerby as a potential abuser of my spirit. Nobody entered my life without a period of mistrust. I transferred from school to school not wanting to stay in one place for too long for fear that someone I trusted would turn against me and hurt me again. But because of people like Tim, I realized that there are trustworthy people, that I'm not alone in this struggle, and that I did nothing to cause my rape. I no longer live in fear. Now I am surrounded by friends and resources who stand by me when I need them. I used to think that the way to win was to stay silent, forget, and live on the defensive. But now I know that I was defeating myself in the worst way. I believe the boy who raped me wanted me to stay silent and live in fear. He wanted to control my entire existence with his powerful actions. I'm sure he thought with a few thrusts into my body he could drain away my power and keep me a prisoner to fear. But now I live as a survivor, not as his victim.

Five years later, I still get nervous when I meet new people. Looking back on my first date with Ricardo, I realize I communicated clearly with

him but that he just didn't like what I communicated. I realize that he was going to rape me that night regardless of my actions. Aside from never going out with anyone for the rest of my life, there seems no way to ensure with 100 percent certainty that I'm not going to be raped again. But I do use a few guidelines. I would get to know a guy before I went on a date with him. I meet dates at the movie theatre or at clubs so that if things get uncomfortable I can leave. Generally, I don't let dates know where I live until I feel confident that I can trust them. And I carry myself in an assertive manner. Perhaps none of these things will ensure my safety, but they are reasonable measures that make me feel more secure.

I no longer try to be Wonder Woman and I know I can be so much more than one out of four. There are situations that I can't handle alone and there are others which I know I have the ability to deal with. I know that not all men are bad and I trust myself enough to trust others. I could wish I had not been raped, but more importantly, I wish I could regain the years I lost to fear, mistrust, and self-hate. But now I recognize that I am a strong, wonderful individual who again believes she can do anything, be anything, dream anything.

Notes

1. Robin Warshaw, *I Never Called It Rape* (New York: Harper & Row, 1988).

20

Is It Rape If He's My Boyfriend?

J. M. Alexander

I look bored on the train. I have perfected this look—the more panicky I feel on the inside, the more I draw a mask over my face. By refusing to acknowledge what I see, I hope to make myself invisible, invincible. Behind this disinterested mask, I am very aware of everyone in my car, where they sit, how they sit, where and when they get on and off. As I pretend to let my eyes wander aimlessly, I examine the woman sitting across from me. She is my age and is riding home from school. She too is cultivating nonchalance, but is less practiced—I see the fear in the corners of her eyes and the absentminded way that her keys so neatly fan between her knuckles. (I said less practiced, not more afraid.) I shift my jacket so she can read the STOP RAPE button pinned to my pocket. She does, and turns away, as if she hasn't seen. But I know she has, and I silently wish her a safe walk when she gets off at the next stop. She does not look back, but I do.

I turn my head away. I am headed home, and I think about my day, and what I've just written, and I think about how I piece my thoughts together. Once, I didn't see the world like this. I blend past and present almost unconsciously, this time warp may or may not scare me. When I am scared, a man who was once a boy I knew is with me, rubbing my stomach, running his fingers through my hair, hugging my shoulders. All of the parts of me James touches tense involuntarily, through years of practice, and I will myself to release them, for him to release me.

I spent three of my college years denying the existence of my abusive high school relationship, all the while volunteering for a sexual and domestic violence hotline, helping to begin rape peer education at my school, serving on endless committees, and speaking out loudly against rape and other forms of sexual violence. I heard so many stories from women who had been raped, women who were my friends, women who became my

friends, women whose names I never knew. Often they would ask me if I had been raped, and I said thankfully (and not wholly convinced), "No." Usually they didn't believe me; how could someone working as hard as I was to end rape not have any kind of personal stake in it?

One day, my longtime friend and the college's resident sexual assault expert spoke in a class of mine. I barely listened, as I'd heard her lecture countless times before and imagined that I could probably recite this one from memory. But for some reason, that day, instead of hearing her words, I heard *my* voice in my head, I heard me crying, and I heard another voice, the voice of my high school boyfriend. James was pleading with me to give him a blow job, *why are you being so mean, all of my friends' girlfriends are nice to their boyfriends and do it, you are so sexy, you're holding out on me, surely you don't love me or you'd do this for me, make me happy?* As the classroom lecture continued, I felt his hands on the back of my head, caressing my hair, pressing me down, coaxing me to just try, just kiss it, it won't hurt, it's just a kiss really. Pressing on the back of my head with both hands. I locked my elbows, shook my head, *No—I can't— Can't? Of course you can, you just have to learn, like sex, you learned how to have sex, you wanted to learn about sex, right?* I *did* want to learn about sex—I felt so naive (I was so naive). I wavered, the hands pressed on my head, I pulled back, the hands played with my hair, *your beautiful hair, sexy hair, you are so sexy, you turn me on, feel me—I'm hard for you, this is for you*—the hands press more and my head is going down and I'm nervous because I want to feel sexy, I want to be sexy, is this what being sexy is all about?

I remember thinking that he was too big for my mouth, that my mouth was stretched, that my lips hurt, that it was hard to swallow with his penis in my mouth, that his hips were bumping into me and he was jerking around and I could just see his shut eyes. I didn't know I was supposed to move up and down but he moved himself, I was just the wet place, I wanted to ask him to not push so hard, not move so fast, but my mouth was full of him and I couldn't. I didn't know what was going to happen but he moved faster and his hands pushed on my head, really pushed this time. I pulled back, because he was pushing too deep in my throat, I felt like gagging, I was gagging, *oh my god I don't feel good,* I push on his hips, I can't get enough leverage, I'm sandwiched in between his hips and his hands on my head, I can't talk, I try to talk, to ask him for a break, *I can't breathe, I don't like this, I*—he came and shot right down my throat, and with the gagging, I choked on him, he stopped pressing on my head and I pulled myself off and gasped for air, inhaled the liquid and coughed and coughed.

Tears came to my eyes as I coughed, and I finally got air and layed down on the bed on my stomach, away from him. More tears as I tried to breathe normally, tried to get the taste out of my mouth, wanted a glass of cool water, salivated to get the coating off my tongue. He said something to me, and dozed, while I stayed where I was, on my stomach, still with quiet tears.

I shake my head and reach to feel the tears on my cheeks, and they are not there, and I look up and my friend is still lecturing across the table from me. Have I been crying? Did my classmates notice? Could anyone else see what I was seeing? I had never seen these images before this lecture . . .

From all of the other stories I've read and heard, I know that the potential for retrospective revising of my story is great, because it's too confusing and embarrassing to tell it like it is, and too scary to admit that for two years I went out with the man who raped me. At the time, I felt in love with him. I have to remember this when I'm telling the story, because now I hate him. It's harder to explain why I stayed with him so long when I forget the feelings I had for him at the time.

James was my first long-term boyfriend, and he seemed to be an exciting guy from the night we met. He was a year older, he was in a band, he drank and did drugs (more and more as time passed), he was smart, he was an outsider, a little bit wild, and sexy. I thought he was all I could want in a boyfriend, and I was flattered that he paid attention to me. I thought I was pretty boring, and I wanted more of that wildness in myself. I wanted the sexual experience, the life experience.

I thought I loved him because he was my boyfriend and I was supposed to love him, just like I was supposed to always want sex with him. I think what I assumed was love was in fact a complicated reliance on him for my sexual identity. He would always tell me he loved me after he ejaculated, and I would say that I loved him too. This became routine, and eventually I think I forgot why we originally started saying it. Love and sex became inextricably intertwined, which meant that each sex act also directly affected my self-esteem. If James didn't want to have sex with me, did that mean he didn't love me? If I refused to have sex with James, would he stop loving me? I know this screwed-up love/sex dynamic had a long-term effect on me because my first year in college, when I felt very alone and friendless, I had lots of sex with different partners just so I could feel loved, even for a moment. Both with James and later, a rejection of sex became a rejection of my whole self. I think I remember feeling in love with him because somehow, my brain believes that if I loved him and he loved

me, then none of those times could've been rape. They could've been mis-understandings or drunken mistakes, but I have it stuck in my head people in love don't rape each other. I think I stayed with him for the same rea-sons—because I wanted to believe that boyfriend and rapist were mutually exclusive, and because continuing to go out with James normalized and validated the screwed-up sexual dynamics of our relationship.

It's very difficult for me to use the "r word"—even now, I don't think I've said "I've been raped" aloud more than a half dozen times. I know the legal definitions of rape, but how does that change when it's my boy-friend? Does it really matter that he pressured me into performing oral sex the first time if other times I agreed to it without pressure? Does it matter that he stuck his fingers in my anus without my consent if it was only briefly, and he felt like experimenting? When I was dating him, I thought all these times didn't matter, when I was really drunk or scared or sick and didn't want to perform some sex act, when for whatever reason, I just didn't want to. This was my boyfriend, and he knew so much more about sex—I was a virgin when we met, and he'd had at least two partners before me—and I thought I just didn't know how to keep him sexually satisfied.

Now I realize, years later, that these times mattered a lot. Even writing about sex with James makes me feel inadequate and insecure. Years later, I am able to distinguish between when I felt nervous about trying new things and when I was genuinely afraid. At the time, I know I didn't have the words or the sexual experience to articulate the difference. My re-sponses to being afraid and vulnerable were to cry, shake, or just lie still. If James was drunk or stoned, which was usually, he'd tell me to stop act-ing frigid. I remember that I was deeply insecure about being frigid. I was embarrassed that I never seemed to know how to satisfy him (though I al-ways managed, inadvertently, to turn him on) and I was thankful that he was so patient with my sexual shortcomings.

James raped or sexually assaulted me each time in our two-year rela-tionship that he performed a sex act on me without my agreement (due to alcohol, lying, sleep, overpowering, pressuring, or just plain not asking), and when he used physical pressure and/or verbal coercion to make me feel as if I *had* to perform sex acts on him that I wouldn't otherwise have chosen to and/or was scared to perform. While it is difficult to remember the times during those two years when I willingly engaged with him in sex acts, I know these times did exist. I also know that I was almost never the initiator of sexual activity, because I was too embarrassed and insecure to believe that he would meet me on common sexual ground. James liked being my teacher about all things sexual, and I took his teachings as truth.

And since none of my friends were sexually active yet, I had no reason to believe that mine wasn't just the average sexual relationship. I didn't know that sex doesn't have to feel guilty and scary and pressured.

We broke up at the end of the summer before my senior year in high school. We broke up because James had cheated on me and had given me herpes, not because he raped me. I was so angry at him then—all I wanted was for him to tell me the truth, for him to admit that he had slept with someone else, but he wouldn't. I just wanted him to tell me what it felt like to have herpes. All I knew about this STD was that I had blisters throughout my mouth, throat, vagina, cervix, and anus, that I had a fever, and that the gynecologist gave me a very painful examination in order to reach her diagnosis. The herpes was an immediate crisis to deal with—I felt dirty, I felt unsexy, I felt like I never wanted to have sex again, like no one would want to have sex with me again, alone and confused. At first, I broke out in these blisters once a month, usually right after my period, though it was never as bad as the first time. My gynecologist insisted that I have an HIV test, and though I tested negative, it dawned on me that James could've given me other STDs. Over the past six years, my breakouts have become less frequent, and now I only get them a couple times each year, usually when I'm stressed, and usually in my mouth. When I first found out I had herpes, it seemed like the end of the world. Even now, I can't help but think of James when I feel the sores beginning to form, and I curse him, and feel guilty and stupid for having unsafe sex that will hurt me for the rest of my life. I get depressed sometimes during these outbreaks, and feel dirty again, especially when I feel the blisters stinging the back of my throat and it's hard to swallow—because he shoved his penis there.

Now, my herpes is usually manageable, and I'm very thankful that it wasn't something worse. But then, herpes definitely had a major impact on me. I have heard many stories where women say, "I was raped, but fortunately I didn't get pregnant, I didn't catch any STDs, I had my friends, I had a great boyfriend." I, on the other hand, recited a different mantra. "I got herpes, but fortunately I didn't get pregnant (I was nervous), I didn't have HIV (I was tested twice), I wasn't raped." The herpes became foremost in my mind—it prevented me from even considering a new partner, because I was sure I was too gross for anyone to want me, and it prevented me allowing myself the time to stop and think about rape, because all I could think about was the lifelong impact of herpes. Most of all, it prevented me from remembering any details of the sexual relationship in which I had contracted herpes in the first place. When I began thinking about it last year, I realized that I didn't really know what it felt like to kiss

James, or how often we kissed. (Did I even *like* kissing him?) How could
I completely block two years' worth of sexual intimacy? My friends filled
in some blanks for me—they told me how we acted in public, how he
talked to me, his insistence on PDA, his flirting with my friends, his de-
tailed discussions of our sex with his friends.

I have very few memories of any consenting sexual contact with him, al-
though my friends say that we had a very active sex life. I was drunk or
drinking for a lot of those experiences, partially because James drank a lot,
and partially I think because I didn't want to deal with what was going on.
One time I remember vividly was when we went drinking with some of his
friends at a vacant house and both got very drunk. I can hear James mak-
ing many sexual comments about me in front of his friends, and I feel him
touching me, grabbing my breasts. I try to laugh it off and be a good sport,
hoping that if I don't pay attention, he'll grow bored. Instead, James takes
me by the hand and pulls me out of the room, mumbling something to his
friends and laughing. Now we are outside, and I am trying to keep up with
him, but I slip through the snow and ice, and trip over tree stumps. We
didn't stop for coats, and I am very cold; *aren't you cold?* He suddenly
stops and leans me up against a pine tree and begins to kiss me. I laugh,
push him away, *you're crazy, it's freezing, come on—let's go back inside.*
He kisses me again, and I am losing my balance on the roots, but as I grab
for the tree I realize that he is very deliberately lowering me to the ground.
Wait—I'm cold—I don't want to—Please, let's just go inside as I feel the
snow seeping through my jeans and patches of ice digging into my back.
James is so aroused by me freezing below him that he unbuttons his jeans,
and then my own. I think *he's just going to put his fingers inside me,
maybe he'll do it fast and then I can get up, I'm shivering,* but then he's
tugging with both hands at my pants. I try to push him off, and twist off the
ground and he yanks my jeans and underwear down to my knees, and I
slam down hard with my bare skin on the ice. *Please*— and he kisses me
quiet. He pulls down his own underwear, rests his legs on mine, and
pushes his penis in and out of me. He wriggles me around, enjoying grind-
ing me deeper into the snow and eventually the dirt. When he finally
comes and relaxes—it takes forever because we're so cold and drunk—I
shove him off and jump up while pulling up my clothes in one motion. I
run back to the house for our coats and am waiting by his car when James
returns. He goes to say goodnight to his friends and then drives me home.
I don't think we say anything—I can see myself crying—and I get out of
the car without acknowledging him when we arrive in my driveway. He
leaves immediately and I go straight to my bathroom to soak in the tub; all

kinds of stuff from the ground got inside me from all of his grinding and deep shoving, and I want desperately to clean myself out. I was still finding pine needles in my underwear days later.

One of my biggest problems during this rape recovery process is my utter lack of control over how I think. Extreme visions come when I least expect them, like the very detailed scene I just described. Explaining these flashbacks is difficult, because they're like memories, but not exactly. They're like reality, except maybe even more intense. Moments can last lifetimes, or freeze-frame, or repeat over and over. For some people, they happen in dreams; others while awake. Some people have them randomly, others are triggered by specific sounds, smells, words, or events. Some flashbacks can totally black out present reality, like mine during the lecture, while others flip back and forth. Lately, my flashbacks happen at the same time as events in the present, in a sensory overload. I can see James' face smiling at me while I look at my boss handing me a project. I cannot control whether I am allowed to remember more or less than what is shown to me. Seeing these two scenes at once isn't like the alternating back and forth, because both are in my vision at once. It's like when you're getting an eye exam and the doctor says to stare at a point on the wall while she checks your eyes and you see that point on the wall but you also see— in front of that point—your doctor peering into your eye with the flashlight. I have my eyes open and I'm seeing in two different time zones simultaneously, as I try to locate myself between and within them.

While I try to deal with this hyper-memory, I've also been battling total forgetfulness. I have been forgetting very basic things, from my best friend's phone number to where I left the tickets I could've sworn I put in my bag this morning. I put things down and can't recollect where I left them. I forget names, I forget faces, I've even gotten lost on the back roads of my hometown, the same roads I have been driving for years. I get lost a lot lately, on foot, in the car, on the subway. It is the getting lost which upsets me the most, even when I'm not running late and have the time to correct my mistakes and get back on course. I do not like feeling disoriented, and very much alone.

This lack of control over my own mind overwhelms me, because before I started remembering the rapes I was an organized person, so organized that I used to keep meticulous track of my own things, and others' too. I feel guilty and ashamed when I can't perform, when people who know my organized and together self wait for me to deliver. I spend a lot of time trying to cover up for my mistakes. I can usually tell the days when I will be particularly off, because my distraction starts early and I spend the rest of

the day feeling like I can never catch up. I'm scatterbrained all the time, not just during the flashbacks.

With all of this craziness in my head, I've consciously decided over the past two years to remain single. I can't commit the mental energy to someone else right now while my emotions are out of control, and I can't imagine asking someone new into my bed that is already such an unsafe space. Partially this is because I'm ashamed to show all of my complicated baggage, and partially it's because I don't want to burden anyone else with my problems. I'd be embarrassed if I started to have a flashback in front of someone new; what if I freaked out in the middle of sex? Though I used to have one-night stands with guys I'd just met, I feel too vulnerable now to risk something so scary. I don't want to admit to anyone that I've been raped, yet I refuse to be emotionally or physically intimate with someone whom I can't tell my rape stories. So for now, this part of my life is on hold.

Two weekends ago I visited a friend, both to get away and to be with someone I love and who loves me very much. We had fun together, but rape was always in my mind, though I didn't tell him. The first night I had a horrible dream, and I paced in another room so I wouldn't wake him. We didn't talk about it the next morning, although I'm sure he heard me. The second night after dinner, we went back to his apartment and relaxed, drank wine, goofed off. We were fine, and I thought I was happy. I *was* happy, until we went to bed and I started crying, and cried and cried for over an hour, I was shaking, I am shaking, *James is here*, he leans over me, looking at me, I can't hear what he's saying, he rolls me over and tugs on my nightgown. Hands on my body, pressing on me, pressure, *I can't breathe*, he's in my mouth, in my throat, *something's in my throat, it's so big, why can't I swallow?* I focus on breathing, I'm panting, my throat tightens, *I can't breathe,* and I start coughing, I can't stop, my lungs hurt, I gag on James caught in my throat, my friend asks if I feel sick, *oh my god I don't feel good*, he helps me out of bed and I run for the bathroom. I gag and cough and finally I am throwing up, *where am I? what am I doing throwing up? is James gone? is this me throwing up?* Once I stop vomiting, the feeling in my throat goes away, and I am exhausted and trembling. I hear myself flush the toilet and make my way back to the room. My friend is waiting for me, scared, so scared—I know he wants to help, but I don't know what to tell him. I crawl on his lap and he holds me for a long time, and I can feel his fear though I can't see his face.

The next morning, I just couldn't look at him; something huge was between us and I couldn't bear more crying, I couldn't bear more vomiting.

James had taken over my body, and I was sure I couldn't be that fun to be with. I knew that I wasn't the person he became friends with and loved. When we finally talked, it was for a long time, and we both cried, and he admitted that I had freaked him out. We both felt much better afterwards, because when he didn't say anything, I thought it was because he was scared of me, when in reality he was trying not to make me feel worse. I explained that it made me feel like he was being more supportive and accepting of me when we both acknowledged the grimness of what was happening. I said that it was okay that he was scared because I had scared myself.

And then I went and took a nap, because I sleep much better when I feel protected by my friends. Usually, I'm afraid to go to sleep, because it's something I must enter and take on alone. It's not my bed—I have gone out of my way to make a nest for myself that is comfortable and mine. It's not the security of my apartment, double-locked. It's that I know that once I go to sleep, it's only a matter of time before I'm awakened to the feeling of James pressing on/in my body. Some nights I crash just to get it over with, but can you imagine what it's like to get into bed every night afraid? At least with friends, I'm not alone. Even though I still have nightmares and sometimes throw up when I'm with other people, I'd much prefer to sleep with someone nearby than by myself.

I have written this story over the past few months, and I'm still stuck in this insomnia and vomiting stage. That night at my friend's has become a ritual that happens every few days, would be happening more often except I take over-the-counter sleeping pills (like Nytol or Sominex) to sleep through the nightmares. I finally began taking the pills because I wasn't getting enough rest, and although I was originally embarrassed about taking them, now I realize they're a short-term necessity. I usually only take one pill per night, because I'm scared I'll become addicted, and I try not to take any on weekends when I can sleep late the next morning. I monitor what I take really closely, because I don't want to rely on drugs forever to help me cope with rape. For right now though, I'm learning, slowly, how to deal with the logistics of this healing process on a daily basis.

I have another vivid rape memory, but this story isn't mine. This story belongs to a seventeen-year-old girl named Susan, and the woman on the subway reminds me of her. Her story happened when we went to summer school together. Susan is the first person who ever told me that she'd been raped, though she didn't use that hateful word. I remember the scene clearly, how she sat and where she sat and how her eyes wandered around her dorm room as 10,000 Maniacs played in the background. I examine

this girl sitting across from me. She is trying to remain nonchalant, but there is fear in the corners of her eyes. As she tells me her story, she shrinks down into her bed, curls up in the corner, tries to make herself invisible. I draw a mask over my face as she tells me that her date from last night, a guy from the sports camp across the way, pinned her down and fucked her, slapped her and choked her when she tried to break free. I wish that I knew what to say, and remain silent. She starts to cry and I turn away, as if I haven't seen. I hope she can't see how panicky I feel inside, but she does, and I apologetically leave at the next possible moment. I do not look back as she shuts the door, and as I walk back to my own room I see the STOP RAPE sign pinned to the bulletin board in the hall and without thinking I fan my keys between my knuckles.

After remembering and telling my own story, I wish I could rewrite my silence in Susan's.

21

The Rape Exam: What to Expect on a Visit to the Hospital

Eileen P. Kirk, M.D. and William W. Young, M.D.
Dartmouth Medical School

Eileen P. Kirk is an assistant professor of obstetrics & gynecology and clinical surgery and a staff obstetrician/gynecologist at the Dartmouth-Hitchcock Medical Center. She has received the Randall Travel Award from the Mayo Clinic and is widely published in her field.

William W. Young won the Wyeth Award in 1990 for the "New Hampshire Uniform Sexual Assault Protocol," the best public service program in obstetrics & gynecology in the United States. He has been the chairman of the American College of Obstetricians and Gynecologists, and is a member of the Advisory Committee on Sexual Assault Protocol, Office of the Attorney General. He is widely published on the subject of national protocols for the treatment of sexual assault victims, has written and acted in a video for police officers titled, "Emergency Evaluation of Sexual Assault Victims," and lectures nationally on these subjects.

The medical community has many services to offer to a victim of sexual assault. Recognizing that various obstacles may prevent victims from accessing the health care system, the U.S. Department of Justice, Office for Victims of Crime sponsored the development of national models and protocols specifically to help identify and address the obstacles victims face.[1] This chapter will review advances made by the medical community to respond to victims' needs and will explain what a rape victim can now expect during a medical examination following a sexual assault.

Definition

Sexual assault is defined medically as "any act of sexual contact or intimacy performed upon one person by another, and without mutual consent, or with an inability of the victim to give consent due to age, mental or physical incapacity."[2]

Advances Made By the Medical Community

The advances made by the medical community all revolve around one primary goal: To minimize the physical and psychological trauma to the victim. This task requires an understanding that the victim of sexual assault has been seriously hurt, emotionally and physically, and as such her treatment should be considered a medical emergency.

Understanding the Victim: Rape Trauma Syndrome

It is easy for doctors to turn attention to the physical needs of patients. As health care providers, we do this every day in our office practices. And for victims of sexual assault, we are sensitive to the fact that the physical signs of abuse may not always be obvious, especially with acquaintance rape (because victims rarely fight with their attackers). When bodily injury is found, treatment can be initiated. However, the absence of cuts, fractures, and bruises does not mean that an attack did not occur.

Sexual assault is always associated with coercion and threatened or actual violence by which the assailant takes control from the victim. The need to have evidence of violence or resistance to violence to define "rape" is a damaging cultural myth unfortunately accepted by poorly informed professionals and tragically by victims themselves.[3]

Emotional trauma leads to a wide constellation of responses in victims of sexual assault. Described as the rape trauma syndrome, it is divided into two phases. The acute phase, which occurs immediately after the attack, is consistent with feelings of fear, guilt, embarrassment, disbelief, and fatigue. The victim may blame herself for drinking too much or wearing provocative clothing. She needs to be reassured that nothing she did makes rape permissible. Loss of appetite, difficulty sleeping, tension, and a variety of physical complaints (like headaches) are commonly described when there is a delay between the attack and the time the victim seeks medical care.

These symptoms are not unique to female victims. Male victims may feel responsible for their own abuse. Whether their participation with re-

gards to the act of ejaculation, excessive alcohol or drug consumption or their inability to fight off their attacker, they too may feel guilt and embarrassment which precludes them from seeking help.

In the emergency room, often victims display tearful discourse, anger, or complete despondency toward the health care team. As providers, we need to help them regain the control which was taken from them. The most direct way of accomplishing this is to allow them to choose the subsequent care and evaluation that they are comfortable with.

The second phase of the rape trauma syndrome is called the reorganization phase. Depression, withdrawal from social situations, attempts to repress memories of assault, and indiscriminate sexual behavior have been described in this phase.[4] It can be especially painful and difficult for the victim of sexual assault. Ideally, the reorganization phase is a process when the victim begins to cope constructively with her abuse. The processes are as individualized as the victims. For some, coping will center around a legal prosecution. For others, counseling will provide a focus and process.

Many states have designated services to help victims proceed through the reorganization phase. Most states provide 24-hour hot lines, confidential emotional support, peer counseling and support groups, medical and legal options/referrals, and information on court advocacy. (See Appendix for rape crisis centers nationally.) Many college campuses offer similar support services. Victims are never forced to participate in any program.

Victims of acquaintance rape frequently do not go to the hospital for medical care immediately following their attacks. By the time they do, often they have been experiencing many emotional responses, and their coping mechanisms may not be as constructive as they could be. Referrals for counseling or crisis centers should be offered and facilitated: a victim should not be afraid of a frank discussion with her health care provider. Discussing the rape trauma syndrome can validate her emotions and feelings, while referrals set a path for continued constructive recovery.

Health Care Provider

The physician (specifically, the obstetrician/gynecologist) has traditionally been the health care provider for victims of sexual assault. Progress in expanding care options for victims of sexual assault has resulted in care for victims by family practitioners, internists, emergency room physicians and, more recently, by nurses specifically trained in sexual assault issues.

Several studies have emphasized that victims of sexual assault are more

concerned about having a sensitive, knowledgeable individual rather than someone with a big title or of a particular sex.[5] There are instances, however, where cultural norms may prohibit a female from being undressed in the presence of a male who is not her husband or an individual may express more comfort talking to a provider of the same sex. Health care providers recognize this and will try to accommodate victims' requests.

Location of the Exam

The goal of the medical community is to provide 24-hour-a-day, 7-day-a-week availability to assist the victim of sexual assault. In most states, the hospital emergency room can provide this service. They are equipped to care for physical injuries on an emergency basis and many have put together a team to help victims of sexual assault with emotional issues as well. Student health care is another option for students; many college health centers provide comprehensive care for sexual assault victims.

In most hospital emergency departments, a conference room or private setting is designated for patients to sit separate from the general waiting area. This is particularly helpful if police are involved, giving victims a tranquil place and a private location to discuss confidential matters.

Victims can also receive medical attention from private doctors offices, clinics, or nonphysician providers (midwives, nurse practitioners). All health care providers who care for women should be able to refer patients appropriately. They should provide information regarding sexually transmitted diseases, pregnancy prevention, and referrals for counseling in particular.

Advocates

Sexual assault victims frequently feel frightened and alone. The presence of a supportive friend, family member, or professional "rape crises" advocate can be helpful and therapeutic. Advocates should be introduced as early as possible since the emergency department visit, medical examination, and possible police interviews may all be threatening to the victim. Emergency departments frequently have lists of trained community advocates on call specifically for this purpose.

In our own experience, we have found that the emergency room nurse assigned to sexual assault cases is an excellent advocate for the patient and is sometimes overlooked in this regard. Many can explain procedures simply and concisely. They can empathize and validate patient's concerns in

such a way that we feel complements our role as physician providers. Many have additional formal training in addition to years of clinical experience.

Whether a patient chooses to have a friend, family member, or an advocate (or no one at all) called is her choice. The victim's confidentiality will be protected. A police officer is not considered an advocate and is not present during examinations.

Cost

Victims of sexual assault may not always have medical insurance or resources to pay for their care. Recognizing that this may prevent them from accessing care, several states now pay for the cost of the exam if patients complete the forensic portion of the examination (i.e. the "rape kit") within several days of the exam and report the assault to the police. In New Hampshire, the examination must be done within five days of the assault for it to be cost-free. **Reporting the assault and having the examination is again done confidentially, and does not mean she will need to prosecute.**

What to Expect During a Medical Examination for Sexual Assault

There are two general goals of the medical examination following sexual assault. The first is to minimize the subsequent physical and emotional trauma by recognizing injuries, preventing disease, and initiating careful follow-up counseling. The second goal is to maximize the probability of collecting evidence that will confirm the identity of the assailant, confirm that a sexual assault occurred, and aid in the prosecution of the assailant. The latter goal is centered around collecting evidence for legal purposes. **It is important for victims to understand that they may always seek medical treatment even if they do not wish to have evidence collected.** Sexually transmitted diseases, pregnancy, and psychological distress are real possibilities following sexual assault which can be prevented or helped by prompt, sensitive medical care.

Lack of confidence in the legal system, fear of exposure, threats by the assailant, embarrassment, and other factors may cause a victim to question the need for evidence collection and/or notification of the police. (It is estimated that only 1 in 10 sexual assaults is reported to the police.) Health care providers encourage reporting to identify the assailant and hopefully protect other victims, and anonymous reporting is available in some states.

If a victim chooses to report anonymously, she will receive medical care and evidence will be collected, but the police are notified of the attack without knowing the name of the victim. Even if police are involved, the decision to pursuing legal prosecution is always made by the victim and a prosecuting attorney at a later time.

Victims may decline any portion(s) of the rape examination. Because they have been sexually assaulted, they may fear additional discomfort associated with pelvic exams, especially if they have never had an examination previously. Victims should voice their fears and concerns, and examiners should provide as much information about the examination as possible. The patient will be asked to give informed consent before proceeding with the examination.

Questions the Victim May Expect from Health Care Providers

General questions regarding the assault:
- When and where assault occurred
- Type of sexual contact
 (vaginal, oral, rectal)
- Number of assailants
- Physical injuries sustained
- Date of last voluntary intercourse
- Force used or threatened

Actions of the victim following the attack:
- Did you shower?
- Change your clothes?
- Brush your teeth?
- Eat or drink?
- Urinate, defecate, or douche?
 (these activities may hamper evidence collection)

General medical information for the victim:
- Past surgeries
- History of chronic underlying medical illnesses
- Medications and allergies
- Emotional coping
- Were you using a contraceptive?

- Menstrual history
- Were you using a tampon or sanitary napkin?
 (may absorb semen and be used in analysis)

Information About Sexually Transmitted Diseases (STDs)

No one is exactly sure what the risk of acquiring a sexually transmitted disease during a rape is. Several studies have reported a risk of acquiring gonorrhea following an assault to be between 4 and 6 percent, with an approximate 2 percent risk of acquiring chlamydia.[6, 7] Condom use reduces the risk of these and other infections. Even if blood work and cultures are taken immediately following an assault and are negative, victims must be rescreened later to ensure that they have not developed any infections at a later date. Health care providers should help victims schedule follow-up evaluations.

Because there is a risk of getting a sexually transmitted disease following a sexual assault, the medical community should offer and recommend that victims consider medications to decrease the risk of developing diseases. Because gonorrhea and chlamydia are underlying causes of pelvic inflammatory disease and subsequent infertility, treatment for these diseases should be considered. The inconvenience of taking a course of antibiotics is offset by the infections these bacteria may cause. **However, it is always the victim's decision as to whether she wishes to take advantage of this medication.**

Pregnancy Prevention

The female victim of rape may fear a pregnancy has resulted from the rape, and should receive counseling regarding options of post-assault contraception (sometimes called "the morning-after pill"). The psychological advantage of postcoital contraception is great when compared with the trauma of an unplanned pregnancy. Reported risk of pregnancy for victims of sexual assault is estimated to be 5 to 30 percent, depending on where in the menstrual cycle the victim is.[3, 8] Postcoital contraception reduces this risk by approximately 75 percent.

Postcoital contraception usually consists of a regimen involving high estrogen-containing birth control pills. Side effects of this medication are typically nausea and irregular menstrual bleeding. Because the com-

pounds can cause birth defects, a pregnancy test needs to be done before they are prescribed. They are most effective within twenty-four hours of an assault, but can be given within seventy-two hours.

Evidence Collection: The Rape Kit

The rape kit is an established collection of instructions, documentation forms, slides, swabs, and containers for placing the physical evidence that is collected during a medical examination. Although each state's rape kit may vary a little from one another, most ask for the following evidence to be collected.

Photography/illustrations:
 Medical providers are asked to document physical injuries in a descriptive manner. This is usually done on presketched diagrams in the rape kit. In rare situations, a provider may feel that a drawing does not accurately depict an injury and may suggest a photograph be obtained, but only with the consent of the victim.

Clothing:
 Clothing may provide evidence that may be helpful in criminal prosecution. Saliva, semen, hair, or fibers found on clothing can be analyzed by crime labs, and clothing may support evidence of struggle. At the time of an examination, a victim is usually requested to submit clothing they wore during an attack, particularly undergarments.

Swabs/smears:
 Q-tips are used to collect secretions from the mouth, vagina, rectum, penis, scrotum, or any suspicious area, like a bite mark. These are used to determine the presence of semen or sperm. They are also analyzed for blood types and other markers which are important in linking a specific assailant to a specific victim. New molecular biochemical techniques can give a lot of genetic information about an assailant with only small amounts of recovered secretions. This technology is sometimes referred to as DNA fingerprinting.

Hair:
 Combing the head and pubic hair regions of the victim may yield hair from the assailant. In the past, hairs were removed from the victim to use for comparison, accomplished by pulling them out. This procedure has

been abandoned as a routine protocol by many states.[9] In cases where this is felt to be necessary, it can be requested from the victim at a later time and again depends on consent of the victim.

Saliva:
Saliva is collected for analysis by placing a paper disk in the patient's mouth. A thirty minute time frame during which the victim does not eat or drink anything is preferred before the specimen is collected.

Whole blood specimens:
Blood is collected from the victim and sent to the crime lab. This specimen provides information regarding the blood type of the victim as well as other genetic markers. Knowing the victim's genetic markers allows a comparison of genetic information found in secretions which may ultimately help identify foreign genetic information belonging to the assailant.

Toxicology studies:
Blood alcohol levels or blood studies for other drugs of abuse are not routinely drawn. Exceptions to this include a victim reporting being drugged by an assailant, a victim whose medical condition warrants this information, or if there is a clinical evidence that the victim is too intoxicated/drugged to effectively give consent to sex.

If a victim decides to prosecute, her doctor may be called to testify on her behalf. My first experience with the legal system involved testifying on behalf of a woman charging an acquaintance with date rape. She came to our local emergency room barely able to walk as a tampon had been forcibly pushed up inside her vagina, causing her terrible pain. I felt that she had an excellent case legally, but the alleged assailant was not convicted. All efforts seemed in vain. The frustration this woman felt cannot be overstated, and I share that frustration. Reflecting on this experience, I am convinced that I as a physician, the medical community as a whole, and society in general have long strides to make in providing for victims of sexual assault.

Ways to Further Advance Care For Victims of Sexual Assault

Victims of sexual assault and members of the medical community need to continue to work together to advance and improve care for sexual assault patients. Encouraging active dialogue between victims and professional care providers is the most effective way of changing attitudes, behaviors,

and protocols. Positive as well as negative feedback can lead to constructive changes.

Another way to directly assist victims of sexual assault is to become active in support and advocacy groups. Any individual can become a victim of sexual abuse. Many will be excellent advocates in helping subsequent victims with emotional issues or in the legal arena.

Sexual assault victims are best served by a community that recognizes and is knowledgeable about sexual assault issues. Keeping a community aware and politically savvy requires education. To this end, victims of sexual assault and the professionals who care for them must maintain a personal commitment from which the entire community will benefit.

Notes

1. Goddard, M., "Sexual Assault: A Hospital/Community Protocol for Forensic and Medical Examination." Washington, D.C. United States Department of Justice, Office of Victims of Crime 1988:1–80.

2. "Sexual Assault: A Hospital/Community Protocol for Forensic and Medical Examination." The State of New Hampshire Office of the Attorney General.

3. Beckmann, C., "Sexual Emergencies." *Medical Aspects of Human Sexuality*, Aug. 1990, pp. 69–76.

4. Burkhart et. al. (1983) quoted in Parrot, Andrea, "Medical Community Response to Acquaintance Rape-Recommendations."

5. Martin, P., DiNitto, D., Maxwell, S., and Norton, D., "Controversies Surrounding the Rape Kit Exam in the 1980s: Issues and Alternatives." *Crime and Delinquency,* Vol. 31, No 2, April 1985, 223–246.

6. Jenny, C., Hooton, T., Bowers, A., Copass, M., Krieger, J., Hillier, S., Kiviat, N., Corey, L., Stamm, W., and Holmes. K., "Sexually Transmitted Diseases in Victims of Rape." *NEJM,* Vol. 323, No 11, March 15, 1990, pp. 713–716.

7. Hayman, C., and Lanza, C., "Sexual Assault on Women and Girls." *Am J Obstet & Gynecol* 1971, Vol. 109, pp. 480–486.

8. Hatcher, R., Trussell, J., Stewart, F., Stewart, G., Kowal, D., Guest, F., Cates, W., and Policar, M., *Contraceptive Technology,* 16th edition, Irvington Publishers Inc., New York, 1994, pp. 415–432.

9. Young, W., Bracken, A., Goddard, M., Matheson, S., and the New Hampshire Sexual Assault Medical Examination Protocol Project Committee, "Sexual Assault: Review of a National Model for Forensic and Medical Evaluation." *Obstet & Gynecol,* Vol. 80, No 5, November 1992, pp. 878–883.

22

Wider Repercussions: A Victim, Her Mother, and Her Friend Talk About a Date Rape

Sadie Stoddard, Caroline Winter, and Mary Stoddard

Sadie

Last August, I went to Bermuda for a week with my field hockey team to compete in a coed international tournament. Our coach, Mrs. P., assured us that the tournament was only for fun and that there would be many other high school teams competing. I was psyched, but my parents were reluctant to let me go because they were afraid I would get hurt. There was no way I was going to pass up a trip to Bermuda, so after much whining and begging on my part, my parents finally let me go.

Mrs. P. made arrangements for us to stay at the Bermuda Regiment which she described as a small but comfortable dormitory-like youth hostel. When we arrived, we were shocked to find ourselves staying in army barracks with soldiers in the next room. Our "youth hostel" consisted of rows of rusty bunk beds and cockroaches the size of fists. We were thoroughly disgusted and if it weren't for Elbow Beach just across the street, most of us probably would have immediately flown home.

We soon befriended a group of British soldiers who were staying at the Regiment. The soldiers were amazing people, not to mention totally gorgeous. I became close friends with a twenty-year-old man named Sandy who had been in the British army since he was sixteen. He had fought in Northern Ireland and would probably be sent back there soon, and we spent a lot of time talking about his experiences. I gained a great deal of respect for him and valued his opinion immensely. He had seen so much at such a young age, and was so sure and honest about his feelings.

We spent the first two days in Bermuda at the beach with the soldiers. By the time the tournament started, we had grown accustomed to the heat and were reluctantly getting used to living with cockroaches. However, when we arrived at the stadium, we learned we were the only high school team in the tournament and were scheduled to play professional teams from around the world. The team closest to ours in age was a group of twenty year olds from Switzerland who were the best in their country. Our first game was against a Central American team who, needless to say, destroyed us ten to zero. Two girls fainted because of the heat but our coach forced them to play because we didn't have any subs. The rest of the week was the same: we would go to the tournament each morning, lose every game by at least seven points, and return to the barracks yelling and screaming at each other.

On our last night in Bermuda, the soldiers invited us to go with them to the Oasis, a popular club. Since no one on our team was older than seventeen, and we needed to be twenty-one to be admitted, we took turns going to the door and trying to get in. I went with the soldiers because I looked the youngest, and got in quite easily. I felt very proud to be in the Oasis because many of my teammates hadn't passed as over twenty-one and had gone to the barracks in disappointment.

I had never been to a club, and I was having a lot of fun. There was a room with a karaoke stage and my teammates and I watched the soldiers make complete fools of themselves singing in their drunken British accents. I had a few tropical drinks, not realizing how strong they were because they tasted so good.

After a while, I went for a walk around the club to find some of my other teammates. I found most of them on the dance floor. Being the world's most uncoordinated dancer, I decided to head back to the karaoke room where I could safely sit and not embarrass myself. I was a little bit tipsy, but I really didn't think I was affected much by the alcohol.

On my way back, I bumped into a really cute guy.

"Hi. I couldn't help but notice you when you walked by a little while ago. Why's a pretty girl like you all alone?"

I smiled and I'm sure my face turned bright red. This guy was really cute. He was medium height (which was good for me, being only 4' 10"), and muscular. He was black, and right away I knew he was a Bermuda native because of his accent.

I was totally flattered. True, it was a cheesy pick-up line, but all the same, it was intended for me. This really cute Bermudian guy had chosen

me above all the older and pretty girls in this club. My heart started beating a mile a minute as I struggled not to act like a total geek.

"What's your name?" he asked me.

"Sadie," I said, trying to sound as cool as possible.

"What?"

"Sadie!" I yelled over the music and drunken voices of the bar.

"Well, hello, Sadie. They call me Freddie." At this point, we were face-to-face and screaming in each other's ears.

"Hey, do you want to go someplace a little quieter? It's way too noisy in here," he yelled into my ear.

"What?" I yelled. After he laughed and repeated himself two more times, I said, "What time is it?" gesturing to my wrist.

"Uh, quarter of two."

"Oh, well I have to leave at two."

"Well, Sadie, I at least have to get a dance with you before you have to go."

My heart stopped. There was no way I was stepping on that dance floor. "Naw, I don't feel like dancing," I said, trying to sound as casual as possible.

"Well, then do you want to go outside and talk until you have to leave?"

"Sure," I said. He took my hand.

He lead me out of that room and toward the elevator, where we passed three of my teammates.

"I'll meet you guys outside in fifteen minutes, okay?" I said to them as I walked by.

They smiled at me and I kept walking with Freddie. We went down the elevator, through the lobby, and outside. We went and sat down on a bench across the street .

"You know, Sadie, you're very pretty. You must have a boyfriend back home."

I laughed and shook my head.

"No? I wonder what's wrong with those boys."

Oh my God, I almost died. I felt so happy at that moment. I wanted to run home, grab a camera, run back, and take a picture of this gorgeous guy saying all these flattering things to me. My friends back home were just not going to believe me.

We talked for a while about where we were from, how old we were, generally making small talk. He was born and raised in Bermuda, was twenty-two years old, and his favorite color was blue. He looked straight at me, and said, "Can I kiss you?"

"What a gentleman!" I thought. "No guy has ever asked permission to kiss me before." I nodded and we kissed. All that went through my mind while we were kissing was, "This is definitely a Kodak moment!"

He whispered, "When do you have to leave Bermuda?"

"Tomorrow."

"Tomorrow!" he said, standing up, "But you haven't even seen the island! Come on, I'll show you around a bit."

"Now? What time is it?"

"Aw, you got time. Come on," he said as he pulled me to my feet. "There's someplace I want to show you."

"Okay, but I have to be back here soon or my friends will kill me."

He put his arm around me and we started walking down the street. We were talking about the differences between Bermuda and my home town, and after a while we got to a beach. He looked around, mumbled something about it being too crowded, and said, "Come on, I want to show you something."

He took my hand and led me across the street and down a side street. There was an old rundown building on our right and he turned and walked right up the driveway.

"Where are we going?" I asked, slowing down.

"This used to be a famous hotel, and about ten years ago there was this big fire and it has been closed down ever since. Come on, there's a great view of the ocean from the lawn over here."

He stepped over a "Keep Out" sign, and I followed. We walked around the building, down a path, and onto the grass. He led me to a tree, and sat down under it.

"I can't see the ocean," I wanted to say, but I didn't because I thought I'd sound like an idiot.

"What time is it? I should probably start heading back," I finally managed to say.

"Oh, we got time," he said as he leaned over and started to kiss me. After a couple of seconds, he whispered,"Do you want to do it?"

"Huh?" I said, sitting up straight.

"Do you want to do it, you know, make love?"

I had never had sex before and the thought of having sex with this total stranger hadn't even crossed my mind.

"No. Look, I gotta get back, my friends are waiting for me."

"You aren't going nowhere just yet," I remember him saying as he pushed me back down on the grass.

This is the point at which everything blurs together. I went numb. I remember looking up and seeing the branches of the tree we were under. I could hear myself saying, "No! No! Stop! Please . . ." and I could feel him on top of me and then inside me, but it didn't seem real. I couldn't think straight. I was in a nightmare: everything was fuzzy and no matter how hard I tried, I couldn't move. I've tried countless times to explain the rape in more detail, but I can't. I can remember everything that happened, but no matter how hard I try, I can't get it on paper.

I walked back to the Oasis, with him right behind me. I walked into the lobby and up the stairs and back into the bar. I didn't know what to do. All these things were swirling in my brain, and I couldn't sort them out. I saw one of the soldiers talking to a group of girls and I walked right up to him.

"I need you to take me home," I said, looking over my shoulder to see if Freddie was still there. He was gone.

"Sadie! Where have you been? Everybody's been looking for you! You're in deep shit, let me tell you!"

"I need you to take me home," I repeated. I could hear my voice shaking.

"All right, listen. It's ten of three. Let me say good-bye to these ladies and at three o'clock I'll take you home."

"I want to go home now!" I said, and I started to cry.

"All right, all right, come on," he said, taking me by the arm and rolling his eyes at the girls. We went down the elevator and outside. He led me to the parking lot, where two of my teammates were sitting by the soldiers' van. They ran over to me and hugged me and started asking me all kinds of questions, but I just climbed into the van and stared straight ahead. The whole ride back to the barracks I kept telling myself all I had to do was fall asleep and everything would be fine by morning.

My whole team was waiting for me when I got to the Regiment. The girls who saw me leave with Freddie were really worried when I wasn't waiting for them at two o'clock. When I got out of the van and they surrounded me with hugs, I just cried and said I had to go to bed. In my bunk, I lay there and cried. I couldn't think, I was still numb. After a few minutes, Mary Ellen and Kristen, two of my teammates, came in and took me outside. Mary Ellen sat me on the floor of the bathroom, looked me straight in the eye, and asked, "Did he rape you?"

"I don't know," I said, too confused to think straight, but knowing he did. I just sat on the bathroom floor crying hysterically, hating myself and hoping that morning would come soon and take away all the pain.

Kristen told one of the soldiers that I had been raped, and he called the

police. I didn't want him to and I started screaming hysterically when Mary Ellen told me he had called them. Caroline came and led me outside the bathroom, and I sat on the steps, cradled in her arms, crying harder than I ever had in my life. All I wanted to do was fall asleep and wake up in the morning like this was all some kind of bad dream.

Only when a cruiser arrived did Mrs. P. wake up. After the policeman questioned a few of the girls, he took Mrs. P. and me to the emergency room of a hospital, where two doctors gave me a thoroughly frightful and degrading examination. They pulled out strands of my hair, and combed through my pubic hair and cut out pieces of it and put them in plastic bags. I'm not exactly sure what else they did, because I was so numb and upset, but I know it was very long and painful. I had never had any kind of pelvic exam before and I just covered my eyes and waited for it to be over.

After we left the hospital, an officer drove Mrs. P. and me to the police station, where I was questioned. The whole way there, Mrs. P. chattered about how beautiful Bermuda was, as if she were on a scenic tour bus. The police officer just looked at her as if she were a lunatic and kept driving.

At the station, a police officer asked me to tell the whole story. I still couldn't think straight. I just stared straight ahead of me and numbly rattled off exactly what happened. start to finish. That was the only time I have ever been able to tell my whole story, bar none, because I was so numb.

When I was finally driven back to the barracks, I immediately fell asleep. I didn't want to talk to anyone, I just wanted to go to sleep and put the whole incident behind me. When I woke up, I found that my team had already left for Boston and I was left to stay another day with Mrs. P. at the barracks. Caroline had offered to stay the extra day with me, so I was relieved. I didn't want everyone there, swarming all over me anyway, so I was happy they had all gone home.

I spent the rest of the day with Sandy and Caroline. They were really helpful and tried hard to keep me calm. Most of the soldiers didn't know how to act toward me, so I was pretty much ignored. I didn't mind because I felt safe just being there at the barracks with them. I tried to avoid Mrs. P., because whenever she saw me she would slap me on the back and bellow, "Aren't we lucky to be in sunny Bermuda an extra day? I just love Bermuda flowers!" Sandy, Caroline, and I decided she must have gone crazy.

Sandy told me I had to tell my parents. I was hoping I could just leave Bermuda and all my feelings behind. I wanted to go home like nothing

ever happened and never tell them. Sandy reminded me that they would probably notice when I didn't show up at the Boston airport with my team, so I walked down to the pay phone and dialed my number. To my extreme relief, I got my nine-year-old sister's shrill, nasal voice on the answering machine. After the beep, I was very surprised to hear my calm reassured voice announce to my parent's machine that something came up, so don't go to pick me up at the airport today, and I would call them later.

A few hours later, Mrs. P. came up to me and announced that it was time to call my parents again. I told her I would rather do it alone, but she said she needed to talk to them. I was a tiny bit relieved because I had no idea what I was going to say to them, but I still felt that I should talk to them first. She beat me to the phone. I don't remember what she said to my mom because I was concentrating too hard on finding a way to dig myself a hole in the floor and escape from that room. I do remember Mrs. P. saying, "She's fine" over and over again and being very blunt. When Mrs. P. handed me the phone, my mom said, "How did this happen?"

I said, "I don't know—I was drinking."

I'll never forget how my mother said, "Oh, Sadie," the disappointment in her voice, the long pause, and then, "You could have AIDS!" The sound of her voice saying this still rings through my head. The thought of AIDS was too immense to even register. I didn't want to talk to her anymore, and Mrs. P. was bugging me to let her talk to my mother, so I said, "Mom, Mrs. P. wants to talk to you."

My mom snapped, "I don't want to talk to *that woman.*" I heard more silence from my mother and then, "Sadie, your father just walked in. Let me talk to him and then call you back."

I handed the phone to Ms. P. and heard her say, "She's fine" once more before I dove out the door and ran to my bunk in shock. I felt so ashamed, like I had let my parents down. It was then that I realized the immensity of what had happened to me. I wasn't going to be able to just forget about the rape the next day when I left Bermuda, and the fact my parents knew made me realize that what Freddie had done was very serious and it was going to take me a long time to heal.

Later that day I was told I had to go back to the police station. They were questioning someone and they wanted me to identify him. A cruiser came and picked me up, and Caroline and Mrs. P. came with me to the station. I was really eager to get it all over with and go home. When we got to the station, we were told to sit and wait until they were ready. I was so ner-

vous, I thought my stomach was going to explode and millions of butter-flies were going to come flying out. After about fifteen minutes, a police-man walked over and said, "Are you ready?"

I nodded, stood up, and followed him to a closed door.

"Okay," he said, holding the doorknob, "All I want you to do is walk in there, tell the officer who the man is, and walk out, okay?"

I nodded and he opened the door. I was expecting a line-up and a big one-way mirror, like I had always seen on TV. I took one step in the room and gasped. My heart stopped. The room was the size of a closet. There was only enough room in it for a desk and two chairs. Sitting at the desk was a police officer, and across from him was Freddie and some man who must have been his lawyer. He was so close to me, he could have reached out and grabbed me. He was just staring at me, and I felt sick.

"Is the man you are accusing of raping you at the sight of such-and-such hotel in the morning of September 8th at approximately 3:15 A.M.?" the of-ficer read from something on his desk.

"Yes," I whispered and stared at the floor.

"Will you please identify the man you are accusing by pointing."

I looked at him straight in the eye and pointed at his face.

"Thank you," the officer said and led me outside the room.

I walked back to where Caroline and Mrs. P. were waiting, hugged Car-oline, and started to cry. I felt like a thousand tons of bricks had been lifted off my shoulders. That was the hardest thing I think I'll ever have to do in my life, and it was over. Now all I had to do was sit in this room and wait for them to tell me I could leave the station. I could go back to the barracks with Caroline and sit with Sandy until it was time for me to go home.

A police officer came over and offered us Freeze Pops. He handed me a blue one and I smiled.

"She's smiling!" he exclaimed as he gave me a hug. We all laughed and he led us outside to the cruiser.

I couldn't sleep that night, and after Mrs. P. and Caroline fell asleep, I walked outside where Sandy and some of the soldiers were playing cards. Eventually, the rest of the soldiers went into their barracks and went to bed, but Sandy stayed outside with me. I couldn't stop blaming myself for leaving the club with Freddie in the first place, and Sandy spent hours try-ing to convince me that nothing that happened was my fault.

"That fucking creep is the one at fault, not you. He is the one who de-serves all the pain and suffering. He knew exactly what he was doing, for that I hope he burns in hell."

We spent some time discussing what I was going to do when I got home.

I couldn't decide if I really wanted to go or not. I didn't want to face my parents, because here in Bermuda it felt like the rape was just a bad dream, and I knew once I got home and faced my parents and my friends, it would all become real. I knew I didn't want to stay in Bermuda, because everywhere I turned, I felt Freddie was near me, following me around. The one thing I knew for certain was that I did not want to leave Sandy.

I left Bermuda early the next morning. I don't think I'll ever be able to go back there, because as I boarded the plane, I left a part of my soul that was haunted by horrible visions and feelings. When I arrived in Boston, I was convinced I was over it. I felt I had dealt with it and it was over. When I saw my parents waiting for me at the airport and I saw their tear-stained faces, I had a sick, hollow feeling in my stomach because I realized the pain I had caused them. I didn't know how to act. My headmaster, the school guidance counselor, and some parents had come to the airport to greet Caroline and me, and they were all looking at me like I was some kind of orphan who only had two days to live. It seemed like they were all expecting me to come running off the plane crying hysterically and praying to God for mercy. I didn't feel like crying. I just wanted to go home and sit in my room where I didn't have to look at my parents' faces. I felt like everyone was staring at me, analyzing every move I made and shaking their heads with pity every time I blinked my eyes. I just smiled, hugged my parents, and babbled the whole way home about how great Bermuda was.

I didn't want to talk to anyone about it. I was determined to be over it. School was to start in less than a week and I decided not to let anything stand in the way of my senior year. I went with my class on our annual orientation trip and I convinced myself that I was perfectly fine. My field hockey team doted on me with hugs and tears and I just shrugged them off by saying I was okay.

Gradually, though, I realized I wasn't okay. I felt alone. I hadn't told my friends what had happened because I didn't know how (I couldn't exactly say, "Hey guys! Guess what happened to me last week!"), and I got angry because they were acting as if everything were normal. I didn't feel like I could talk to anyone. My friends on the field hockey team didn't know how to act toward me, so most of them just smothered me with hugs as if I were a baby, even though I felt like I had aged a lifetime. They would call me and say things like, "Hi Sadie honey, how are you, sweetie? Just calling to tell you that we all love you," and adults that I didn't even know kept hugging me and smiling at me like I was some kind of helpless puppy. Even though I knew they all meant well, I felt like everyone was being

fake and that they didn't mean what they said, but they were acting that way because they felt they had to.

When I started school that week, I was a complete mess. I became paranoid and every time someone spoke to me I wondered if they "knew," like it was some big awful secret that determined how they acted toward me. I couldn't stop thinking about two years ago, when one of my friends pointed to a girl and whispered, "She was raped, you know." The way I acted around that girl totally changed. Every time I was near her, all I could think about was the fact that she was raped. I didn't know what to say to her, and I started avoiding her altogether. Now I wished I had kept in touch, because I needed desperately to talk to someone who understood what I was going through. I wondered if people thought the same things about me as I did about this girl. I felt like some kind of freak. I was embarrassed to talk to anyone, because if they knew, I didn't want them thinking of me any differently than before I was raped. Honestly, I didn't want anyone to know what happened, but I knew there was no way to control who found out. I wished I had a big checklist, and I could look down the list of names and there would be an X in front of everybody who knew. I didn't know if any of my teachers knew, and what they were thinking. I felt so helpless. I was told by numerous people on my field hockey team to shrug it off and not worry so much about who knew about the rape or not, but for many months, this really bothered me.

Mrs. P. told the headmaster that our team was drinking the whole time and was out of control as soon as we got there. Even though all the parents of the team called the school and convinced them that Mrs. P. was lying to protect herself, I couldn't get over my deep anger toward Mrs. P. She was still our field hockey coach for the season, and I had to put up with her senseless singing and babbling and each day overcome my urges to hit her over the head with my field hockey stick.

I didn't know what to feel or how to act anymore. I became very moody and would cry in class for no reason. I even broke down in church one Sunday. I was in the choir and as we were singing I just started bawling. My parents became super-nice to me. They tiptoed around me as if they were afraid I would blow up if they upset me in the teeniest way. I was seeing a psychologist once every two weeks, but I really didn't think she understood me. The first thing she said to me when I went to see her was, "Did you have an orgasm?" She kept telling me what stage of recovery I was entering. "Well, you were still in denial last time I saw you, so you should probably be feeling anger and guilt for the next couple of weeks." The thing that angered me the most about her was when she told me I would be

totally "cured" by Christmas. When December 25 rolled along, I was up in my room deeply depressed because I felt so lonely, and I knew that my psychologist had no clue what she was talking about.

I found myself acting in different ways around different people. When I was with the field hockey team I was really quiet, but when I was with my other friends (most of whom didn't know), I found myself acting really angry and obnoxious. I was a brat to Mrs. P., and at home I didn't even talk to my parents. I just went straight to my room and turned on the radio. I felt so alone. I couldn't talk to anyone, and I felt no one understood what I went through.

At night, when I lay in bed trying to get to sleep, I would start thinking about what happened, and I would get really angry and frustrated. I don't think I was angry so much because of the rape, but because I couldn't cry and let it out. The only time I would cry was for trivial, stupid things, like when my mother would buy Alpha-Bits instead of Lucky Charms for breakfast. Since I left Bermuda, I hadn't cried for real, and I wished I could just yell and scream and get it all over with. I kept telling people it was getting easier and soon it would all go away, but I was becoming afraid that everything was going to stay inside me and haunt me forever. I couldn't tell, write, or even deliberately think about the specific details of the rape. I could remember every detail in flashbacks, but I couldn't make myself put them in order. I tried countless times to sit down with somebody and tell them exactly what happened, but something inside me was holding it tight.

My parents hired a lawyer and made me go into his office and talk with him. I literally went in kicking and screaming, making quite a scene outside in the street. I announced to him that I didn't want to talk about it, and he said that was fine. Everyone kept telling me how good it would be for me to press charges, and how I would regret it for the rest of my life if I let Freddie off the hook. I wanted him to pay, I really did, but I knew I couldn't face him again, and I couldn't talk about what happened. No one seemed to understand how hard it was for me to talk about the rape. They seemed to think if they could just get me to blurt everything out, I would be instantly cured. I admit, I would have felt a lot better if I could have just sat down and faced everything I went through. I really wanted to talk about it, but I couldn't. No one seemed to understand that.

I couldn't even say the word *rape*. I would refer to it as "the whole thing," or "what happened." The first time I wrote the word rape down was in December, when I was writing an essay for a college application. The word stared back at me and sent chills down my spine, and I felt nauseous.

It was hard to write, and even harder to say. I still find myself saying, "the Bermuda incident," and I flinch every time I hear *rape* on TV.

As a few months passed, I told a few of my closest friends and it became easier for me to talk about. As field hockey season ended and ice hockey began, I started to gain confidence in myself once more. I was still paranoid about who knew and who didn't, but I was beginning to focus my anger on the person who caused it: my attacker. I had started to convince myself that even though I made the mistake of drinking and going off alone with a total stranger, being raped was not my fault. But I was still very moody and I knew that it would take a while for me to fully recover.

As I sit and write this now, I realize how much I have overcome since I left Bermuda four months ago. I was able to start school a week after I had been raped and overcome most of my fears and feelings while surrounded by people who had no idea what I was going through. I had to spend all my free time in psychologists' and lawyers' offices while most of my friends were at the mall or getting their driver's licenses. I learned to stop blaming myself and even when my family received the letter from Bermuda's attorney general stating that there was not enough evidence to prosecute, I knew deep in my heart that I didn't do anything wrong. Although I still have some bad days, I have come a long way from that bathroom floor in the Bermuda Regiment, and know if I will get anything out of this rape, it is that I will become a much stronger person.

People have told me from the start that this is something that is going to stay with me and haunt me for the rest of my life. "He has taken something from you that you can never get back," I have heard over and over again. It's been almost a year now since I left Bermuda, and I can honestly say I'm almost completely fine. It seems like some distant memory, like a nightmare I'm on the verge of forgetting. I don't mind talking about my rape. If I had my way, everyone in the world would know that I'm a victim of rape. It's a part of me now. Not the most happy of parts, but a part that has changed me, has molded me into a strong, wise, young woman who isn't afraid to say, "I was raped and this is my story."

Caroline

"Caroline."

I spun around at the sound of Sadie's voice, breathing a sigh of relief. We had been looking for her for an hour, and I was getting really worried. From the time we realized that she was missing, I couldn't keep from imagining all of the awful things that might have happened to her. As soon as I heard her call my name, all I could think about was finally getting home and getting into bed. When I saw Sadie's face my fear returned. Her eyes were red and puffy, and although she smiled when she saw me, she was not convincing. I knew that something awful had happened.

That night the members of our field hockey team had decided to go to a dance club. We had been in Bermuda for a week already, and after a couple of evenings, the stores had all been shopped in, and the town quickly lost its appeal. Nobody wanted to stay home, all fourteen of us in one small room, and the dance clubs were an enticing alternative. They held the excitement of meeting new people, and we were lured in by the blaring techno music we could hear from the street.

After convincing the coach to let us go, we all showered, spending close to two hours getting ready. When everyone had finally gotten dressed, we hurried out of the barracks, and walked down the driveway to catch taxis. Everyone was excited, but we knew enough to informally remind each other of the guidelines which had been established at the start of the trip: don't venture off in groups of less than three; remember curfew; look out for each other. From the outset, rules were broken. At least twice girls had wandered off alone at night, yet we lacked any explicit guidance, and basically took advantage of our one absentminded chaperone. We thought we were taking precautions, yet what happened to Sadie must have been inevitable to some degree, because next thing I knew I was sitting opposite a stiff detective from the Bermuda police department.

He sat down across from me, placed his cup of coffee on the table, and shuffled through a jumbled pile of papers before greeting me. When he finally introduced himself, I tried to keep my emotions under control, but inside I had more feelings than I knew how to cope with. All I could see when I closed my eyes was Sadie's innocent, trusting face. I figured that somehow what had happened was my fault; I was the captain of the team.

When the detective asked me if I had seen the man who raped my friend, I nodded, afraid that if I attempted to speak I would burst into tears. As he tried to pull together the pieces of the night before, I was replaying my brief meeting with the short, stocky native boy over and over again in my

mind. I tried to clear my head, but my thoughts were distorted by memories of frantically flashing strobe lights and the thick fog of dark cigarette smoke; I could just barely picture the two of them standing in front of me. I saw the young man reaching his hand out to me in a greeting, and I noticed Sadie standing next to him, her face beaming. I looked at them without any trace of suspicion.

In retrospect, I condemned myself for my lack of intuition. Why couldn't I have perceived his intentions? Even worse, had I been too self-absorbed to prevent the rape? I couldn't stop thinking that the fun I had that night had contributed to what happened to Sadie. I felt guilty that while she was being raped, I was probably dancing and laughing.

The first fun-filled days of the trip had been erased, and guilt, grief, and worry loomed heavy in my mind. Confusing and contradictory thoughts swirled around my head, as I looked for someone to blame. I questioned our coach's judgment about the amount of freedom we, a sheltered group of teenage girls, had been given. The resentment, even hatred, I had toward Freddie ran deep. I wanted him to experience the pain that he had inflicted upon my friend.

I was also upset to feel myself blaming Sadie, no matter how hard I tried not to. I had always hated that kind of "blame the victim" mentality, yet now that I was in the situation, I felt it surfacing in myself. Although I pitied my injured friend, felt guilty myself, and hated Freddie, I still had doubts about Sadie's role in the rape. I wondered why she had disregarded our rule against going off alone, why she had left the club with a complete stranger, and why she had ignored the approaching curfew. At the same time, I hated myself for having those thoughts.

As I sat in the police station, I managed to respond to the detective's questions without breaking down. Although I was with the detective physically, mentally I was with Sadie. I remembered the pleading look on her face when she told me that she had been raped, and I was frustrated that I did not have a quick and easy solution for her. Eventually, we had just sat down on the steps of the barracks, hugged each other, and cried for an interminable amount of time. By the time we were gathered enough to call the hospital and the police, it was already six-thirty in the morning. At that point, our coach had woken up, and she took Sadie to the hospital while I waited for the detective.

Before he arrived, not wanting him or the rest of the team to see me upset, I wandered down to a small, deserted beach across the street where I attempted to sort through the chaotic events of the past twenty-four

hours. I was too tired to think straight, and my emotions were distorted by fatigue.

Now, with many months and several hundred miles between me and the island, I know that blaming myself is counterproductive. Although I still feel the old emotions arise periodically, I have tried to put everything that happened in Bermuda behind me. Certain anxieties and fears remain unresolved, and will probably never be completely eradicated, yet I have also seen some good things come out of the experience. Although it's been hard to watch her in such pain, Sadie has let me know that my support has helped her to heal. It helped her to write her story, and I respect her immensely for having the courage to tell it.

But whenever I look at my Sadie, I feel a pang of sadness. I've had trouble facing the reality of what happened to Sadie; the rape has exposed me to a world that I did not want to see or believe in. What upsets me most is the injustice that in one moment, one man changed her life forever.

I still struggle to trust others, and I am more skeptical about new situations than ever before. Part of the innocent, trusting child in me was left in Bermuda, and I still wonder if maybe, things could have turned out differently.

* * *

Mary Stoddard

Telling my part of this has not been easy: it is hard to think of myself as the mother of a *rape victim*. For a long time, I really didn't want to think about it, didn't want to confront the fact that it was my daughter who had been raped.

Instead of coping with Sadie's rape, I held my family together. I was there for her whenever she wanted to talk. I made sure she got the medical, legal, and psychological help she needed. I made sure the school bent over backwards for her to make her last year no different than her first three. I made sure my husband didn't kill the coach or the headmaster whenever he saw them. I made sure my ten year old didn't hear what happened to her sister, since I didn't want her innocence to be shattered as well. And I made sure Sadie's brothers continued on with their goals in life—at times I thought they might give up. I was surprised at how upset our friends became when we told about Sadie's rape, so I stopped telling people. I was

amazed at how the rape had disrupted all of our lives, and focused my attention on minimizing this disruption. Now I realize that I put so much energy into holding the family together because it was safer than the rage I felt when I thought about Sadie's rape.

When Sadie first told me about her field hockey trip to Bermuda she was concerned that we couldn't afford to send her. The coach called me to give me more information and to encourage me to let Sadie go. Mrs. P. said the trip would be a great opportunity for the team and would get their last season together off to a good start. She also suggested that Sadie could use the practice if she wanted to play field hockey in college. She assured me the expenses would be minimal because the girls would stay in "host homes" with Bermuda families involved with the field hockey tournament. I told the coach that if Sadie wanted to go, we would find the money to send her but that I was concerned about Sadie's safety. The coach assured me that I was being overprotective and that she would take good care of my daughter. I told her Sadie could go, but when I hung up the phone, I still felt apprehensive. When I found out the tournament was sponsored by Bacardi Rum, I became even more apprehensive.

I called the headmaster to see if he could reassure me a little. Why were they going? And how could one person take responsibility for fifteen girls? Several days later Mrs. P. called me, furious that I would go over her head and ask the headmaster questions. She promised the headmaster that she would address my concerns, but she only told me to relax and not be such a worrywart.

One week before the trip, Mrs. P. called me and said that the plans had changed a little (I remember thinking, "Oh good, the trip has been canceled"). She was very excited—there weren't enough host families so our team got to stay in the "Bermuda Regiment." She described the Regiment as being similar to our armories and she was happy that the whole team would now all be in the same dorm. She neglected to tell me that the regiment was active and soldiers on R&R from England were living in the next room. These soldiers ended up being lifesavers for the girls, but had I known about them before Sadie left, I would not have let her go. All summer I had a strong feeling that she shouldn't go, but every time I voiced my feelings, Mrs. P. pooh-poohed it. She made me feel like a neurotic mother who just couldn't let go of her daughter.

When Sadie finally left for the tournament, I remember thinking that I really had to relax and try to let go of my kids—not be so overprotective. Sadie called daily after each game, describing how every other team there had killed them and how hot it was and they were constantly offered liquor

by the adults that surrounded them. By the middle of the week, Sadie stopped calling so we figured she wasn't as homesick, and by the end of the week, we missed her and couldn't wait for her return.

The morning of the day she was to come home we went shopping, then came home to check on her flight before we left for the airport. There was a message on our machine from Sadie saying that she had to stay an extra day and would call later. I was dumbfounded—I assumed that she was having some trouble because she didn't have a passport. I started calling parents of Sadie's teammates to see if their daughters were also delayed, but I couldn't get through to anyone.

Then the headmaster called and asked if I had heard anything. I said no. He told me Sadie had gotten herself into a little "scrape" and had to stay an extra day. When I asked him what kind of scrape, he said someone had accosted her.

After a while, Mrs. P. called and told me that Sadie was fine. She said Sadie had met one of the islanders at a party and left with him—and that he had tried to rape her. She had been checked out at the hospital and was fine, really fine, and she had been so brave and . . . I just remember listening to her rambling and suddenly it occurred to me to ask: "Was she raped?" Mrs. P. said, "Yes, yes she was." I remember feeling like I just wanted to die, that the whole sheltered life I had constructed for my kids was just shattering around me. I tried to take deep breaths, hoping it was just a bad dream. I thought, "Why did Mrs. P. have to say yes when I asked her outright if Sadie had been raped? Why couldn't she be vague like the headmaster had been? Why couldn't Sadie have been 'almost raped'?"— that seemed so much less serious. I asked to speak to Sadie, and tried to block out the sick feeling in my stomach, a feeling I had never felt before but have felt many times since.

Sadie got on the phone and sounded as sweet and young as ever. "Are you okay?" I asked her. I didn't know what else to say, so after a long pause I said, "What happened?" She just said, "I don't know . . . I was drinking." That was all she said. "I'll call you later," I told her. Her father had just walked in and at that point knew only that Sadie was not coming home that day. I just wanted to get off the phone and catch my breath. I was in total shock that Sadie had been drinking and at a club.

After I hung up the phone with Sadie, I turned to my husband Matt and blurted out, "It's bad—she was raped—she said she was drinking—that's all I know." I went up to my room and tried to think but I just didn't know what to do. In all my forty-four years I had never had to deal with anything like this before. Matt, who has a temper and can blow up over nothing,

came in and hugged me and said, "We can deal with this. We need to go there—we need to get Sadie." A minute later he broke down crying and said, "How could this have happened? How could anyone hurt her? Our little girl . . ." I couldn't cry, I just said, "I don't know." Matt spent the next hour keeping himself busy calling everyone he knew who might know how we could get to Bermuda. He called all of the airlines, but by the time the next flight left, Sadie would be on her way home. That night Sadie was to face her attacker and identify him for the police. We wanted to be there with her but it was impossible. We were both extremely upset. I remember thinking, "Now I know what feeling numb is like."

I don't think we slept that night—endless questions ran through my head. Why had we let her go? I knew she shouldn't have gone. Why didn't I listen to my instincts? Why did the coach think she could chaperone fifteen girls? And why hadn't the coach called us the night before, when the rape happened? We might have been able to be with Sadie when she had her physical at the hospital and when she had to face her attacker. Now all we could do was wait, helplessly.

Finally, the time came for us to go to the airport. We decided that I would take Sadie right to the car and my husband would get her luggage. We knew Mrs. P. had stayed with Sadie and we didn't know what to say to her. When we walked through the gate, we were met by the headmaster, the school psychologist, and the Winters, who were picking up Caroline. The plane was late and while waiting I made idle chitchat (my husband wouldn't speak with anyone). It was a very awkward moment. The plane finally landed and we stood waiting anxiously for Sadie—I wondered if she would be bruised or crying, but when she we saw her, she seemed fine. I remember how sunburned and how small she looked. The headmaster, school psychologist, and the Winters hovered around her. My idea of grabbing her and leaving wasn't going to happen. The coach came over and hugged me and my husband and started crying and saying that she took care of Sadie as if she were her own daughter. Caroline's mother wanted Sadie to go with Caroline to a restaurant where the rest of the team was waiting, to assure the other girls she was all right. I just wanted to keep her home but Sadie wanted to go so we agreed that Sadie's older brother, Mike, would take her for a while then bring her home. While they were at the restaurant, Mike heard the girls talk about the whole trip. Supposedly, the coach got drunk every night, passed out, and left the girls on their own. They talked about being surrounded by alcohol all week and how on the last night, a lot of them had tried some of the island drinks, with the cute little umbrellas, and how they tasted like pineapple juice.

During the two weeks after Sadie was raped, we gradually learned some of the details. The police in Bermuda were very cooperative. One sergeant in particular told us everything Sadie had told him. She and the other girls had gotten into an over-21 club with some of the soldiers from the armory, where they were served alcohol. The girls were pretty much on their own for over a week in a tropical paradise surrounded by partying adults. I think it's remarkable that Sadie was the only one hurt. The sergeant told us that Sadie was sitting with all her friends and the soldiers and some of the girls and soldiers got up to dance. It was noisy and crowded. One of the islanders came over and started talking to Sadie. Then he asked her to dance and she told him she didn't know how so they continued to talk. After awhile, the man commented on how noisy the club was and suggested they go outside to talk. When he started to get too pushy, Sadie said "no" to his sexual advances and tried to go back to the club, but he held her down and raped her. Sadie is only 4' 10", and this man was "short but stocky."

A week later, school started. At first, we wanted Sadie to go somewhere else, but Sadie really wanted to go back to Pickering. Then, as the first day got closer, Sadie didn't want to go, but I didn't want the rape to ruin everything. Sadie needed a little encouragement but she got through it. I expected the school to help Sadie with whatever she needed and it has. Every once in a while a student or teacher says something that upsets Sadie and I call the headmaster and he fixes it.

My biggest feeling has become anger. I am angry at the school and the coach for obvious reasons. I am angry at the school for allowing the coach to remain at the school and still have an effect on Sadie. I am angry that because Sadie wanted to limit the amount of stress she had this year, she dropped three honors classes and took accelerated classes instead. As a result, her college selection process has suffered, and she's going to one of her "safeties" because she didn't get into her first-choice schools. I am angry at my husband because when I suggested we go to Bermuda with the team, he said we couldn't afford it (but wouldn't give up his annual sailing trip to Cape Cod). And I'm angry at myself for not listening to my intuition and not allowing her to go.

For a while, I was angry at Sadie, too. I was surprised that she had been drinking because our family was so against it: my husband and I do not drink and my son lives in a chemical-free dorm because he is so opposed to drinking. I was surprised that she was with a boy; she had only been on one date before (a double-date at that). My immediate perception of the situation was that she had gone to Bermuda, tasted liquor for the first time, and gotten raped. I was angry at Sadie for being so trusting and making

herself so vulnerable. I realize now, however, that even if Sadie was not as careful as she might have been, she took risks that most sixteen year olds would, and that trusting someone is not a crime. She did not ask to be hurt so badly, and I would never blame her for what happened.

I *do* blame Sadie's attacker for his actions. But he could say he was in an over-21 club and had every reason to believe that she was twenty-one. He would have to be very stupid to believe that—Sadie still has trouble convincing the wait staff in restaurants that she is over twelve and ready for the adult menu. I'm sure he knew exactly what he was doing. But when it was time to decide whether to prosecute him or not, the sergeant said that the case was iffy. The sergeant believed Sadie, and was willing to help in any way we wanted. The attacker was tested for HIV and all sexually transmitted diseases, at our request. (Apparently we would not have had that right in the U.S.) After several weeks, the sergeant and we decided not to prosecute. The psychologist felt that more harm than good would come to Sadie if she were forced to return to Bermuda and testify, especially since there was a good chance the rapist would go free.

I am not sure anyone ever recovers from something like this. Now that Sadie has graduated, we are starting to take the necessary steps to make sure this doesn't happen again. My husband and I have never believed in filing suit against anyone, but we both feel that this should have never happened, so we've decided to sue Pickering. There is no way one coach should have ever been allowed to take fifteen teenaged girls to Bermuda. Five other parents and I all offered to go as chaperones but we were assured that additional chaperones were unnecessary. I feel Pickering betrayed us and I want them to be more careful in the future. Neither the coach nor the headmaster has ever acknowledged any wrongdoing on the school's part, and Mrs. P. has never been reprimanded. Some rules concerning field trips have been changed, but that's all.

We're getting through this. Sadie continues to see the psychologist, although she doesn't seem to think it does any good. She has frequent nightmares. She is still very uncomfortable around boys and will only socialize with boys when other girls are around. She went to her prom with a male friend and felt safe until they slow danced—then she "freaked out." She started to cry and got upset when he kept asking "what's the matter?" After that, she stayed with the girls and left him bewildered, because she hadn't told him about her rape. I think she has a long way to go but we are making slow, steady progress. Just when I think things are getting back to normal, Sadie has a setback, but we are dealing with it. Contributing to this book has probably helped both Sadie and me more than anything else. We

have been forced to face these different issues when it would have been much easier just not to think about them.

I want Sadie to attend college in the fall and be happy. I want her to become a minister (which is what she wants to be) and have a good relationship with someone she loves and have a family and not let this ruin her life. She has a strong, loving family and we will all do whatever it takes to help her.

* * *

Alone
by Sadie

They smile and pat your head,
And say you're being strong.
They tell you they are there for you,
And the hurting won't last too long.

They say they understand,
And they know how you must feel.
They give each other funny looks,
Because they don't know how to deal.

They try to cheer you up,
And worry when you don't smile.
They hold your hand and give you hugs,
But it will only last a while.

Soon the phone will stop its ringing,
No more cards to show they care.
They'll all forget about that night,
But the hurting will still be there.

23

Not My Little Sister

Avery O'Connell

I kept telling myself that things like this don't happen to your little sister. To your friends, to you, to strangers, maybe. But not my little sister. Not the girl who appointed me as her role model when I did not want the responsibility, who blindly took my side whenever there was neighborhood opposition, who withstood the pressures of serious sibling rivalry, who was my play companion as a girl and my confidante as a teenager. She was, in my opinion, too young to have to worry about rape. She hadn't even started college where they teach you to watch out for dangerous situations. No one had ever warned her to be cautious. I don't think anybody thought that at the age of seventeen she would be in danger. How wrong I was.

Ashley and her friends had been drinking. Our community was very small, and for the most part, everybody knew everybody. Ashley usually went to parties attended by students from one or two high schools, so it was difficult to do anything without it being talked about on Monday morning. While the gossip mania was annoying, at least you felt safe knowing that any unacceptable behavior (crime, extreme intoxication, etc.) would be judged by the self-elected high school jury a few days later. However, one party Ashley attended was another story. There were students from many different high schools and the familiarity that protected her from most boys her age was absent.

Her blonde hair, blue eyes, and natural charm have lured the attention of many boys. It's not surprising that Dan set his sights on her for the evening. She drank a lot, as did he and all the people they were with. They seemed to hit it off right away and proceeded to talk to each other for quite a while. They flirted and he became bold, trying to kiss her. Although she never even let him kiss her, the fact that the alcohol was affecting her apparently prompted him to set his aspirations even higher than kissing. He later asked if she wanted to have sex. Ashley reacted with a very simple

"no." They had been talking to each other for quite some time when she felt the alcohol hit her pretty suddenly. Dan followed her to the bathroom to lend his support as she vomited. She wanted to take a nap so she went into one of the bedrooms and locked the door behind her, not noticing the other entrance through the bathroom. The gap in her memory begins at this point and continues through a crucial part of the evening.

She woke up later. In bed with him. Underwear off. She was torn between two reactions she wanted to convey: fear and nonchalance. The invincible attitude that prevailed was reminiscent of a seventeen year old who had spent so much time proving her independence that she had forgotten that some situations warrant getting freaked out. So fearing the worst, but not wanting to appear uncomfortable, she asked, "Did you pull out?"

"Of course!" Dan said, upset at her insinuation that he would be so irresponsible as to neglect to provide some form of birth control. She left the party in a daze, wondering what happened and ashamed at what she thought she had done. In her mind, she had sex with someone she didn't care about, something she vowed never to do. She felt she had cheapened herself and the act of sex by compromising her beliefs.

She didn't call me until a week later. Her shame had forced her into silence, preventing her from asking anyone to help her reassemble her blurred memory of the evening. Even though she had chosen to bear her confusion and fear on her own, there comes a time when even the most independent seventeen year old needs her big sister. So she broke down and called me, and her trauma immediately became my own. "I have a problem," she said. I immediately got a lump in my throat. I don't know what it is about our relationship that makes me so protective of her. It probably stems from memories of her as a baby when my parents always told me, "Now you take care of your little sister, she needs you." I can't help but feel that I failed. Maybe, just maybe, if I had warned her about the dangers of rape when she was younger, this would never have happened. But the fact that she locked the door behind her as she entered that bedroom tells me that she was already pretty aware.

I listened to her story over the phone in my sorority, where the walls had heard other similar accounts. Rape was a very sensitive topic for me because a couple of close friends of mine had survived rapes and I had quickly learned the importance of my role as a listener. Ashley blamed herself entirely so I tried to convince her otherwise, knowing that acquaintance rape takes it toll by creating a persistent guilty conscience. I told her

that the only thing she had done wrong that night was encounter a boy who did not comprehend the meaning of "no."

Her initial reason for calling me was a "weird pain" that seemed like it had been caused by the incident. I persuaded her to go to a clinic for some tests. She went with a close friend of ours, toting a heavy heart and a petrified look on her face. Upon examination, they discovered that Ashley had been torn and an infection had set in. The woman at the clinic asked her what had happened. Ashley attempted to sidestep the questioning since she was seeking a medical opinion, not psychological assistance. But they continued to interrogate her. Finally, she broke down and blurted out, "I was raped, okay?" The next thing she knew, they had her on the phone with a police officer who wanted to hear the story and find out more information about her, including her dating history and our parents' work numbers. She did not want our parents to know because, in her understanding of the situation, they would have a good reason to be mad at her for what she had done. She became irritated not only because the officer threatened to tell our parents, but because the examination had forced her to disclose much more than she had planned. Ashley refused to cooperate with the officer so he became angry and started yelling at her, accusing her of being at fault because she had been drinking. He badgered her with such allegations as "Don't you think you were sort of asking to be raped?" and "Are you sure you told him 'no'?"

It is precisely this prejudice that caused Ashley to blame herself and which discouraged her from turning to anyone (doctors, law enforcement, rape clinic) right after the incident happened. She had unknowingly adopted the societal beliefs which condemn women who are "guilty" of "getting themselves into such situations."

I quickly realized that our only defense was to learn about the legal procedures which had created this aftermath to an already difficult situation. I went to the Women's Resource Center at my university where I was comforted to find a supportive, knowledgeable staff. As far as the sudden involvement of the police, I was told that it all came down to Ashley's age. The day she went to the clinic, she was three days shy of her eighteenth birthday and legally, a minor. Because she was a minor at the time of the crime, she was technically a ward of the state and it was therefore up to the district attorney to press charges. Ashley had no choice in the matter. Basically, if they thought her case was triable, she would have to testify in court. The laws in her state were such that she might have had no choice in the handling of a case that she never even wanted to share with anyone.

The counselor at the center pointed out that, by legal standards, Ashley's state of intoxication rendered her unable to provide consent to any sexual invitations that evening. Even if she had willingly taken him up on his sexual offer, the alcohol's influence was obvious and any "yes" would be legally invalid. It is frightening to think of the ignorance that leads to such situations. My sister and I were both unaware of the legal standards of consent. Ashley's attacker was probably equally unaware of the illegality of his actions. Nevertheless, putting all issues of legality aside, it was his less than outstanding character and his warped sense of privilege which led him to disregard Ashley's wishes in exchange for a few moments of satisfaction.

From the day I learned of Ashley's attack, I wanted to share my sister's story with my parents. Rarely did I keep things from them and I desperately wanted their support for both her and me. In addition, the policeman told Ashley that he would be trying to reach our parents. If nothing else, I didn't want them to find out from him instead of one of us. But Ashley's relationship with my conservative parents had always been strained due to her constant attempts to escape from the very tight reins they held. Our parents were going through some marital problems at the time, and, as weird as it seems, we felt the need to protect them. They were such loving parents that knowing the dangers their daughters faced at a perfectly normal party would have been very difficult for them. The incident had already deeply hurt both Ashley and me, so we wanted to keep the circle of pain as small as possible.

In addition, Ashley wanted to minimize the number of people involved so that she could more easily put the case to rest. Ashley and I are very different in this way. I tend to analyze events and mull over them at length, while she can put something out of her mind and move on. We decided not to tell our parents. Ashley was able to intercept the call from the police officer and said she was my mother, and to this day they still don't know. I know it may sound deceitful, but in such emotional situations it may be easier for those integrally involved if only a few people are informed.

Fortunately for us, the district attorney decided to drop the charges. I realize we may seem cowardly for refusing our opportunity to forever change that boy's interpretation of "no" and his erroneous notion of what a willing sex partner is. Ashley and I were both mad as hell at her attacker and would have liked nothing more than to make him pay for what he had done to her. But we both realized that judicial revenge would not be worth the public scrutiny Ashley would have had to endure. I had heard the stories of young women who had been brave enough to take their attackers to

court. But the interrogation process was always so brutal that these women suffered a round of emotional warfare likened only to rape itself. I had seen media coverage of strong women being forced to relive the brutal and personal details of an evening that most people would never have the nerve to share. Ashley and I both felt that the price of revenge was not something our emotions could afford.

Soon after the district attorney dropped the charges, Ashley also laid the case to rest. Her self-blame was assuaged by the legal standards of consent, her anxiety was arrested once the incident was out of the hands of the law, her trust in boys was regained by the next conscientious boy who came along and respected her wishes, and her hurt must have been healed by time. She never mentions that evening now. We only talk about it when I bring it up for the purposes of writing this essay. Her only scar seems to be a more cautious policy of drinking at parties. I often marvel at her ability to handle her fears so rationally. Ashley, always the one to put such things behind her, has moved on.

I, however, am still fearful. Maybe, because of my overanalytical tendencies, I feel compelled to do enough worrying for both of us. When I first started writing this essay, I felt like I was somehow taking revenge or reconciling the event on Ashley's behalf. But the more I wrote, the more I realized that the process has been more therapeutic for me than for her. As I talked to her and thought about what happened, it became evident that, at this point, I had more to "get over" than she did. I don't mean to portray myself as the victim in this case, but it hasn't been easy watching something like this happen to someone I love so much.

All I know is that four years later I still don't trust men I don't know in dating situations. Nothing in this world sounds more frightening to me than being raped because I don't know if I could ever get over it. I just can't imagine having a memory of such a thing. I fear that I would relive the night over and over, confusing my memory of a violent act with my understanding of what should be an unparalleled act of love. I fear that I would engage in generalization as one of my strongest defense mechanisms. Soon, I would have juxtaposed the character flaw of one man onto his entire sex, even though rationally I know there are plenty of wonderful men out there who would never disregard a woman's wishes. I am forever sobered by the ability of that boy's bad judgment to have such an effect on the sister of an unsuspecting seventeen year old.

Looking back, if there were one cause I had to name for the whole situation, I would pin the blame on a host of *misinterpretations*: Dan's of a willing sex partner, Ashley's of her degree of responsibility for the inci-

dent, the policeman's of the supposedly supportive role of law enforcement when a crime has taken place, and society's of young women who really do mean "no."

There is something unbearable about an injustice that victimizes your little sister. I keep asking myself, "Is nothing sacred?" But throughout the ordeal, I learned the value of "being there" in order to listen, to love, to pray, and to believe in someone when it looks like society won't.

24

How You Can Help a Victim of Rape

Heather Earle

Heather Earle is the coordinator of the sexual awareness/ abuse program at Dartmouth College. She holds a master's in counseling from the University of Minnesota, and is currently working toward her Ph.D. in counseling at the University of Wisconsin at Madison.

Unfortunately, many of us have friends, family, and other loved ones who have experienced some form of sexual victimization.[1] When someone turns to us looking for support in dealing with the pain of a sexual abuse, we often don't know how to respond. Our support may be clouded by our stereotypes of sexual assault, our uneasiness with this issue, or our own history of sexual abuse.

We all respond to emotional experiences differently. We grew up in families that taught us to deal with our emotions in different ways. One family may deal with anger by yelling and shouting, the next family may deal with it by withdrawing from each other, and the next by smiling and pretending that nothing is wrong. Likewise, victims[2] of sexual assault may all deal differently with the emotions that arise after their assaults; there is no "right" way for a survivor to react emotionally. It is important not to believe the stereotypes of how people think a survivor "should" behave. For example, a victim may come to you crying and withdrawn. She[3] may not want you to hug her or even to talk with you, she may simply need you to be physically nearby for her to feel safe. Another victim may need for you to hug her and let her know that you will give her all the emotional support she needs.

At times, a victim may deal with the assault either by denying or minimizing it. For example, she may tell you that "it was no big deal . . . at least I knew him" or "it really was my fault for going to his room anyway." This type of thinking allows the victim to feel in control. Her reasoning

231

may be such that if she could control the outcome, it must not have been so bad. As a support person, it is important to allow her to express these thoughts while gently helping her to see that while she may have engaged in unsafe behaviors, no one asks or deserves to be sexually assaulted.

When a person is sexually assaulted she experiences many losses: her safety, her privacy, and her feelings of self control. She may be feeling helpless and out of control. One way you can begin to empower a survivor is by allowing her to make choices. This can start out on a very small scale, such as asking "Would you like to talk here or someplace else?" "Would you like some coffee or a soda to drink?" What might seem trivial can actually be very empowering for a survivor. Empowering the survivor through decision making should extend to having her decide if she wants to go to the hospital or if she wants to report the assault. You can offer her information about what is involved with each process, but the final decision MUST be made by her. All survivors experience a loss of control after an assault; the healing process begins with regaining that power.

It is important to remember to leave your own biases out of the decision-making process. You may feel that if you were assaulted you would automatically report the assault. However, you must remember that it is the survivor, not you, who will have to wake up to the results of each decision.

Someone may seek you out directly after they have been assaulted or they may seek you out long after the assault took place. If the assault happened in the recent past, it is important for the person to seek medical attention. She may have suffered internal injuries, contracted STDs such as HIV, or have become pregnant. If she comes to you immediately after the assault and wants to go to the hospital, make sure she does not shower, wash, or clean her clothes. Doing so could destroy important evidence that could be used in a court of law. If she wants to change her clothes, make sure you bring the ones she has changed out of to the hospital. Each article should be placed in a paper bag.

A local rape crisis line should be able to help you with information such as where to get hospital attention, where to get the emotional support either you or the survivor may need, and how to report the assault to the police.

You can help a survivor decide whether or not to report her assault by helping her to clarify her feelings and identify her needs. Official crime statistics fail to reflect the true extent of sexual assault because so many victims do not report the crime. Many factors contribute to the low rate of reporting: victims may decide not to report because they believe that the

outcome will be unfavorable; that the criminal justice system is ineffective in handling rape cases; that they will suffer embarrassment as a result of reporting; or that they will not be believed.

ISSUES TO CONSIDER WHEN RESPONDING TO A SURVIVOR OF SEXUAL ASSAULT

- You may be the first person the survivor has ever spoken with about the assault. Your response will be important; it could set the tone for how the survivor feels about herself and the events in the future. A caring, nonjudgmental response will help in her recovery.
- Believe the victim. One of her fears may be that no one will believe her. Everything she tells you may not be completely organized. This is normal and is most likely because she is confused and scared, not because the assault did not occur.
- Listen. Often just being there is enough. Allow her to express herself in whatever way feels most comfortable for her. Don't fall into beliefs about how a sexual assault victim "should behave." We all learn to express ourselves differently.
- Reinforce that the assault was not her fault. Questions like, "Why didn't you scream?" or "Why did you drink so much?" might make her feel like you are blaming her. People are not always as safe as they should be, but no one deserves to be sexually assaulted.
- Allow her to make all of the decisions. You can help by giving her medical, legal, and counseling information but all final decisions must come from her.
- Allow for silent time. Don't fill silences with unnecessary talk. Silence can allow the survivor to calm herself and gather her thoughts. If it appears that the silence is uncomfortable for both of you, it is perfectly fine to acknowledge it. If you are feeling uncomfortable, chances are she is too.
- Ask open-ended questions, instead of those which require only yes or no or other one-word answers. Open-ended questions encourage a person to talk. They also allow her to set the agenda. An example of an open-ended question would be "How do you feel?" (A closed-ended question would be "Are you OK?")
- Try not use the word "why." This word often makes people feel defensive, and likely to feel uncomfortable in talking with you further.

Any statement that uses a "why" can be phrased differently. Example: "Why didn't you call the police right way?" can be rephrased "What made you decide to call the police later?"

- Paraphrase. Often summarizing what the person has said to you can help her clarify the event in her mind. It also demonstrates to her that you are listening and that you care enough to make sure you are understanding correctly. Sometimes what we hear is not what the person meant, therefore, it is important to take ownership for the paraphrase. For example, "I hear you say . . . Is that correct?" or "Am I understanding you correctly when you said . . . ?" It is also helpful to make perception checks periodically if you are feeling confused. For example, "Do I understand that what would be helpful for you is . . . ?"
- Take time to think if you need to. There is no need to give an immediate response. Try to relax. If you are talking on the phone, you may want to take notes.
- Be patient. Wait for the survivor to respond. Allow the person time to think things through—there is no hurry. And remember, don't interrupt her; what she is telling you can be very difficult to articulate.
- Your responsibility is to support her, not to investigate. You may have a desire to find out other information. But before you do, first ask yourself "What makes me want this information? Will it assist me in helping this person?" If the answer is no, don't ask the question.
- Do not hug the person or touch the person in any way without first asking permission; i.e, "Is it okay for me to give you a hug?"
- If you don't have the proper information, say so. It is okay to say, "I don't know, but I can find out for you." A call to your local rape crisis line or hospital can provide you with lots of information.
- Deal with what the survivor wants, not what you think she needs. You should ask the person how you can be of help to her.
- Ask about suicidal thoughts. Facing the issue of sexual assault can be so painful that a survivor may have thoughts of wanting to end her life in order to end the pain. It is okay to ask her if she has such thoughts. Some people fear that asking this question will install ideas of suicide, but if a survivor is feeling suicidal, the thoughts are already there. If a survivor states that she is feeling suicidal and actually has a concrete plan, you need to seek out additional help. Call a local crisis line or your local hospital.
- It is important to educate ourselves. We live in a society that has taught us many myths surrounding the issue of sexual assault. The

media, our family, or our friends may frequently reinforce these beliefs. For you to best help a survivor of sexual assault you will need to examine your own beliefs. Seek out literature that deals with sexual abuse, read writings by survivors, seek out educational programs. It is important for us to realize the impact that these myths have not only on survivors, but also on ourselves as supportive friends. Below are a few of the many myths our society may teach us.

MYTH: Sometimes it is okay for a man to force a woman to have sex, especially if she is dressed provocatively, has led him on, or if she is drunk.
FACT: No woman deserves to be violated. Rape is never justifiable, and nonconsensual intercourse is always illegal. Never assume that the way a person dresses or acts is an invitation for sexual advances.

MYTH: Most rapes are committed by black men, with white women as their victims.
FACT: Rape occurs within all racial communities. In fact, over 90% of rapes are intraracial: usually the rapist and his victim are of the same race and socioeconomic class.

MYTH: Women lie about being raped, especially when they accuse men they date or other acquaintances.
FACT: Many people believe that women falsely accuse men of rape because they feel guilty after engaging in sexual intercourse. However, according to the FBI, in only 2 percent of reported rapes the person bringing the charges was lying. This is less than for other reported crimes.

MYTH: Men do not have to be concerned about sexual assault because it only affects women.
FACT: Anyone can become a victim of rape. Men can also be raped (usually by other men) and often experience the same feelings of shame, guilt, anger, and fear. Furthermore, women's fear of rape will affect men's relationships with them; rape does not occur in a vacuum which can be ignored by men.

MYTH: Rape does not happen to people I know.
FACT: There has been a lot of research conducted in the area of sexual

assault victimization. Mary Koss found that 15.4 percent of the women in her survey had experienced rape sometime after age fourteen, and 12.1 percent had experienced attempted rape.[4] Chances are, you know someone who has been raped.

MYTH: When a man becomes sexually aroused it is difficult, almost impossible, for him to control himself.
FACT: Men can, and are, responsible for controlling their behaviors, just as women are. As one 16-year-old male said, "If you were at your girlfriend's house and you were just about to have sex, and her father walked in—you wouldn't say 'Hold on, I'll be with you in a moment . . . I can't stop.' You would be able to stop, throw your pants on, and be out of there in a flash!"

MYTH: Sexual assault does not happen in the lesbian and gay community.
FACT: Gays and lesbians can experience sexual assaults. Fear of homophobic responses may prevent them from reporting. They may fear that the support person is more interested in their homosexuality than helping them with the healing process.

MYTH: There is no way to protect yourself against sexual assault.
FACT: There are ways to reduce the risk of assault and to increase awareness, sensitivity, and safety. For example, there are self-defense classes which help women be assertive, alert, fight off an attacker, and help others in crisis.

As a support person, it is very normal for you to experience confusion, anger, disgust, fear, and uncertainty. You may want to seek out your own support. In doing so it is very important to keep in mind the survivor's decision to turn to you with such a sensitive issue and use discretion when talking with others about the assault. You should not use the survivor's name or identifying information unless you have her permission. (This does not apply to cases where you believe the survivor will act on suicidal thoughts. In such cases you should immediately seek out additional help.)

When someone we know experiences a sexual assault we often want to "make everything better." We want to take the pain away. Unfortunately, we can not always do this. You will most likely feel very helpless; you may struggle in trying to find ways in which you can better help her. Chances

are you are being much more helpful than you will ever know! Quite frequently a survivor just wants someone there who will offer her emotional support, someone who will not question her, someone who will say, "I believe you and I will support you in whatever decisions you make."

IF YOU HAVE BEEN SEXUALLY ASSAULTED

If you have been sexually assaulted you may also be experiencing many emotions. You may want to run away and hide, hoping the pain will also leave. You may feel angry, scared, or guilty, or you may just want to get on with your life, pretending it never happened. There is no right or wrong way to feel, you are not going crazy, and you are not alone.

Healing is an active, not passive, process which starts when a survivor begins to make the connection between the sexual assault and its effects in her life. The decision to start the healing process can be one of the scariest, yet the most empowering decision you can make. It takes courage to face the unknown, to claim your right to heal, to get the help you need, and to deal with the pain involved. The fear of healing is a sane and valid response to a situation which is truly frightening.

- Trust yourself. You may question your actions, going over and over in your mind different scenarios. If you were forced or coerced to engage in sexual intercourse against your will, what happened to you was not your fault.
- Talk with a trusted friend. You may feel like you don't want to talk with anyone. You may fear that people won't believe you, or you may feel embarrassed. However, the pain can often be made lighter by sharing your experience with a trusted friend. A call to a local rape crisis line can also be helpful.
- Get medical attention. If the assault happened within the past year you should seek out medical attention. Going in for an exam is for YOU. It is to make sure you are physically unharmed. You may have suffered internal injuries that you are not aware of, or have contracted a sexually transmitted disease, such as human papilloma virus (commonly known as genital warts) or HIV (which causes AIDS).
- Seek out counseling. You may have difficulties sleeping, concentrating, you may want to isolate yourself from others, you may find it difficult to go to classes or work. You may no longer feel safe in your

own home. All of these are normal responses to a sexual assault. Recovering takes time; talking with a trained counselor can help you address how the assault has affected your life.

- Talk with other survivors. This may provide a degree of support and understanding that you may not find in your everyday life. Other survivors can share their own strategies for coping with the assault. Many survivors find it empowering to talk with other survivors.

- Sexual assaults of the past. You may have experienced an assault in the past and have told no one. This is not as uncommon as you might think. Again, feelings of shame, embarrassment, guilt, or just wanting to forget about the whole event, may have lead you to keep this a secret. It is never too late to talk with someone.

- Just wanting to forget. Many victims try to hide the assault in some far away place, deep within themselves. This may work for awhile, but it may not. Quite frequently the pain will surface at some time or another. Reading this book, becoming involved in an intimate relationship, hearing others talk about their assault all may bring back feelings. You may wonder why it is so painful after so many years. You may feel frustrated that you were not able to simply forget. Again, meeting with a counselor can help you through the recovery process.

At times the road through recovery may seem unbearable. There will be times when you feel as if you are riding a roller coaster; your moods may be unpredictable. Don't give up. Living through a sexual assault is painful, but as one survivor said, "It has shattered my life. But putting myself back together has offered me the opportunity to look at each aspect of my life, allowing me to decide what I would like to keep, what I would like to discard, and what I would like to strengthen. It has given me the opportunity to become a stronger, healthier person."

Notes

1. "Sexual assault" is a term referring to any unwanted sexual contact. The legal definition of "rape" differs from state to state; generally, most states define rape as sexual penetration against a person's will and without a person's consent.

2. The terms "victim" and "survivor" are often used to refer to someone who has been assaulted. Victim is used to refer to the person directly after the assault,

and survivor is used to refer to someone who has not only survived tɔe assault but is also actively engaged in the healing process.

3. Because the majority of sexual assault survivors are women, the female pronoun will be used throughout this chapter. You should keep in mind, however, that men can also be survivors of sexual assault and many have the same responses and needs as those describe here.

4. Mary Koss, "Hidden Rape: Sexual Aggression and Victimization in a National Sample of Students in Higher Education," *Violence in Daïing Relationships: Emerging Social Issues,*. eds. Maureen Pirog-Good, Jan Stets (New York: Praeger Publishers, 1989), p. 153.

Epilogue

Christine Carter

If there is anything that I'd like to leave you with, it's the knowledge that the women who authored this book are not alone. I did not have to search high and low for rape victims to write about their experiences; I had hundreds more women submit writings than I could possibly publish. Victims surfaced from everywhere; strangers and intimate friends alike told me their stories, often voicing their traumas for the first time. I felt surrounded by victims then, as I was, and as we both are today. Far more women are raped each day than any of us would care to believe. But the longer we believe those who tell us that women are rarely raped, the longer the rapes will continue.

At this point, most of us have been inundated with statistics about date rape. On the one hand, we have heard shocking reports that one in four women will be raped in her lifetime. On the other, we have heard well-known academics decry such claims, saying only one in one thousand women are raped each year. While it is important to understand the scope of rape, so much discussion about prevalence prevents us from confronting the problem. We've been so focused on finding out whether date rape is, in fact, an epidemic, that discussion about *why* date rape happens at all has been stunted. The problem with date rape is not how often it happens, but *that* it happens at all. Incidence can only assess the extent of an existing problem. I believe we need to focus on what date rape is and what causes it, and not just how often it occurs. But since public discussion surrounding rape has, thus far, been focused on the scope of rape, I would like to clarify just what some of the often quoted (and misquoted) numbers are and where they come from. Incidence is a *starting point* for the examination of a serious social problem.

THE UNIFORM CRIME REPORT (UCR) provides us with the most conservative figures on rape (combing all types, stranger and date) available. The UCR is compiled by the FBI from data collected from 16,000 law enforcement agencies representing 96 percent of the nation's popula-

tion. This report (which is updated annually) describes the "forcible rapes" reported to police over the past year, excluding the reports which are deemed to be "baseless" or "unfounded."[1] Because many or most rapes are never reported to the police, the UCR figures represent only a small part of the actual number of women raped each year.[2]

- In 1991, the UCR recorded 106,593 rapes.[3] That means the number of women raped in one year is more than twice the number of Americans killed in the Vietnam War.
- The number of reported rapes has risen dramatically. From 1972 to 1992, there was a 128 percent increase in the number of reported forcible rapes.[4]
- The UCR recorded 1.5 million survivors of forcible rape in the United States between 1972 and 1992.[5]

The U.S. Senate Committee on the Judiciary reports that rape is "the crime least often reported to the authorities." According to the Committee, unreported rapes are increasing faster than reported rapes.[6]

The National Crime Victimization Survey (NCVS) is an annual report administered by the Bureau of the Census for the Bureau of Justice Statistics, which calculates victimizations, whether or not they were reported to the police. The National Crime Survey's victimization rates are calculated using a stratified sample of 50,500 housing units in which each member of each household 12 years of age or older is interviewed in person or by telephone.

- The NCVS recorded 173,000 rapes in 1992.[7] Over the past 20 years, the NCVS has recorded about twice as many victims of rape than the UCR.
- Fifty-seven percent of the completed rapes were committed by non-strangers.
- While the number of crimes committed in the United States is at a 20-year low,[8] the number of rapes is up 33 percent from 1990.[9]

THE MARY P. KOSS STUDY is a good reflection of the prevalence of date and acquaintance rape among high school and college students. In 1985, Mary Koss completed a two-year survey of 6,159 undergraduate students. The sample was representative of college and university students in the United States, which comprise approximately 25 percent of all people

aged 18–24.[10] Koss administered a Sexual Experiences Survey which she and her colleagues had developed and tested in previous studies.[11] This type of survey allows for anonymous disclosure where the UCR and NCVS does not.[12]

- Koss found that 15.4 percent of those women surveyed had experienced rape sometime after age 14, and 12.1 percent had experienced attempted rape.[13] These percentages are usually combined to form the often-quoted "one in four" statistic.
- Eighty-four percent of those raped knew their attackers, and 57 percent of the rapes occurred on dates.[14] Eight percent of the men surveyed had committed acts which met the legal definition of rape or attempted rape.
- Forty-two percent of those raped did not tell anyone at all about their assaults.[15] Only five percent reported their experiences to the police. If the UCR report represents only about one of twenty rapes actually committed, the number of rapes committed each year is actually more than 2 million (which is the number of rapes acknowledged to occur by the U.S. Senate Committee).[16]

More recently, sociologists Robert Michael, John Gagnon, Edward Laumann, and Gina Kolata conducted a massive and scientifically sound study called Sex in America. Their purpose was not solely to determine the prevalence of rape, but found the scope of forced sexual activities significant enough to dedicate a whole chapter to forced sex. Twenty-two percent of the women they surveyed had been forced to do something sexually that they did not want to do. Forty-six percent of those who had been forced were forced by someone they were in love with, but only 4 percent by strangers.

There will always be someone to tell you that date rape doesn't happen. It is too easy to turn away, too easy to believe that rape isn't a problem we need to be concerned about. But we do need to be concerned, and we need to be concerned about more than mere statistics. While the public and media have been arguing about incidence numbers, at the barest of bare minimums, more than 100,000 women are raped each year. And even if that number is much lower than the actual number of women raped, 100,000 is still far too many women raped each year for us not to be concerned—concerned enough to examine the problem, not just the statistic—and take action to stop rape.

Notes

1. The FBI defines forcible rape as, "the carnal knowledge of a female forcibly and against her will. Assaults or attempts to commit rape by force or threat of force are also included; however, statutory rape (without force) and other sex offenses are excluded." By using the term "forcible rape," which is redundant, the FBI seems to be implying that there is such thing as "consensual rape" or rape which is not forced. From Federal Bureau of Investigation, United States Department of Justice, *Crime in the United States*, August 30, 1992, p. 23.

2. "Are we really living in a rape culture?" *Transforming a Rape Culture,* eds. Emilie Buchwald, Pamela Fletcher, Martha Roth (Minneapolis: Milkweed Editions, 1993), p. 7.

3. Federal Bureau of Investigation, 1992. (These are the most recent figures available.)

4. Federal Bureau of Investigation, 1992.

5. Federal Bureau of Investigation, 1992, p. 58. Cited in *Transforming a Rape Culture*, p. 7.

6. U.S. Senate Committee on the Judiciary, "Violence against women: The increase of rape in America," *Response to the Victimization of Women and Children*, vol. 14 (1991), p. 20.

7. "The NCVS recorded 2.3 million rapes of females during the years from 1973 to 1987. Thus, in a fifteen-year period, the NCVS recorded almost 1 million more cases of rape than the twenty-year UCR numbers. For a comparable twenty-year period, the number of female rape survivors in the country would be 3 million women for that twenty-year period alone." From *Transforming a Rape Culture*, p. 8.

8. In 1993 the total number of crimes against U.S. residents—approximately 34 million—was several million lower than in 1973. However, the rate of violent crime (that is, the number of violent offenses per 1,000 inhabitants 12 years old and older) has fluctuated during the past two decades. It is currently 32.1 per 1,000 U.S. residents, while in 1973 it was 32.6 per 1,000 U.S. From, "Crime fell more than five percent last year, reaching 20-year low," US. Department of Justice, BJS, Nov. 14, 1993, no. 202-307-0784.

9. Criminal Victimization in the United States, 1991, Dec. 1992, NCH-139563, pp. 5, 72.

10. U.S. Bureau of Census, 1980. Cited in Koss, "Hidden Rape: Sexual Aggression and Victimization in a National Sample of Students in Higher Education," *Violence in Dating Relationships: Emerging Social Issues*, eds. Maureen Pirog-Good, Jan Stets (New York: Praeger Publishers, 1989), p. 146.

11. See Koss & Oros, 1982 or Koss and Giycz, 1985.

12. A disadvantage to Koss's study is her inclusion of the question, "Have you had sexual intercourse when you didn't want to because a man gave you alcohol or drugs?" to identify rape victims. While impaired coerced consent is certainly an

issue, all women who answer yes to this question have probably not been raped. However, each study done to uncover the incidence of rape has its flaws; comparatively, the Koss study is still considered revolutionary, although nearly 10 years old. Mary Koss, "The Scope of Rape," *Journal of Consulting and Clinical Psychology*, vol. 55, no. 2 (1987), p. 167.

13. These percentages reflect the highest level of victimization experienced by a respondent; no respondent's experiences would be recorded in both percentages. Mary Koss, "Hidden Rape: Sexual Aggression and Victimization in a National Sample of Students in Higher Education," *Violence in Dating Relationships: Emerging Social Issues*, p. 153.

14. Robin Warshaw, *I Never Called It Rape* (New York: Harper & Row, 1988), p. 21.

15. Mary Koss, "The Hidden Rape Victim: Personality, Attitudinal, and Situational Characteristics." *Psychology of Women Quarterly*, vol. 9 (1985), p. 207.

16. U.S. Senate Committee on the Judiciary, "Violence against women: The increase of rape in America," *Response to the Victimization of Women and Children*, vol. 14, (1991), p. 20.

Appendix: Rape Crisis Centers and Hotlines

If you or a friend have been raped, the organizations listed below can provide a lot of information to help you. Crisis center personnel can guide you to the closest hospital (and will often go with you), give advice about reporting and seeking legal help, and provide counseling services. Rape crisis hotlines are an invaluable resource: even if you just need someone knowledgeable to talk to, sometimes they are the best people to call.

ALABAMA
Rape Response Program
205-323-7273 24-hour hotline
Hospital advocacy, individual and group counseling, court accompaniment.

ALASKA
Standing Together Against Rape
907-563-7273 24-hour hotline
Crisis intervention, short-term individual or group counseling, training professionals, community presentations.

ARIZONA
Southern Arizona Center Against Sexual Assault
Tucson Rape Crisis Center
800-400-1001 24-hour hotline
602-327-7273
Individual and group counseling, referrals, medical advocacy and reporting assistance, prevention education, workshops and training.

ARKANSAS
Rape Crisis Service
800-542-1031 24-hour hotline
Crisis intervention, individual and group counseling.

CALIFORNIA
San Francisco Women Against Rape
415-647-7273 24-hour hotline
Individual and group counseling.

Center for Women's Studies and Services
619-233-3080 24-hour hotline
Hospital accompaniment for victims, advocacy, full crisis services.
619-233-8984

Rape Treatment Center
Santa Monica Hospital
310-319-4503
Comprehensive medical examination and treatment, supportive individual
and group counseling for sexual assault victims.

COLORADO
Boulder County Rape Crisis Team
303-443-7300 24-hour crisis hotline
Medical, legal, and police accompaniment. Group and individual counsel-
ing.
303-443-0400

CONNECTICUT
Rape Crisis Center, YWCA
203-624-2273 24-hour hotline
Crisis counseling, advocacy, short-term counseling, support groups.

DELAWARE
CONTACT Delaware, Inc.
800-262-9800 24-hour crisis line (DE only)
302-761-9100 24-hour crisis line
302-761-9700 TTY/TDD
Telephone assistance and counseling, hospital and police accompaniment,
short-term counseling and referrals for long-term counseling, public edu-
cation.

FLORIDA
Roxcy Bolton Rape Treatment Center
Jackson Memorial Hospital
305-585-7273 24-hour hotline
Comprehensive medical examination and treatment, supportive individual and group counseling for any sexual assault victims: men, women, and children.
305-585-6949

Phoenix Center
Sexual Assault Crisis Unit
305-761-7273 24-hour hotline
Comprehensive medical examination for adults and children. 24-hour agency and crisis hotline, individual and group counseling for adult and child victims of sexual abuse.
305-765-5066

GEORGIA
Rape Crisis Center
404-616-4861 24-hour hotline
Hospital-based comprehensive medical exam, individual, family, and group therapy, legal liaison.

HAWAII
Sex Abuse Treatment Center
808-524-7273 24-hour hotline
Crisis intervention, long-term individual and group counseling. Medical and legal advocacy.
808-973-8337

IDAHO
Rape Crisis Alliance
208-345-7273 24-hour hotline
Crisis services, support group, counseling, education.

ILLINOIS
Women's Services YWCA of Metropolitan Chicago
312-372-6600 M-F, 9-5 hotline
Individual and group counseling.
312-372-4105

Chicago Sexual Assault Helpline
312-744-8418 24-hour hotline

INDIANA
Turning Point
800-221-6311 24-hour hotline
Shelter, outreach program, counseling.
812-379-9844

IOWA
YWCA
319-363-5490 24-hour crisis line
Support groups, individual counseling, shelter.

KANSAS
Wichita Area Sexual Assault Center, Inc.
316-263-3002 24-hour hotline
Counseling, support group, hospital accompaniment, and legal aid.

KENTUCKY
RAPE Relief Center
502-581-7273 24-hour hotline
Services for sexual assault survivors, incest groups, individual, legal, court, and hospital advocacy.

LOUISIANA
Stop Rape Crisis Center
504-383-7273 24-hour crisis line
Free individual and support group counseling. Accompaniment to hospital.

YWCA Rape Crisis Program
504-483-8888 24-hour crisis hotline
Individual counseling and support groups for boys, girls, teen girls, incest survivors, partners and caretakers of survivors. Courtroom advocacy program. Community education.
504-482-9922

MAINE
Rape Crisis Center, Inc.
207-774-3613 (collect calls accepted) 24-hour hotline
Peer counseling and extensive referrals for further counseling for victims, family, and friends. Hospital, court, and police advocacy.

MARYLAND
Sexual Assault Recovery Center
401-366-7273 24-hour hotline
Medical and legal advocacy. Therapists and counseling, community education.

MASSACHUSETTS
Boston Area Rape Crisis Center
617-492-7273 24-hour hotline
Spanish Hotline: 617-492-2803
TTY: 617-492-7273 (M-F, 9-5)
Legal, medical, police advocacy. Drop-in and closed support groups, and drop-in individual counseling. Referral service for other services.

MICHIGAN
Rape Counseling Center
313-833-1660 24-hour crisis line
Emergency room accompaniment. Individual counseling and support groups.

MINNESOTA
Rape and Sexual Assault Center
612-825-4357 24-hour hotline
Free walk-in and short-term counseling. Professional individual and group counseling. Legal advocacy. Community education.
825-2409

MISSOURI
Metropolitan Organization to Counter Sexual Assault (MOCSA)
816-531-0233 24-hour hotline
816-561-1222 Survivor support line (M-F, 9-8)
Free counseling and rape crisis intervention, support groups. Hospital, police, and legal advocacy. Child assault team, offender program, and developmental disabilities program.

MONTANA
Women's Place
800-540-7295 24-hour hotline
Crisis line for domestic violence, sexual assault, or child sexual abuse. Peer support groups. Legal and medical advocacy and referrals.
406-543-7606

Billings Rape Task Force
406-259-6506 24-hour crisis hotline
Short-term crisis counseling, support groups, hospital, police, and court accompaniment, resource library, community programming.
406-245-6721

NEBRASKA
Women Against Violence
402-345-7273 24-hour hotline
Medical and legal advocacy, support groups, and referrals. "Get away gang" program for children.

NEVADA
Community Action Against Rape
702-366-1640 24-hour hotline
Medical, legal, and police advocacy. Referrals for counseling.

NEW HAMPSHIRE
Women's Information Service (WISE)
603-448-5525 (call collect) 24-hour crisis line
Information and referral service, individual peer support, support groups
for survivors, medical, legal, welfare, and housing advocacy.

NEW JERSEY
YWCA of Bergen County Rape Crisis Center
201-487-2227 24-hour hotline
Crisis intervention, emotional support, counseling referral, free therapist-
directed support groups, medical and legal accompaniment.

NEW MEXICO
Albuquerque Rape Crisis Center
505-266-7711 24-hour crisis line
Hospital accompaniment, police and legal advocacy. Free individual coun-
seling and support groups. Community education.

NEW YORK
Sex Crimes Report Line
New York City
212-267-7273 24-hour hotline
Confidential referral service for counseling and advocacy programs
throughout New York City. Questions answered by female detectives. Re-
porting is not necessary when using this service.

Syracuse Rape Crisis Center
315-422-7273 24-hour hotline
Direct service counseling, long- and short-term, school-based education
program, legal and medical advocacy.

NORTH CAROLINA
Mecklenburg County Rape Crisis Center
704-375-9900 24-hour hotline
Free confidential counseling, hospital, legal, police advocacy, referrals.

NORTH DAKOTA
Rape and Abuse Crisis Center of Fargo-Moorhead
701-293-7273 24-hour hotline
Crisis intervention, information and referrals, individual and group counseling, assistance in legal, police procedures.

OHIO
Cleveland Rape Crisis Center
216-391-3912 24-hour hotline
Hospital and justice system advocacy, individual counseling and peer support groups.

OKLAHOMA
YWCA Rape Crisis Center
405-943-7273 24-hour hotline
Medical, police, and legal advocacy, individual and group counseling for victims of domestic violence or sexual assault.

OREGON
Portland Women's Crisis Line
503-235-5333 24-hour crisis line
Support groups for adults and teens, advocacy for reporting and not reporting, domestic or sexual violence.

PENNSYLVANIA
Pittsburgh Action Against Rape
412-765-2731 24-hour hotline
Offers crisis intervention for victim, counseling individually or in groups for men, women, and children, preventative education throughout the community.
412-431-5665

Women Organized Against Rape
215-985-3333 24-hour hotline
Comprehensive services for victims (women, men, and children) and friends and family. Court and hospital accompaniment. Individual and group counseling, short- and long-term. Volunteer training and community education.
215-985-3315 (office)

RHODE ISLAND
Rhode Island Rape Crisis Center
401-421-4100 24-hour hotline
Crisis intervention, individual and group counseling, legal advocacy. Prevention education, professional training. Children's advocacy center.

SOUTH CAROLINA
People Against Rape
800-241-7273
803-722-7273 24-hour hotlines
Free counseling and medical, legal, and police advocacy for victims of sexual assault and childhood sexual abuse.

SOUTH DAKOTA
Resource Center for Women
605-226-1212 24-hour hotline
Counseling, temporary shelter, protection orders, advocacy.

TENNESSEE
Memphis Sexual Assault Resource Center
901-528-2161 24-hour hotline
On-site forensic/medical evaluations, counseling, adult and child advocacy for police and court.

TEXAS
Dallas County Rape Crisis and Child Sexual Assault Center
214-653-8740 24-hour crisis line
Rape counseling, medical, police and legal advocacy.

Austin Rape Crisis Center
512-440-7273 24-hour hotline
Emergency services, individual and group counseling for adults, children, incest victims, and men.

Houston Area Women's Center
713-528-7273 24-hour crisis line
Crisis intervention, support groups, hospital and legal advocacy.
713-528-2121 information and referrals

Information about all issues relevant to women: battering, sexual assault, breast cancer, etc.

UTAH
Salt Lake Rape Crisis Center
801-467-7273 24-hour hotline
Individual short-term crisis counseling, support groups, hospital accompaniment, community education program.
801-467-7279 (office)

VERMONT
Women's Rape Crisis Center
802-863-1236 24-hour hotline
Medical, legal, and police advocacy. Short-term crisis counseling and referrals for long-term counseling for women and men. Support groups. Community education.

VIRGINIA
Sexual Assault Resource Agency (SARA)
804-977-7273 24-hour crisis line
Individual counseling and support groups, community education, legal and medical advocacy, referrals.
804-295-7273

WASHINGTON
Seattle Rape Relief
206-632-7273 24-hour crisis line
Advocate counselors, support groups, drop-in groups, legal and medical advocacy, education in community.
(206) 325-5531

WASHINGTON D.C.
DC Rape Crisis Center
202-333-7273 24-hour hotline
Free individual counseling, support groups for survivors, friends, and family. Accompaniment in hospital, police, legal procedures.
202-232-0789

WEST VIRGINIA
Rape and Domestic Violence Information Center
304-292-5102 24-hour line
Medical and police advocacy, counseling, community education.

WISCONSIN
Sexual Assault Center
414-436-8899 24-hour crisis line
Free and confidential services for victims, friends, and family members. Emotional support, information, referrals. Medical, police, and legal advocacy. Public education.

WYOMING
Wyoming Coalition Against Domestic Violence and Sexual Assault
800-990-3877 24-hour hotline
Referrals to local crisis hotlines, counseling services, and advocacy programs.

NATIONAL
Sexual Abuse Helpline
National Referral Service
800-255-6111
24-hour hotline, gives referrals to local services nationwide. (Note: it is often easier to get an in-state referral from one of the organizations listed above.)

— *Many thanks to Reini Jensen, who compiled this list.*